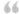 **To Petr and Renata, for showing me the world.** "

#wanderlust

Copyright © 2020 Quarto Publishing plc

Published in 2020 by Harper Design

An Imprint of HarperCollins*Publishers*
195 Broadway
New York, NY 10007
Tel: (212) 207-7000
Fax: (212) 207-7654
harperdesign@harpercollins.com
www.harpercollins.com

Distributed throughout the world by
HarperCollins Publishers
195 Broadway
New York, NY 10007

ISBN 978-0-06-298103-5

Library of Congress Control Number: 2020008164

This book was conceived, designed, and produced by
The Bright Press, an imprint of The Quarto Group
The Old Brewery
6 Blundell Street
London, N7 9BH
United Kingdom
T (0)20 7700 6700 F (0)20 7700 8066
www.quartoknows.com

Bright Press Publishing Team:
Publisher: James Evans
Editorial Director: Isheeta Mustafi
Managing Editor: Jacqui Sayers
Art Director: Katherine Radcliffe
Development Editor: Abbie Sharman
Project Editor: Angela Koo
Design: JC Lanaway

Printed in Singapore
First Printing, 2020

Cover credits:
Front:
Design by Greg Stalley
Photography by Peter Parkorr

Back:
Photography (left to right) by
Anna Karsten @anna.everywhere,
EB Adventure Photography | Shutterstock

#

wanderlust

The World's 500 Most Unforgettable Travel Destinations

Sabina
Trojanova

HARPER
DESIGN
An Imprint of HarperCollins Publishers

#contents

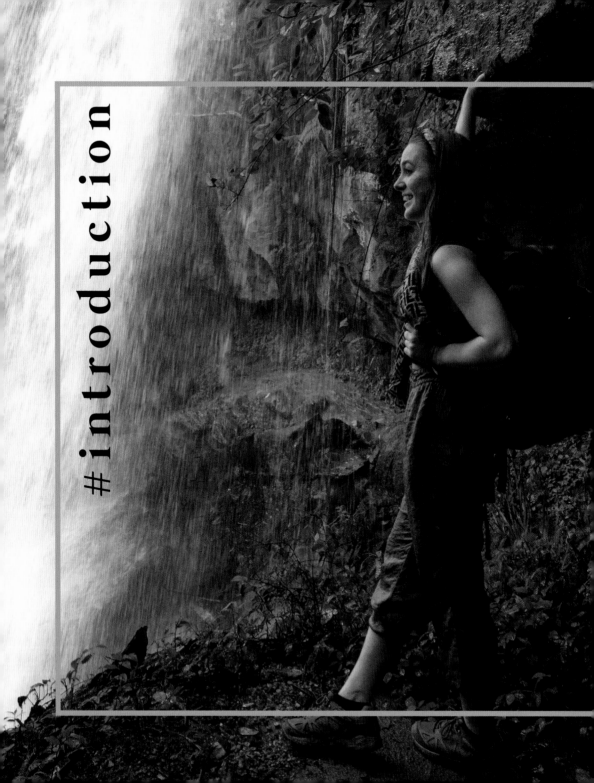

#introduction

Once reserved for the fortunate few, travel has become more accessible than ever—especially for those of us blessed with "strong" passports. But with the whole planet on your doorstep, where should you go?

I created #wanderlust to introduce you to corners of our planet that don't often get featured on social media and to represent diverse female travelers. That's the real beauty of travel—it introduces us to places and people that are unlike anything we've ever known, and helps us see our commonalities.

Thank you for picking up my book, and I hope it'll take you on many adventures!

Sabina
x

Follow me on Instagram
and YouTube @girlvsglobe

1

Beach
Escapes

#lap of luxury

Canouan ever have enough beach time?

If you're contemplating backpacking around the Caribbean, Canouan isn't for you. This tiny outcrop in Saint Vincent and the Grenadines caters to the richest of the rich, with luxury resorts, yachts, and a championship golf course. In just 3 square miles (7.8 square km), the activites on offer will leave you spoiled for choice.

Martinique is magnifique

If you like your Caribbean islands with a French twist, you'll love Martinique's continental panache—from the Jardin de Balata botanical gardens to Fort-de-France's colonial architecture. Even the currency is European (euro). Visiting Martinique's white beaches and tropical rainforests doesn't come cheap, but there's no other place like it.

▶ Get vitamin sea in Turks and Caicos

For a tranquil getaway, Turks and Caicos is a worthy contender. Switch off your daily autopilot and enjoy the moment, with your toes in the unspoilt white sands of Grace Bay Beach. Pack a snorkel to explore the crushed pink coral seabed—a unique feature of this Atlantic archipelago. After you've had your fill of beach time, explore ruins in the jungle or take a boat ride to witness the annual humpback whale migration.

Turks and Caicos

▶ Snack away to an East African island

Zanzibar is a melting pot of influences, from mainland Africa to India and Arabia. Historic Stone Town is a maze of narrow alleys, brass-studded teak doors, and arabesque balconies, reflecting the island's eclectic character. So does its cuisine, from Portuguese–Indian *sorpotel* to Swahili fish curries and Chinese-inspired *tambi* noodles.

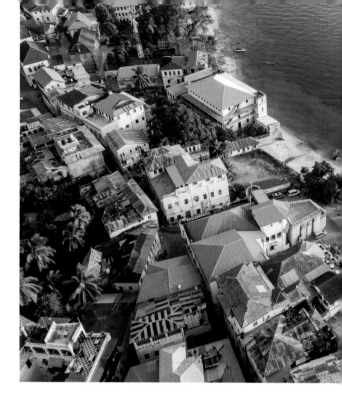

Zanzibar, Africa

Practice your resting beach face in St. Barts

Saint Barthélemy (or St. Barts/ St. Barths) is the go-to vacation spot for Hollywood socialites. Combining laidback Caribbean vibes with upscale boutiques and yacht-filled harbors, the island allows celebs to unwind in style. But that doesn't mean it's pretentious! Put a hibiscus flower behind your ear, grab some flip-flops, and hit St. Jean Beach.

▶ Enjoy the Capri sun

Private motor vehicles aren't allowed on Capri, which leaves public transporNtion, boats, and your own two feet. Enjoy a limoncello at an elegant cafe and try to guess who owns the yachts parked along the island's cove-studded coastline. Once you conclude your celeb-spotting adventure, take a day trip to the Blue Grotto—a cavern bathed in the ethereal glow reflected off its turquoise waters.

Capri, Italy

Disappear to Bermuda

Don't let the Bermuda Triangle's reputation put you off Bermuda—this North Atlantic island is all smiles and sunshine. Many of its distinctive pastel-colored buildings were built by shipwrecked English sailors in the seventeenth century. From traditional pubs to afternoon tea spots, the island has a quintessentially English air of sophistication.

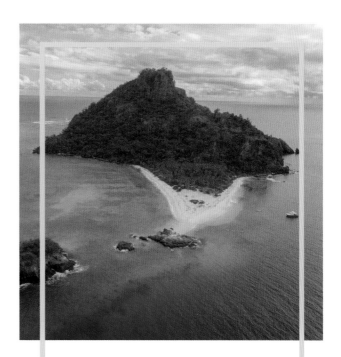

Cast away to Fiji

If your life feels like a shipwreck, head to Fiji. *Cast Away* was filmed on Monuriki—an uninhabited island with a lagoon perfect for snorkeling. Stay at Likuliku Lagoon Resort on nearby Malolo Island for spectacular views of Monuriki. If paying $900 a night is out of the question, visit on a day trip.

Bring . . .

an old volleyball for a Wilson selfie!

Bring your best France to St-Jean-Cap-Ferrat

St-Jean-Cap-Ferrat is one of the planet's most exclusive postcodes. The village sits between Nice and Monaco, flanked by a yacht-stuffed harbor and paths shaded by eucalyptus trees. Hire a sunbed on iconic Paloma Beach or head to the tropical gardens at Villa Ephrussi de Rothschild, owned by one of the world's wealthiest families.

◄ Jamaican everyone so jealous

Port Antonio is Jamaica's main banana port, and the best introduction to the island— a buzzing tangle of street vendors, lively markets, and rundown eighteenth-century buildings. There are no all-inclusive giants here, just laidback vibes and natural beauty. Try nearby Frenchman's Cove, Monkey Island, or Blue Lagoon for a tranquil getaway.

Jamaica's Blue Lagoon

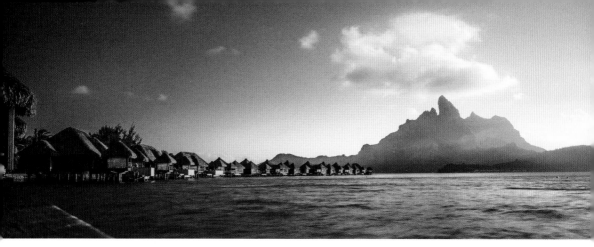

Bora Bora's Mount Otemanu

Bae watch in the Maldives

Romantics flock to the Maldives for weddings and honeymoons, but you don't need to have marriage on your mind to fall in love with this island, with its sugar-white sand and aquamarine waters. But beware—those overwater villas, in-room massages, and butlers come at a price!

▲ Watch sunsets not Netflix in Bora Bora

White sand, greenery, volcanic peaks—it's no wonder this French Polynesian island has been attracting the rich and famous for decades. Snorkel around the barrier reef, enjoy a cocktail by the ocean, or climb the mystical Mount Otemanu.

► Oh, we're going to Ibiza

Most people visit Ibiza for DJs and beach parties. For an alternative approach, book a villa far from the crowds and explore the island's history. From the Carthaginians to the Moors, Romans, and pirates, you'll join a long line of wanderers drawn to its shores.

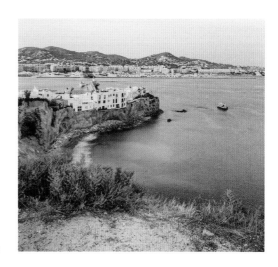

Ibiza, Spain

Sheikh it up in Saudi Arabia

Getting a visa to Saudi Arabia used to be nearly impossible unless you were on business or making the pilgrimage to Mecca (see page 246). But the Arabian shore is beginning to welcome holidaymakers. The Red Sea mega-resort won't open until 2022, but you can make a splash at the Al Fanateer Beach in Al Jubail or visit the luxurious Duurat Al Arous in Jeddah.

Go chasing waterfalls in Samoa

If you love culture and tradition, Samoa will blow your mind. These islands have been settled by the Lapita people for 3,500 years. Samoa is also blessed with hundreds of waterfalls. Togitogiga Waterfall was once frequented by great warriors, the Fuipisia Falls are home to colorful birds, and Afu Aau Waterfall provides cool respite underneath a lush forest canopy.

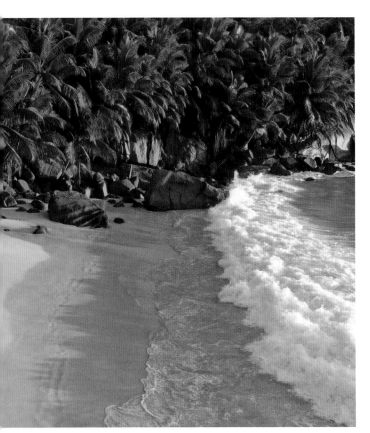

◄ Vacation like royalty in the Seychelles

When British explorers stumbled upon the Seychelles, they thought they'd found the Garden of Eden. This 115-island archipelago is a natural marvel, with diverse marine life, swaying palms, and the warm Indian Ocean. Visit the exclusive North Island where Prince William and Kate Middleton spent their honeymoon, or explore the French and British colonial buildings on Mahé.

The Seychelles

Become a Bahama mama

Mother Nature was kind to the Bahamas. This slice of paradise comprises more than 700 coral-circled islands, with pink sand beaches and crystal waters. Exploring is particularly fun after sundown, with busy cocktail bars and sultry island rhythms. If that isn't your thing, test your haggling skills at one of the archipelago's spice or ceramics markets instead.

When . . .

June to November, avoiding the hurricane season

#hippie vibes

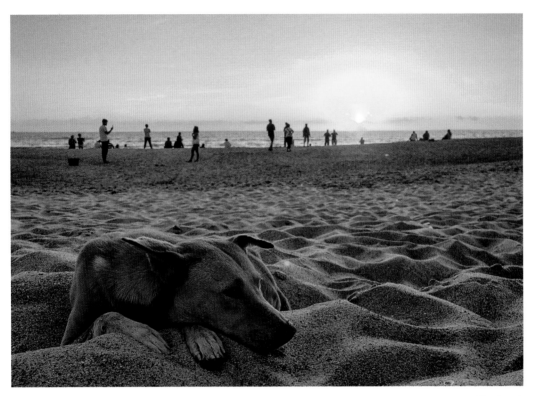

Goa beach

▲ Goa to the beach in India

What's the point of catching rays without becoming enlightened? Goa offers a spiritual boost, from sunrise yoga to meditation retreats. This Indian beach town—beloved by flower children since the 1960s—is a truly modern destination. Join the backpackers in Arambol, visit Anjuna's hippie market, and savor local Indo-Portuguese curries.

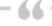

With age, comes wisdom. With travel, comes understanding.

SANDRA LAKE, *Canadian author*

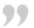

You are Ghana love Kokrobite

Kokrobite lies just 18 miles (29 km) west of Accra. Its proximity to the capital makes the fishing village popular among Ghanaian weekenders, backpackers, and volunteers looking to let off steam. Soak up the Rastafarian vibes, join a drum circle on the beach, or head to Big Milly's Backyard, where you can buy anything from clothing to musical instruments.

Pepper, spice, and everything nice in Cambodia

Sleepy Kampot, with its crumbling French colonial architecture is best known for pepper plantations and salt fields, but it can spice up your vacation in myriad ways. Visit its Fish Market, motorbike up Bokor Mountain, kayak around the Green Cathedral, or see waterfalls and gibbons on a hike in Preah Monivong Bokor National Park.

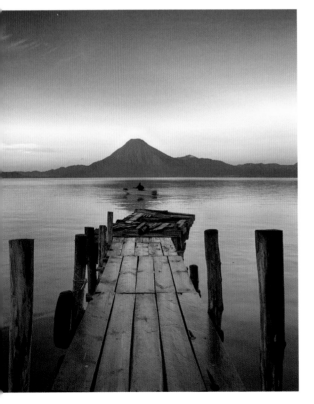

◄ Make your friends Panajachel-ous

Panajachel is the gateway to Lake Atitlán (see page 173). Its proximity to the lake's sparkling waters makes it a favorite among weekending Guatemalans and backpackers alike. Start your explorations on the Calle Santander, with its handicraft sellers, bars, and omnipresent tuk-tuks. Once the bustle becomes too much, head to the shore for a spectacular view of three volcanoes—San Pedro, Tolimán, and Atitlán. Or relax with a traditional Mayan steam bath (*temazcal*).

Lake Atitlán

► You will Negril-ly enjoy Jamaica

Once in Negril, you need never leave Seven Mile Beach. By day, you can swim in its calm waters or simply enjoy the sunshine, with a plate of jerk chicken in one hand and a glass of ginger beer in the other. Once night falls, stay for funky reggae beats and lots of dancing.

Negril, Jamaica

◄ Visit Malawi if you Maclear-ly need a break

At the southern end of Lake Malawi is Cape Maclear—a small town surrounded by forested mountains and towering granite rocks. This laidback village attracts an adventurous crowd, undeterred by the long minibus journey from Lilongwe. Dive with colorful cichlid fish at Otter Point, camp on one of the nearby deserted islands, or join the party at the Funky Cichlid. If you're over dorm rooms, try the rustic Warm Heart Adventure Lodge.

Lake Malawi

Say beach please in Montezuma

Montezuma in Costa Rica attracts free thinkers with its wild beaches and bohemian flair. Kick back on the central Playa Montezuma or the more private beaches of Las Manchas, Las Rocas, or Los Cedros. When you tire of sunbathing, snorkeling, paddleboarding, and scuba diving, visit the turtle sanctuary inside Romelia Wildlife Reserve.

Bring . . .

Michael Crichton's *Jurassic Park*, inspired by Costa Rica's natural beauty

"

You lose sight of things . . . and when you travel, everything balances out.

DARANNA GIDEL, *American novelist*

"

Tropic like it's hot in Colombia

Taganga Bay is known for its lush mountainous backdrop and banging nightlife. Scuba divers come here for affordable PADI (Professional Association of Diving Instructors) certifications, flitting between the beach and *discotecas*. You can also visit Tayrona National Park by boat or explore coffee plantations in Minca. You'll find no luxury resorts here, just hostels and bed-and-breakfasts.

> ## We live in a wonderful world that is full of beauty, charm and adventure. There is no end to the adventures we can have if only we seek them with our eyes open.

JAWAHARLAL NEHRU,
First Prime Minister of India

◄ That's what she Sidi Bou Said

This blue-and-white Tunisian town is renowned for its arts scene. In the early 1900s it was home to European painters, local craftsmen, and renowned writers such as André Gide. Art lovers will appreciate the Palace Dar Nejma Ezzahra and the outdoor marketplace at D'Art Lella Salha; water lovers will adore Amilcar Beach.

Sidi Bou Said

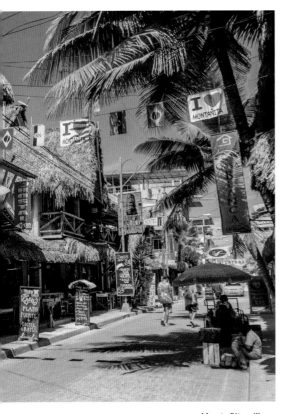

Montañita village

Little Corn Island

▲ Open the Ecuador to new experiences

Locals, backpackers, surfers—Montañita has attracted the hippie crowd since the 1960s. You can catch waves, whale watch from May until September, or visit the Dos Mangas community in the nearby forests. The slow pace may even tempt you to linger. Why not, with apartments at roughly $600 a month?

▲ Don't worry, beach happy in Nicaragua

Little Corn Island is a well-kept secret, protected by the effort required to get there: you'll fly to Managua, catch a small plane to Big Corn Island, then hop on a panga boat. Upon arrival, this tiny Caribbean isle will delight you with hidden beaches, coconut bread, and Sunday baseball games.

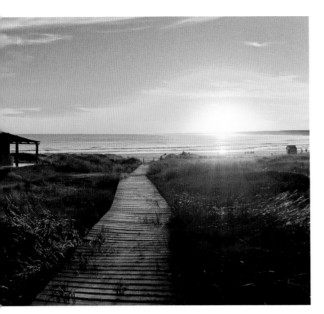

◄ Live in slow motion in Uruguay

Cabo Polonio isn't everyone's idea of fun. There's no electricity, and asking for the Wi-Fi password will earn you a blank stare. Instead, this fishing village will welcome you with unspoiled beaches, artisanal stores, and a large sea lion colony. The hamlet truly shines at nighttime, completely silent and lit by some of the brightest stars in Uruguay due to low levels of light pollution.

Cabo Polonio

► Come up for Air in Indonesia

Just a hop from Bali are the bohemian Gili Islands. There are three in total, each with its own character. Social butterflies enjoy Gili Trawangan, with its international backpacking crowd and party scene. Gili Meno is the least developed, making it perfect for romantic getaways. Gili Air is a blend of the two, mixing local character with yoga and Bob Marley tunes.

Gili Islands

Go nuclear in Puerto Rico

If you like your beaches small and secluded, pick Rincón for your next vacation: Steps Beach, within Tres Palmas Marine Reserve, is full of hawksbill turtles and parrotfish; Sandy Beach is calm and central; and Domes Beach (below) is a popular surfing spot, near a defunct nuclear facility. Once you tire of being a mermaid, enjoy the views from Punta Higuero Lighthouse.

When . . .

mid-April to June, avoiding busy winters and rainy summers

It's only Zipolite to visit Mexico

Throw caution to the wind in Zipolite, where happy hour lasts all day. This tiny Mexican town in the southwestern state of Oaxaca is a backpacker magnet. Stay in a rustic waterfront cabin or camp on the sand. When you get hungry, enjoy a *tlayuda*—a crunchy tortilla with refried beans, avocado, and cheese.

Bring . . .

very little— even swimwear is optional!

▶ Hakuna matata in Kenya

Yoga bunnies, add Lamu to your bucket list! This small Kenyan town hosts the Lamu Yoga Festival, with sunrise workshops on the beach and meditation at dusk. If you miss it, you can attend yoga classes at Banana House in Shela Village. Take the time to explore the historic old town, too. Lamu is a UNESCO World Heritage Site and one of the best-preserved Swahili settlements in East Africa.

Yoga in Lamu

Get moves like Jagger in Brazil

Arembepé, a small town on Brazil's Coconut Coast, had its hippie heyday in the 1970s, when the likes of Janis Joplin and Mick Jagger flocked there. Fifty years later, it's time for a revival! Barra do Jacuipe is as picturesque as ever, and the healing workshops at Sitio Folha d'Agua still run. Locals speak Portuguese, so bring a phrasebook!

Visit the Cameroonian coast for shore

Nature lovers will appreciate what laidback Limbe in Cameroon has to offer, from black sand beaches to the diverse plants inside the Botanic Garden and the lowland gorilla-rehabilitating Limbe Wildlife Centre. Hike around Mount Cameroon National Park, where you can reach the summit of an active volcano and glimpse endangered elephants.

Have you ever Benin West Africa?

Grand-Popo was once a major slave port; in addition, coastal erosion destroyed most of its old colonial architecture. But today's Grand-Popo is much more positive—a popular vacation spot, with a coconut-lined beach. Visit the market near Mono River, learn about Finnish–African culture at Villa Karo, and explore local voodoo customs.

#under the sea

► You're manta come to Nusa Penida

Nusa Penida is a far cry from nearby Bali—this small Indonesian island only attracts adventurous souls. Kelingking Beach, or T-Rex, is a great spot for swimming with giant manta rays, as is the aptly named Manta Bay. If you need respite from the heat, go underground at Goa Giri Putri— a magical cave temple.

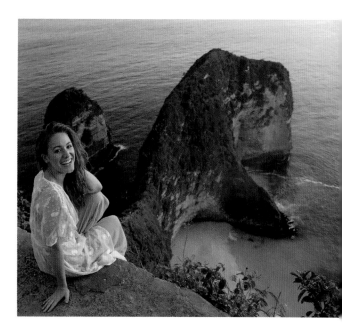

Kelingking Beach

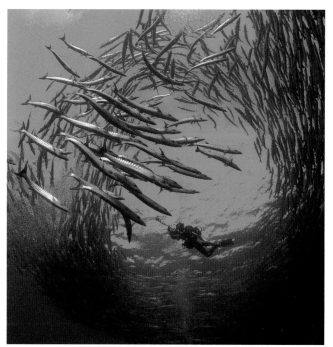

◄ Oh, barracuda in Malaysia

Sipadan Island in Malaysia was declared an "untouched piece of art" by explorer Jacques Cousteau. The waters surrounding it contain thousands of fish species and coral formations. The most popular diving location is Barracuda Point, where you can encounter swirls of these razor-fanged fish.

Barracuda Point

Cocos Island

▲ Go loco for Cocos

Diving around Cocos Island isn't for the faint of heart. Traveling from mainland Costa Rica takes thirty-six hours, and the water has strong currents. But you'll be rewarded, especially during the rainy season (June to November), when Bajo Alcyone attracts hammerheads, rays, and whale sharks.

Swim with mermaids in Mozambique

Mozambique's Bazaruto Archipelago attracts humans and animals alike. Most of the region is designated a marine national park and considered one of the best diving spots in the world. You might see dolphins, whales, and over 2,000 species of deep-sea fish. Bazaruto is even home to dugongs, the rare manatee-like creatures thought to have inspired the myths behind mermaids.

Open an Ecuador to adventure

The Galápagos Islands are a top destination for animal lovers. This is where Charles Darwin came up with his theory of evolution, after all! Travelers come to enjoy open-water dives with excellent visibility. Head to Isabela Island to see sea lions and penguins, visit the Roca Redonda underwater volcano, or explore Darwin Island's unique geological formations.

Have a cracking time in Iceland

Iceland offers a diving experience so cool you'll need a wetsuit! The Silfra Fissure is a rift separating the North American and Eurasian plates—you literally swim between two continents. It's filled with glacial water filtered through porous lava rock, producing some of the clearest water on the planet, with unbeatable visibility.

Bring . . .

thermal underwear and gloves

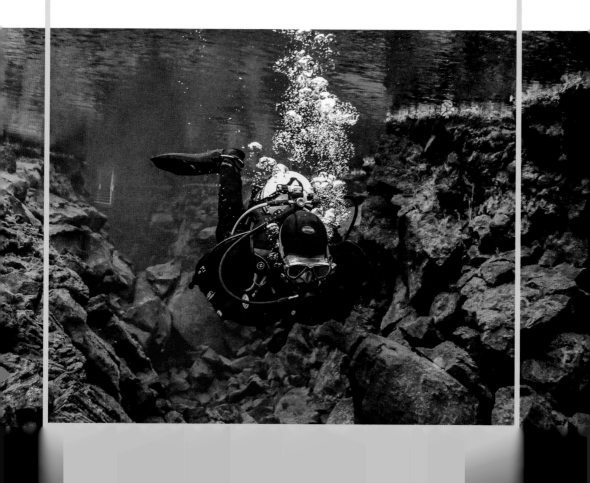

▼ You will Dahab a fun time in Egypt

Far from Cairo's pyramids and busy streets is Dahab. This sleepy fishing village has evolved into a bohemian beach town, popular among free-spirited backpackers; it's also considered one of Africa's best diving destinations. Adventurous freedivers can challenge themselves at the 330-ft (100-m) deep Blue Hole, while beginners can benefit from affordable Red Sea coast scuba diving schools.

Pack like sardines for South Africa

Don't let the name fool you—the Sardine Run is about more than sardines! Millions of fish and predators move along the Eastern Cape to the south coast of KwaZulu-Natal, including great white sharks and humpback whales. This is one of the world's largest biomass migrations. Witness it on a diving or snorkeling holiday in Aliwal Shoal between June and July.

▼ Get that sinking feeling in Belize

Belize's Great Blue Hole is a giant sinkhole, popular among divers for its underwater caves. A UNESCO World Heritage Site, the reef is a real aquatic circus, filled with midnight parrotfish, Caribbean reef sharks, and hammerheads. Dive operators offer day trips from Placencia and Ambergris Caye. For the most impressive perspective, you'll need a helicopter!

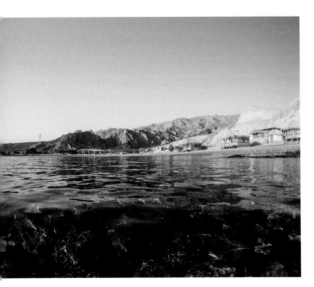

Dahab's beach

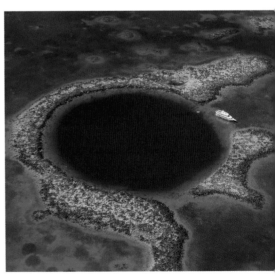

Great Blue Hole

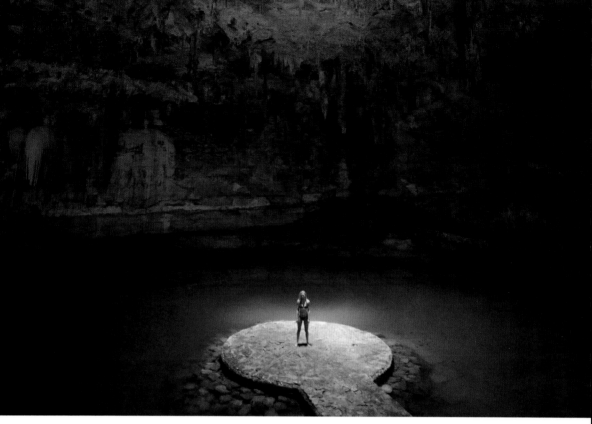

Mexican cenote

Start a Mexican wave on Isla Mujeres

If regular museums bore you, head to Isla Mujeres in southeastern Mexico for the Cancún Underwater Museum of Art (MUSA), exhibiting 500 life-size sculptures devoted to the art of conservation. You needn't be a qualified diver—some statues can be accessed via snorkeling, or viewed from a glass-bottomed boat

▲ Get yourself a nice Yucatán in Mexico

Mexico's Yucatán Peninsula is known for its cenotes—natural sinkholes that formed when the thin limestone bedrock collapsed, exposing the fresh groundwater below. See the most picturesque examples in the Sistema Sac Actun near Tulum— a 215-mile (350-km) long underwater cave system.

Don't be jelly in Palau

Book a trip to the Micronesian nation of Palau to swim in one of the world's most unique lakes. Jellyfish Lake is named after its millions of tiny harmless jellyfish. A drought crisis in 2016 caused a steep decline in numbers, but it looks like the floating medusas are back, so plan your trip ASAP!

Bring . . .

an underwater camera

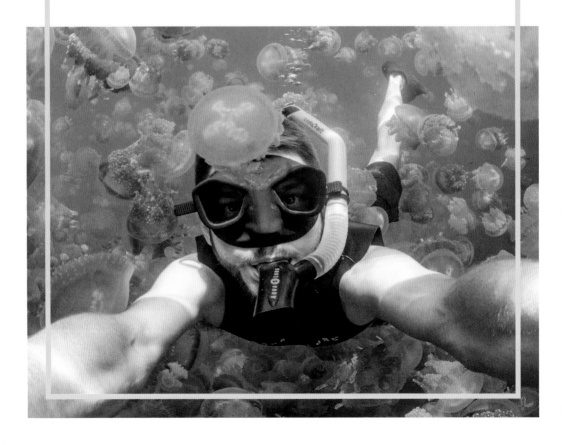

▼ You've gotta Koh Tao Thailand

If you want a qualification from PADI, head to the island of Koh Tao, with its calm waters and experienced instructors. It's also one of the cheapest places in the world for diving courses, making this expensive hobby accessible to first timers. Amp up the excitement with a UV night dive and navigate through a sea of glow-in-the-dark creatures.

Dive into East China's Atlantis

Looking at the surface of Qiandao Lake, you'd never guess it concealed an entire city—1,300-year-old Shi Cheng. You'll see intricate stone architecture from the Ming and Qing Dynasties and well-preserved carvings of lions, dragons, and phoenixes. This unique trip, requiring deep-water, night, and buoyancy experience, is for advanced divers only.

Koh Tao

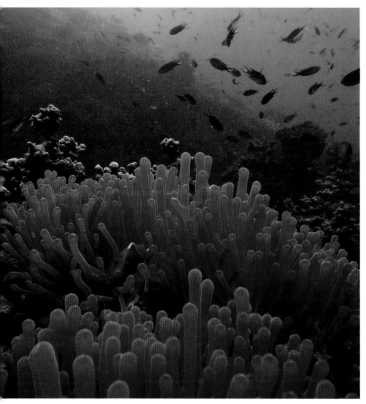

> **Man cannot discover new oceans unless he has the courage to lose sight of the shore.**

ANDRÉ GIDE,
French writer

#unusual beaches

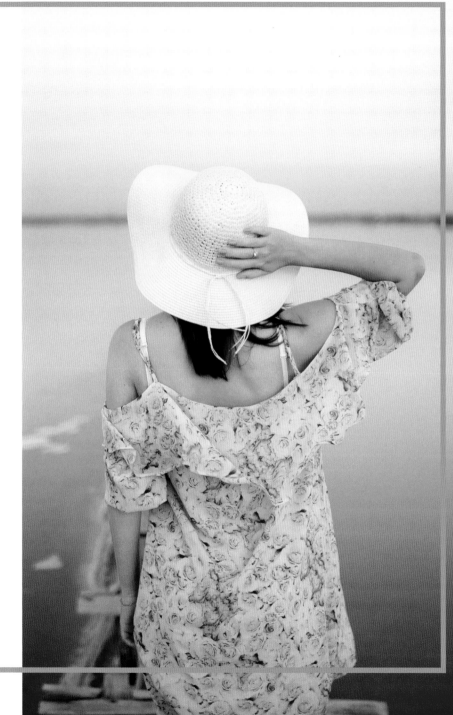

▶ Happy feet in Cape Town

Visit Cape Town's penguin colony at Boulders Beach—these tuxedoed fellas established themselves here in the 1980s and numbers have soared to 3,000. African penguins are an endangered species, but a viewing platform will allow you to get close to these wild animals without encroaching on their space.

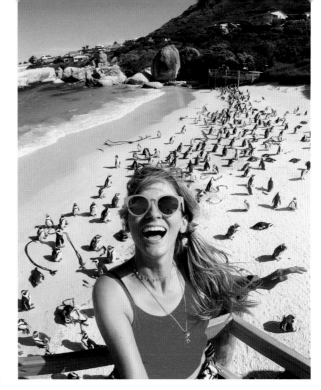

Boulders Beach

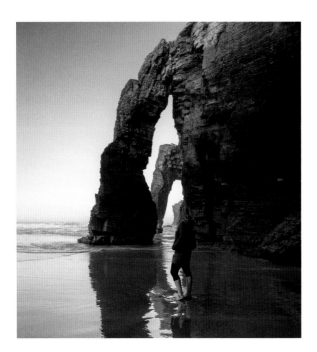

◀ Swim under cathedrals in Spain

Praia das Catedrais on the Galician coast isn't your typical Spanish beach. Atlantic waves have carved arches into the rock, resembling man-made cathedrals in both splendor and stature, some over 90 ft (27 m)! In summer you must make a free reservation to access the beach—numbers are capped at 5,000 to preserve its natural beauty.

Praia das Catedrais

▶ Embrace your inner basic beach in Malta

Rent a boat or catch a ferry from Malta, and make for the azure waters of the Blue Lagoon. Located on nearby Comino Island, this shallow bay gets incredibly busy every summer, but that doesn't mean it's overrated. Rarely will you find such calm, vibrant waters—it's just like a giant swimming pool!

Blue Lagoon

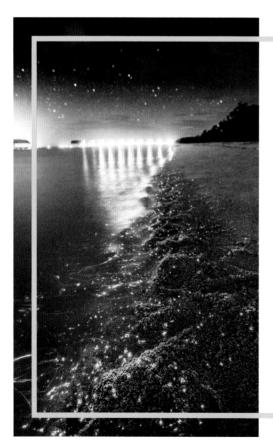

Find light in the darkness in the Maldives

In the Maldives, you can stargaze while looking at your feet. That's not a riddle—bioluminescent plankton turns beaches into fields of glowing stars at nighttime, the most beautiful being the Sea of Stars, on Vaadhoo Island. If the Maldives are out of the question, you can also experience this phenomenon in Puerto Rico or San Diego.

When . . .

June to October, when the bioluminescence is brightest

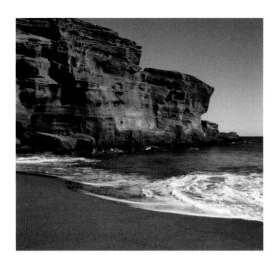

◄ Get in the green in Hawaii

The world has just four green beaches—in Norway, the Galápagos Islands, Guam, and Hawaii. The sand's hue comes from a silicate called olivine. Nowhere is it as vibrant as Hawaii's Papakolea Beach. Accessible only on foot, your photos will make Facebook friends green with envy.

Papakolea Beach

► Shell I see you in Australia?

The proverbial woman selling seashells by the seashore wouldn't have much business on Australia's Shell Beach. This 43-mile (70-km) stretch of coastline is covered in millions of shells, up to 32 ft (10 m) deep! Take a walk along the beach or enjoy a dip in the ocean. Then for lunch, head to nearby Denham, with buildings like the Old Pearler Restaurant, constructed with local seashells.

Shell Beach

A cool-weather day trip to the seaside

1 Glacier later on Iceland's coast

Iceland's Reynisfjara Beach was ranked one of the world's best nontropical beaches by *National Geographic*. With black sand, giant basalt stacks, and wild waves, it's like a scene from a monochromatic drama. For more black sand, visit Jökulsárlón Beach, with its shimmering glaciers!

When
September to October, for the Northern Lights

2 Bundles of fun at Barafundle Bay

It's hard to believe that Barafundle Bay is in Wales, not the Caribbean, but strong winds and refreshing water will soon tip you off. The bay is a half-mile (1 km) walk from the parking lot, flanked by dunes and pines. Unsurprisingly, it's consistently voted one of Britain's best beaches.

When
March to May, for mild weather

3 You should really Sligo to Ireland

Bundoran Beach has attracted sunbathers since the nineteenth century. In winter, it's also popular with dog walkers who enjoy clifftop views of Benbulben Mountain. But the area's particularly known for top surfing conditions along Tullan Strand.

When
September through April, for the best surfing

4 Ice skate in subtropical Busan

South Korea's Busan is popular in summer for it hot springs, historic temples, and parasol-lined beach. But in the winter, Haeundae Beach switches gears with a giant ice rink on the sand, allowing you to skate by the ocean.

When
Mid-December to late February, for the ice rink

1

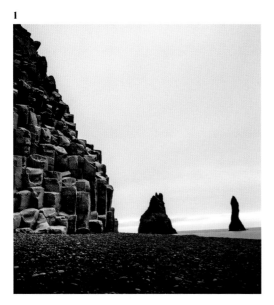

2

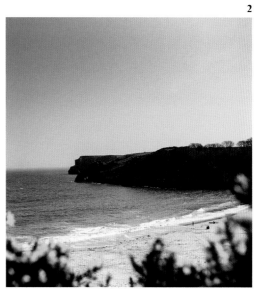

3

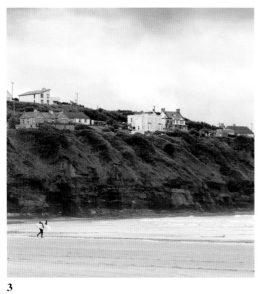

4

Bragg about your Californian trip

One man's trash is another man's treasure at Glass Beach, Fort Bragg. Once a massive dump site, it was closed down in the 1960s and attempts were made to clear the area. Many glass and pottery shards slipped through the cracks, turning into the colorful sea glass beloved by visitors today.

Bring . . .

self-restraint—it's forbidden to take sea glass home

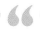

Travel and change of place impart new vigor to the mind.

SENECA, *Roman philosopher*

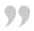

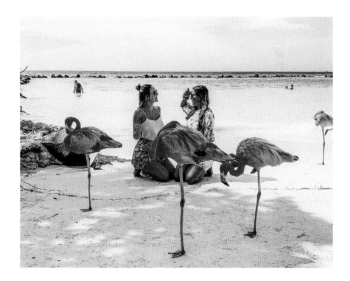

▲ Flamingo to Aruba this summer

Aruba's Flamingo Beach has become an Instagram sensation—who wouldn't want to sip cocktails surrounded by flamingos? The beach is on a private island owned by the Renaissance Aruba Resort, but day passes are available for north of $100. Do remember, though, to respect the birds' personal space.

▶ Don't hog the beach in the Bahamas

You might have seen stray dogs on beaches, but have you sunbathed next to squealing piglets? For this surreal experience, head to the appropriately named Pig Beach in the Bahamas. Visit early for a dip with the pigs—by noon they're usually napping. Who can blame them? But no matter how cute they are, allow them plenty of breathing room.

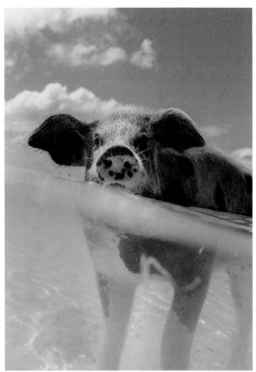

Pig Beach

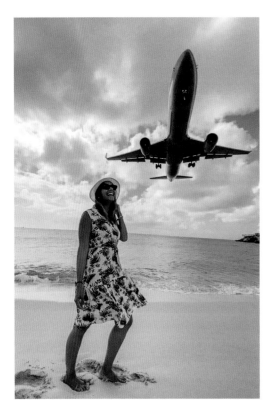

◀ Hold onto your hat in Saint Maarten

Be careful visiting Maho Beach in Saint Maarten—the beach sits directly under the flight path of the island's international airport. Due to its short runway, planes approach at an exceptionally low altitude—less than 100 ft (30 m). If you're only there to get a tan, earplugs will help!

Maho Beach

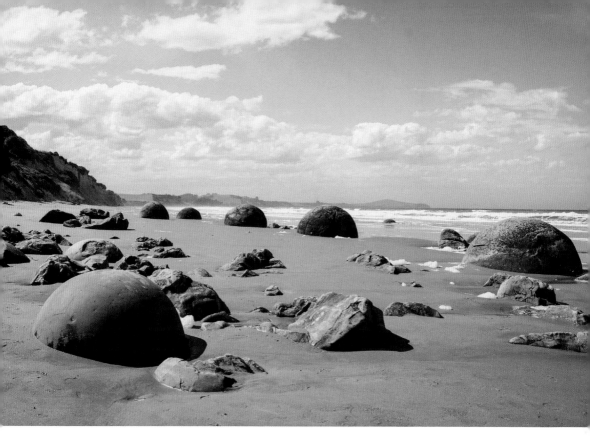

Koekohe Beach

Train your dragon in Komodo

The Indonesian island of Komodo is
famous for its giant, reptilian inhabitants—
Komodo dragons. More than 4,000 dragons
live on this small island, outnumbering
local inhabitants two to one. One of the
New 7 Wonders of Nature, Komodo National
Park will delight you with mangroves and
coral reefs, as well as these 10-ft (3-m)
long lizards.

▲ Have a Moeraki-lous time in NZ

If you like your sunbathing with a side
of whimsy, visit Koekohe Beach on
New Zealand's South Island, whose sands
are dotted with giant Moeraki Boulders.
Scientists claim these calcite mounds
formed 65 million years ago. But Maoris
believe they are calabashes, washed
ashore from the ancient Āraiteuru
canoe that transported their ancestors.

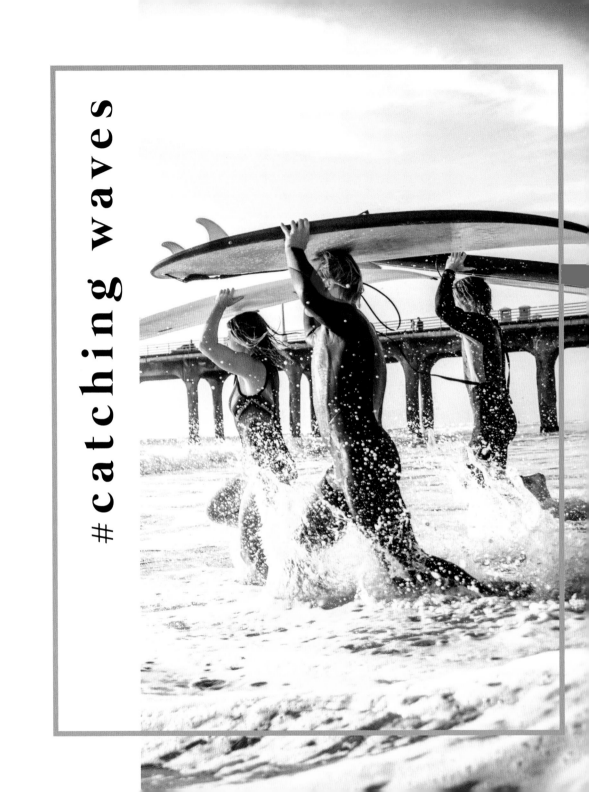

#catching waves

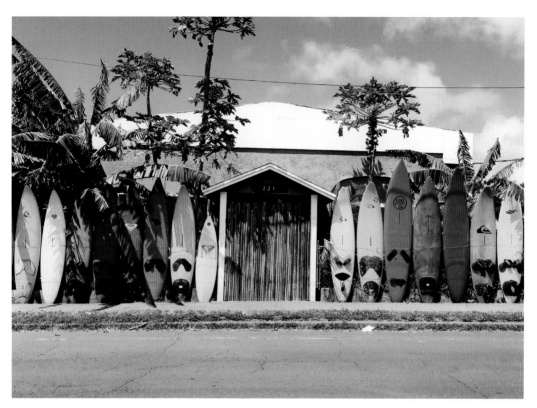

Hawaiian boards

▲ Don't ask for a reason Hawaii

Surfing has a long history in Hawaii. Visiting in 1866, Mark Twain described the locals as "amusing themselves with the national pastime of surf-bathing." Nowadays travelers from all over the world come here to tame the waves. Learn the basics at White Plains Beach, or try Jaws on Maui if you're a pro.

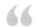

The life you have led doesn't need to be the only life you have.

ANNA QUINDLEN, *American author*

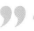

▶ Surf on fake waves in Germany

For an unusual surfing adventure, try Munich. Its mile-long, man-made river attracts experienced surfers with its challenging artificial wave, the Eisbachwelle. You'll find it in the city center, inside the English Garden—one of the world's largest urban parks. If you don't fancy participating, recline on the bank and just observe the pros.

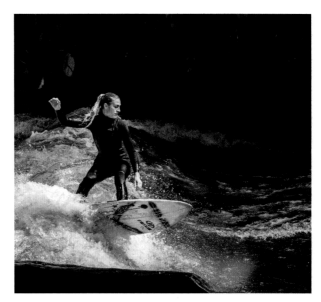

Munich's Eisbachwelle

▶ Bring your favorite Portu-gals to Carrapateira

You don't have to be a surfer or a hippie to enjoy Carrapateira, but it definitely helps! Rent a camper and join the laidback crowd at this western Algarve village. Beginners enjoy the remote Praia do Amado in summer, while professionals take advantage of larger winter waves. There are also several cliff walks, stretching all the way to Praia da Bordeira.

Carrapateira surfer

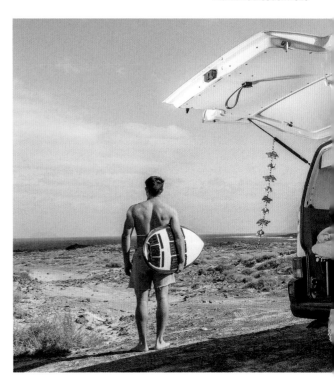

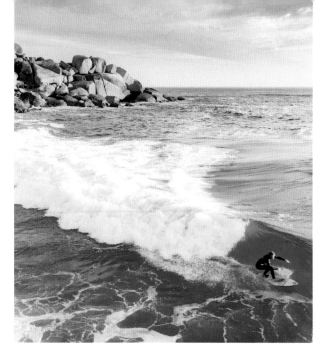

Cape Town

◄ Seas the day in South Africa

If you've never surfed, visit South Africa. The waves are reliable, the Indian Ocean warm, and individual lessons extremely affordable. South Africa has the world's third-highest shark attack rate, but many beaches are now protected by nets. Try Muizenberg in Cape Town, North Beach in Durban, or Coffee Bay on the Wild Coast.

Have an endless summer in New Zealand

New Zealand's Manu Bay first entered the international subconscious after featuring in the 1996 movie *Endless Summer*. It's primarily known as a world-class surfing spot, but Raglan Beach also offers swimming, kayaking, and paddleboarding. To the south you'll find forest hikes, the Bridal Veil Falls and Mount Karioi, an extinct volcano with vistas of the Tasman Sea.

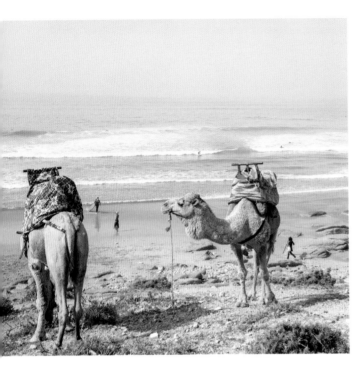

◄ Get out in Taghazout

The village of Taghazout is a unique surfing destination, boasting plenty of Moroccan flavor. Warm up your muscles with a sunrise yoga session against the backdrop of sunbaked blue and white-washed buildings, before heading into the sea. You'll share the beach with surfers and the occasional camel. Then reward yourself with an avocado smoothie or a bowl of tajine.

Taghazout camels

► The best bar (Hai)nan

The Chinese island of Hainan hasn't acquired worldwide notoriety yet, but this tropical destination attracts around 10 million domestic tourists annually. You can catch mellow waves at Riyue Bay, near the resort town of Sanya. Enjoy the long stretch of golden sand against a backdrop of volcanic mountains and forests. China is not a traditional surfing destination, so you'll enjoy the waves in relative peace.

Hainanese surf

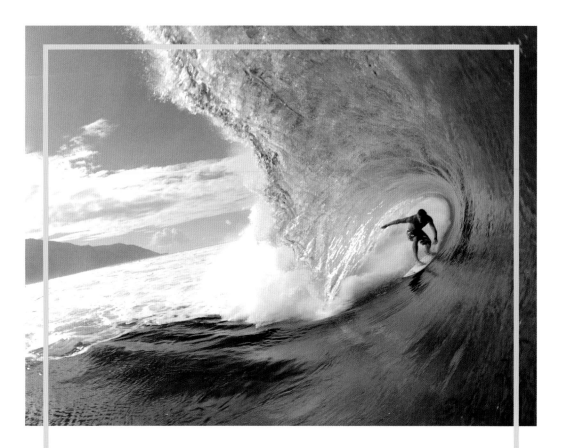

Explore the origins of surfing in Tahiti

While it may seem a modern invention, surfing was integral to ancient Polynesian culture. Observed by British explorers in the eighteenth century, it actually dates back centuries. Hone your skills today on the black beaches of Papenoo and Papara. Experienced surfers choose the consistent barrels of Teahupo'o.

When . . .

May to August, for the gnarliest waves

▶ Good times and tan lines in Bali

Detox with a combination of surfing, yoga, and meditation in Bali. Most beginners start their journey on Kuta Beach or Canggu's Batu Bolong Beach, popularly known as Old Man's. Uluwatu is better suited to more experienced surfers, but beginners can try their luck at Padang Padang Beach, which regularly hosts events like the Rip Curl Cup and was featured in 2010's *Eat Pray Love.*

Uluwatu sunset

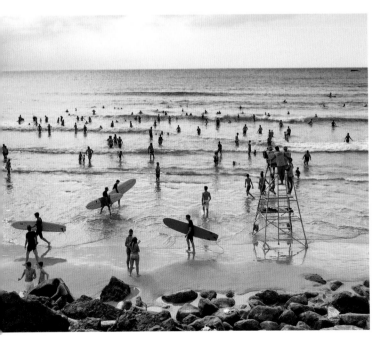

◀ Make a splash in Biarritz

Surfing made its European debut in the 1950s in Biarritz. This French Basque Country resort offers waves year round, particularly on the beaches of Côtes des Basques and Grande Plage de Biarritz. Visit Anglet's International Surf Film Festival in July for silver screen inspiration, then refuel with some hot chocolate.

Biarritz waves

▶ Feel on Cloud 9 in Siargao

Cloud 9 is one of the most famous waves in the Philippines—if not the world. It's located on the lush, teardrop-shaped Siargao Island, known for clear waters and perfect surfing conditions. If you're not ready for the barrels of Cloud 9, try the Jacking Horse. Afterward, relax by the Sugba Lagoon.

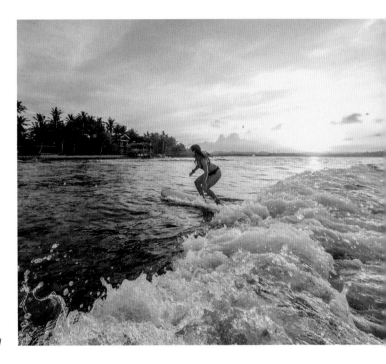

Siargao Island

Have a Watergate moment in Cornwall

No, not that Watergate! Watergate Bay in Cornwall, England, is a sandy beach stretching 2 miles (3.2 km) and a surf pilgrimage. Book a lesson at the Extreme Academy, or time your visit to coincide with the annual Boardmasters Festival for a weekend's sun, surf, and music. Nearby attractions include Newquay's Fistral Beach, the Lost Gardens of Heligan, and the Eden Project, which houses the world's largest indoor rainforest.

Catch gnarly waves in California

Surfing and California go together like peanut butter and jelly! Enjoy the West Coast sunshine at Rincón surf spot ("Queen of the Coast") in Santa Barbara, home to one of the best waves in the state. The long right-hand point tends to be crowded, as expected with a spot this famous. Later, visit the eighteenth-century Old Mission, take the 3.5-mile (5.5-km) hike to Inspiration Point, and enjoy seafood at Stearns Wharf.

2

Urban Jungle

film famous

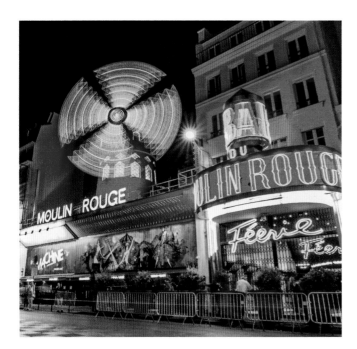

◀ In Paris you can-can

Feathers, sequins, and champagne . . . nowhere teleports you to the Belle Époque like the Moulin Rouge, in Paris's 18th arrondissement. You'll recognize the world-famous cabaret by the red windmill on its roof. That, and Baz Luhrmann's eponymous movie starring Nicole Kidman and Ewan McGregor.

Moulin Rouge

▶ Dream of Californication

No conversation about the film industry is complete without mentioning Hollywood. From the Hollywood sign to Mulholland Drive, the neighborhood is a movie buff's paradise. For behind-the-scenes insight, head to Universal Studios, home to many iconic movie sets, a maze from *The Walking Dead*, and the Wizarding World of Harry Potter. More of a *Friends* fan? Visit Warner Bros. Studios instead.

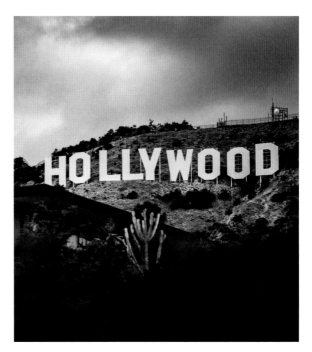

Hollywood Hills

Get lost in translation

The accolades received by *Lost in Translation* are so numerous, they have their own Wikipedia page. But more impressive are the stunning Tokyo locations featured in the 2003 hit. Try Karaoke Kan in the Shibuya-ku district, where Bill Murray and Scarlett Johansson sang their famous duet. And for accommodation, choose the Park Hyatt Tokyo, one of director Sofia Coppola's favorite places.

Discover the true Grand Budapest

The Grand Budapest Hotel is a classic Wes Anderson creation, all pastel hues and whimsy. Although shot in Germany, the fictional Republic of Zubrowka was inspired by locations across the Czech Republic—in particular, Karlovy Vary. The movie's hotel exterior was based on the town's Hotel Bristol Palace and Grandhotel Pupp. The latter hosts the Karlovy Vary International Film Festival every July.

◄ Expecto Patronum in Oxford

Harry Potter fans will instantly recognize Oxford's Christ Church Cathedral in England as the inspiration behind the Great Hall of Hogwarts. In fact, the entire town is like a vision straight from the Wizarding World. After exploring its cobbled streets, detour to Warner Bros. Studios near London to take a guided walk through the same world, including the original sets of the Forbidden Forest and Diagon Alley.

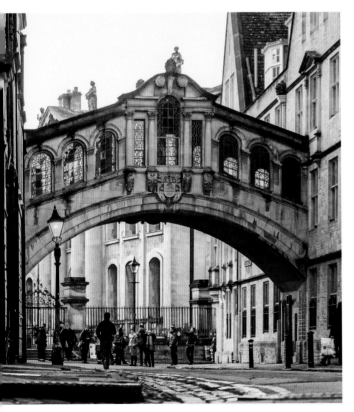

Oxford's Bridge of Sighs

Become an extra in Malta

Malta is yet another *Game of Thrones* filming location (see page 63), with much of the first season shot in historic Mdina—including Ned Stark's fight with Jaime Lannister. This island, with its Arabic and Sicilian influences, Baroque architecture, and crystal clear waters, has become one of Europe's most popular filming locations, serving as the backdrop to blockbusters *Gladiator*, *World War Z*, and *Troy*.

When . . .

May to September, to catch village fiestas

▼ Make moves in Kampala

Queen of Katwe, starring Lupita Nyong'o and David Oyelowo, tells the story of a girl from a slum in Kampala. Phiona Mutesi, whom the movie is based on, became an international sensation after her victories at the World Chess Olympiads. Visiting the neighborhoods of Katwe and nearby Bwaise makes clear the difficulties she had to overcome to become one of the country's first titled female chess players.

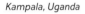

Kampala, Uganda

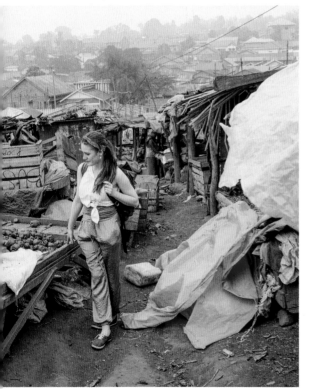

Get nostalgic in Bruges

In Bruges, starring Colin Farrell and Brendan Gleeson, introduced audiences worldwide to this Belgian town's fairy-tale vibes. Crisscrossed by canals and dotted with gingerbread houses, its center is a UNESCO World Heritage Site and a popular spot for lovebirds. Don't forget to try some *moules-frites*—mussels with fries.

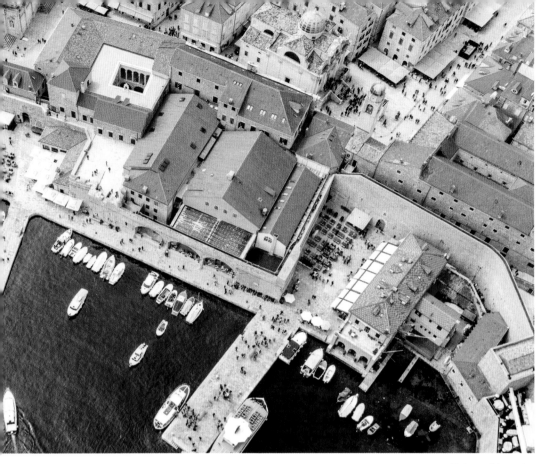

Dubrovnik's marina

▲ Walk through Westeros

The *Game of Thrones* series might have ended, but you needn't leave Westeros behind. A visit to the medieval walled city of Dubrovnik, Croatia, will make you feel like you're strolling through the winding streets of King's Landing. (If you fancy yourself more of a Stark, visit the mysterious Dark Hedges in Northern Ireland.)

Tell me, what is it you plan to do with your one wild and precious life?

MARY OLIVER, *American poet*

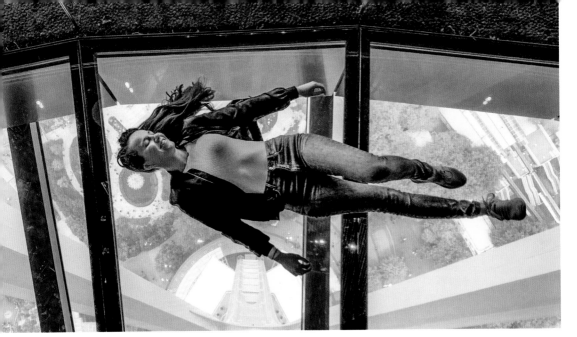

Space Needle

▲ Defy gravity in Seattle

The Space Needle is a true Seattleite icon. The observation deck is 605 ft (184 m) tall and its elevators travel at 10 mph (16 kmh), taking you to the top in 41 seconds. A revolving glass floor has also been added, making this the world's first building to have one, and the place to conquer your fear of heights.

Pick up dystopian vibes in Chicago

Chicago has been the location for many movies. You may recognize its famous *Cloud Gate* (right)—the "Bean"—from *Transformers: Age of Extinction*. Chicago also provides a gritty backdrop for action-packed productions like the dystopian *Divergent* series, *Public Enemies*, and *The Dark Knight*.

When . . .

during October's International Film Festival

▶ Join the Wolfpack in Bangkok

The first *Hangover* movie featured many iconic Las Vegas locations, including the Strip and Caesars Palace. But the sequel introduced us to somewhere much more exotic—Thailand's Bangkok. To party like the Wolfpack, go to the sixty-third-floor Sky Bar, where you can enjoy incredible views of the city while sipping a Hangovertini cocktail.

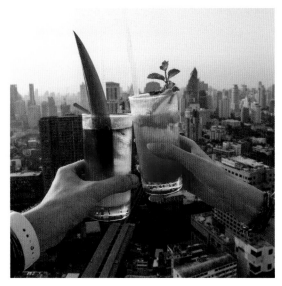

Sky Bar

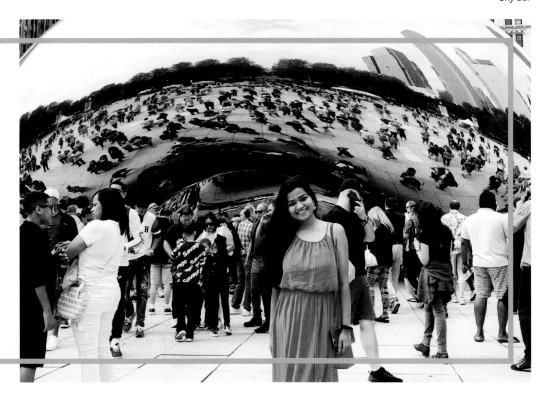

All-American East Coast road trip

1 Wake up in the city that doesn't sleep

If there's one city every movie enthusiast should visit, it's New York. From Times Square and Rockefeller Center to the Empire State Building and Grand Central Terminal, the Big Apple has been featured in more classics than one can count. Popular spots include Carrie Bradshaw's apartment at 64 Perry Street, and Cafe Lalo from *You've Got Mail*.

2 Follow current affairs in Washington, D.C.

The White House undersells itself with its simple name. The main building boasts six stories, thirty-five bathrooms, and 132 rooms. Its many amenities include a bowling alley, tennis court, swimming pool, and movie theater—fitting for a location featured in fifty plus movies.

Drive time

NYC to D.C. • *4 hrs 15 mins*

3 Write a love story in Charleston

If you're a romantic, Charleston, South Carolina, is the place for you. When scouting for locations, producers of *The Notebook* fell in love with it and crafted the fictional town of Seabrook around it. While exploring Boone Hall Plantation, Cypress Gardens, and College of Charleston, keep your eyes peeled for your own Noah or Allie.

Drive time

D.C. to South Carolina • *7 hrs 51 mins*

4 Visit Deep South plantations

Louisiana's Plantation Country has attracted filmmakers working on pictures like *12 Years a Slave*, *Django Unchained*, and *Mudbound*. Opulent estates cluster around the Mississippi River, including Oak Alley, but most were constructed by slave labor. Honor the memory of those individuals while learning about the region's history.

Drive time

South Carolina to New Orleans • *11 hrs 13 mins*

1

2

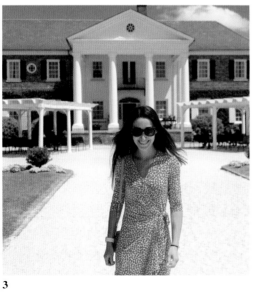

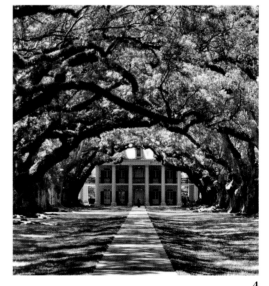

3

4

#food havens

▼ Be charmed by Moroccan tajine

Few places are quite as overwhelming as Jemaa el-Fnaa, a sprawling marketplace in Marrakech's medina quarter. A whirlwind of orange-juice sellers, snake charmers, and traditional healers, the square forms the magical entrance to the city souk. The market is full of hidden restaurants dishing out thick avocado smoothies and tajine—a slow-cooked stew made in an earthenware pot of the same name.

> "
>
> # We travel, some of us forever, to seek other states, other lives, other souls.
>
> ANAÏS NIN, *French writer*
>
> "

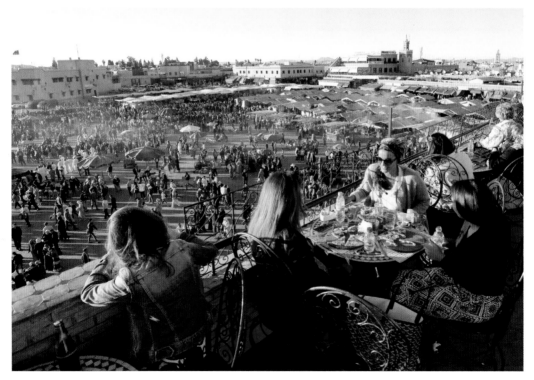

Jemaa el-Fnaa

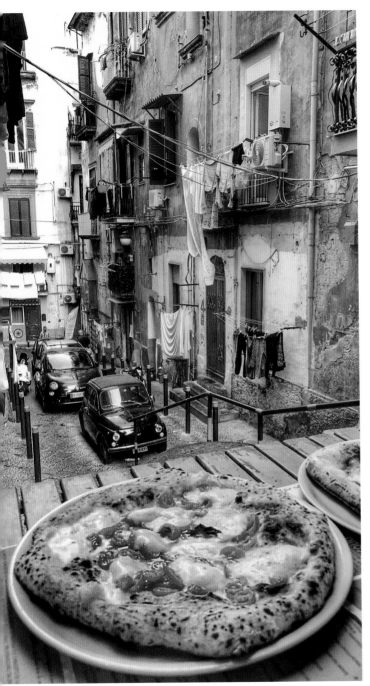

Pinch a pintxo in Spain

Who needs tapas when you can have pintxos? San Sebastián in the Basque Country is famous for these bar snacks, traditionally consisting of bite-size delicacies attached to pieces of bread with a cocktail stick. The best known of these is *gilda*—pickled anchovies, peppers, and green olives. But the list of popular pintxos is endless, from salted cod to a local sheep's milk cheese called *idiazabal*.

◄ Enjoy cheesy times in Naples

Pizza? Check. Pasta? Check. Gelato? Check. Naples may not be Italy's prettiest city, but when it comes to food, it punches above its weight. A genuine Neapolitan pizza, for example, must tick several boxes— the eligibility criteria span a whopping eleven pages! As a general rule, it should be made in a wood-fired oven and decorated with simple toppings like fresh mozzarella, tomatoes, and basil.

Neapolitan pizza

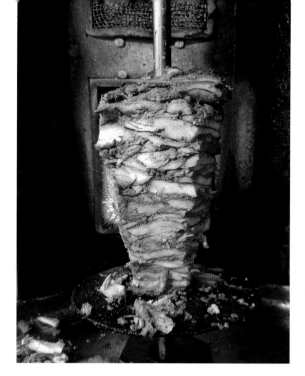

◄ Feast on shawarma, falafel, and tabbouleh in Beirut

You'd need one thousand and one nights to sample all that the Lebanese capital offers in terms of cuisine! Start with *mana'eesh*—a flatbread topped with *za'atar*, a zingy combination of sumac, sesame, and thyme. Move on to *shawarma*, *kibbeh*, and fresh tabbouleh, then wash it down with icy *jallab* (grape molasses and rosewater).

Lebanese shawarma

► Seafood and eat in Osaka

Osaka is famous for two dishes—*takoyaki* (right) and *okonomiyaki*. *Takoyaki* are battered, fried octopus chunks, while *okonomiyaki* is a pancake made with vegetables, meat, and fish flakes. Add to this the usual Japanese fare of sushi, ramen, and tempura, and you've got the perfect destination for seafood lovers. (And speaking of seafood, Tokyo's famous Tsukiji Fish Market deserves a spot on your itinerary.)

Osakan takoyaki

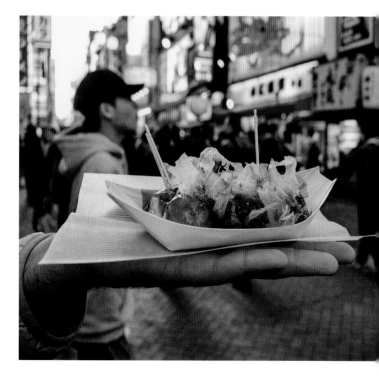

▼ Taste the world in London

English food gets a bad rap, but don't worry—eating out in London resembles a global flavor tour. Visit one of the city's many food markets (Borough Market and the Sunday Market on Brick Lane are exceptional), where you can sample anything from curries, to experimental fusion dishes, to twists on good old fish and chips!

London street food

South African braai

▲ Coastline meets waistline in Cape Town

Cape Town is known for its rugged beauty, but it's also a foodie destination. There's nothing quite as South African as *braai*, the local take on barbecue. But don't leave without trying biltong (cured dried meat), a Gatsby (a sandwich with meat, fries, and sauce), and bunny chow. You can figure out the last one on your own, but don't worry—no bunnies involved!

See Vietnam pho sure

Vietnamese food seems to be having a moment, but nothing beats authentic dishes from Hanoi's street kitchens—a crunchy *banh mi* or a steaming bowl of *pho* (below). Or how about trying some local alternatives like *bun cha* (grilled pork and noodles) or *banh trang nuong*, a quintessentially Vietnamese take on pizza?

When . . .

Vietnamese New Year, if you don't mind crowds

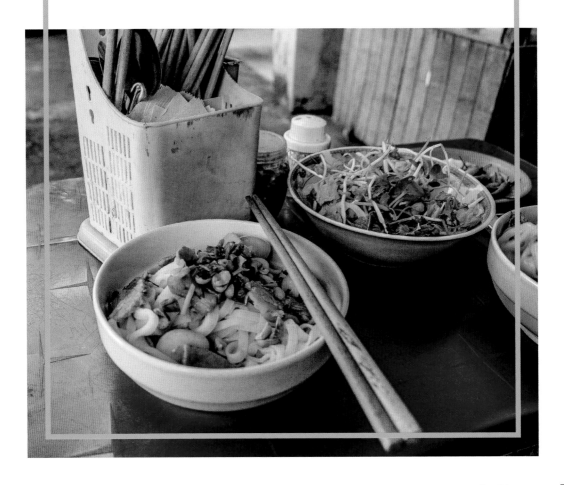

▶ Don't read this if you're Hungary

Aside from goulash, Hungarian food doesn't have a big international following. But that's our loss! Local staples like *paprikás*, *lecsó*, and *lángos* are comfort food at its finest, the latter being a circle of fried dough, doused in garlic oil, and topped with sour cream and cheese. The perfect place to enjoy it is Budapest's cavernous Central Market Hall—one of the city's most buzzing (and delicious) attractions.

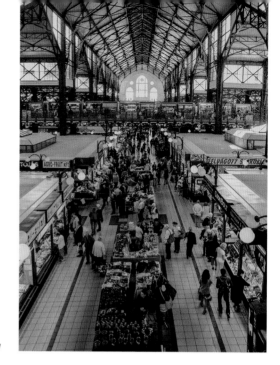

Budapest's Central Market Hall

▶ Hot dogs, *smörgås*, and fish markets

People travel to Copenhagen purely to dine at Noma—René Redzepi's two-Michelin-star restaurant. Noma has won the prestigious title of World's Best Restaurant three times and was featured in Anthony Bourdain's *Parts Unknown*. But if you can't afford Noma's price tags, the Danish waterside capital will delight you with its ubiquitous hot dog carts, fresh fish, and *smørrebrød*.

Copenhagen fish market

▶ Let's taco about Mexico

Everyone loves Tex-Mex, but have you tried a real taco in Mexico, where mountains of shredded cheese and sour cream are replaced with *pico de gallo* and *crema*? You can also swap loaded nachos with *chilaquiles*— a breakfast of corn tortillas, simmered with salsa, then topped with eggs.

Mexican tacos

Skip the lie-in in Lyon

If Paris is the sophisticated mother of French cuisine, Lyon is her unpretentious cousin. Touted as the world capital of gastronomy by food critic Curnonsky (the "Prince of Gastronomy") in 1935, it has only gained in status since then. With more than one thousand restaurants, there's something for everyone. From croissants to *escargot*, you'll find all the national staples, alongside regional delicacies such as Lyonnaise potatoes.

▶ Steak your claim in Buenos Aires

If you love steak and red wine, get thee to Argentina! Once there, grab a beef fillet from the *asado* (barbecue), dip it in chimichurri sauce, and wash it down with a glass of Malbec. Got a sweet tooth? *Dulce de leche* is similar to caramel and oh-so-delicious. For the ultimate sugary feast, try *pastel de tres leches*—sponge soaked in evaporated and condensed milk, and heavy cream.

Argentinian asado

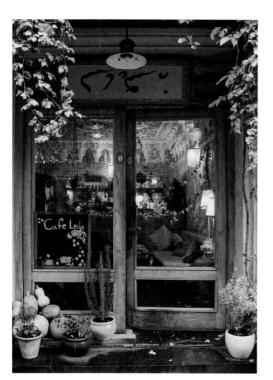

◄ Gorge on Georgian grub

If you haven't tried Georgian food yet, get to Tbilisi—their cozy eateries and carby dishes have the power to change lives (and waistlines). *Khachapuri* is a hunk of dough, filled with *sulguni* cheese and topped with an egg. Or for something lighter, try *lobio* salad, with kidney beans and fresh herbs.

Vegetarian cafe, Tbilisi

Get curried away in Mumbai

You'll find bold flavors and colors across India, but for sheer variety, Mumbai comes first. The metropolis will introduce you to flavors from all over the country, from a Gujarati thali and Keralan fish curry to Goan vindaloo. Visit one of Mumbai's many street food vendors and savor the joy of eating with your hands.

When . . .

during Advent, for the Christmas markets

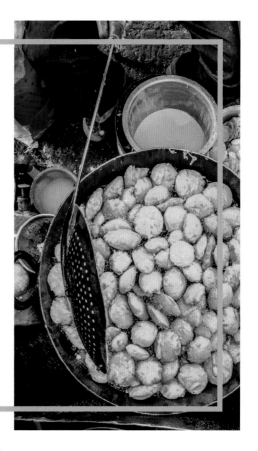

◄ Drink the original Pilsner

Even if you've never heard of it, chances are you're familiar with the small Czech town of Pilsen. It's home to the world's first pale lager, the original Pilsner. To learn more, tour the Pilsner Urquell Brewery, which has been producing the concoction since 1842.

Mugs of Pilsner

Canadian poutine

▲ Put in for poutine

If poutine is all that comes to mind when you think of Canadian food, you're in for a surprise. How about some Nova Scotian lobster rolls, Montreal bagels and smoked meat, or Saskatoon berry pie? For the best selection of international cuisines, don't miss the foodie scene in Toronto.

Eat a Brazilian calories

Home of the açaí berry, Brazil has more to offer than superfoods. Throw caution to the wind and enjoy a calorie-laden *acarajé*—a twice-fried patty stuffed with dried shrimp. Follow it up with *pastéis* and a plate of bean-and-sausage *feijoada*, before entering a blissful food coma.

▶ Try a genuine Chinese takeout

Beijing's Wangfujing Market will challenge your perceptions of Chinese cuisine. You won't find egg rolls or chop suey here—instead, prepare for an onslaught of fragrant dishes that vary from region to region, from the kick of Szechuan pepper to the tender crispiness of Peking duck. If you're traveling with others, share an authentic Chinese hot pot on Gui Jie ("Ghost Street"). Be warned— the spicy soup is very spicy!

When . . .

in spring, for smaller crowds and flowers in bloom

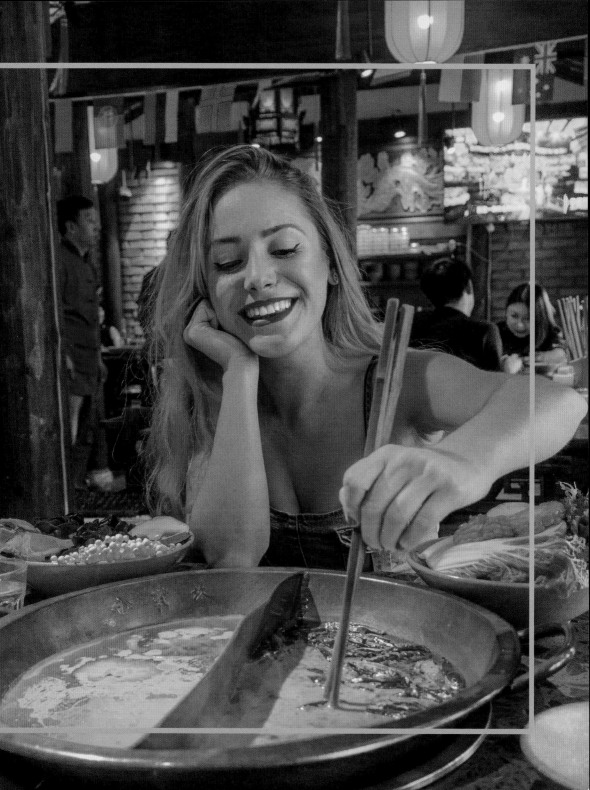

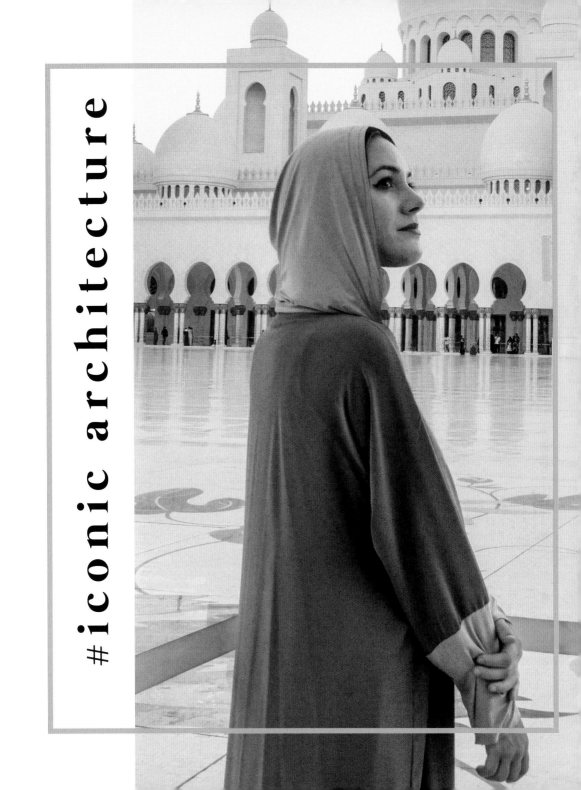

#iconic architecture

▶ Explore Spain's Moorish past

Described by Moorish poets as "a pearl set in emeralds," the Alhambra is one of Europe's most impressive fortresses. Built in the fourteenth century, during Spain's Muslim rule, its construction was a multifaith effort by Muslim, Christian, and Jewish artisans— a testament to the beauty we can create by working together.

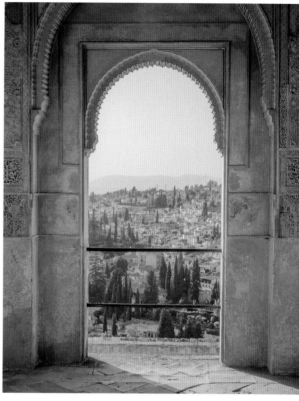

Granada's Alhambra

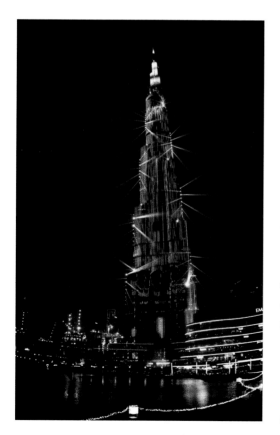

◀ Scale the world's tallest building (for now . . .)

The Burj Khalifa qualified as the tallest building in the world upon completion in 2010, but even if another project eclipses it, this skyscraper merits a visit. The outdoor observation deck at level 124 gives new meaning to the term "bird's eye view," with Dubai sprawling out 1,480 ft (450 m) below.

Burj Khalifa

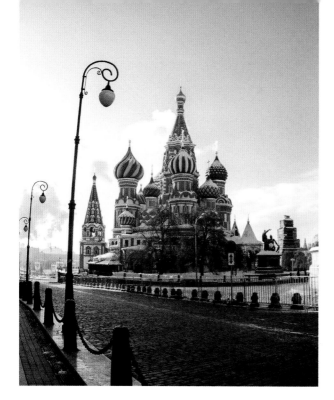

◄ Be blinded by the beauty of Russia

Legend has it that Russian czar Ivan the Terrible had the architect of St. Basil's Cathedral blinded after its completion—ensuring he couldn't re-create its splendor elsewhere. Its colorful, flame-shaped spires certainly have no parallel. A stone's throw from the Kremlin, the cathedral is the crowning jewel of Moscow's Red Square.

St. Basil's Cathedral

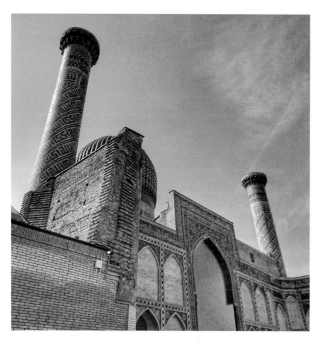

◄ Get schooled in Uzbekistan

Entering Samarkand in the fourth century BCE, Alexander the Great declared, "Everything I have heard about [it] is true, except it is more beautiful than I imagined." This was long before the Registan and its three madrasas (schools). These were constructed between 1417 and 1636 and are covered in intricate mosaics, transforming them into unique works of art.

Registan Square

Have a colossal Italian adventure

Once the site of deadly gladiator fights, the Roman Colosseum is the most popular attraction in the world, with 7.4 million visitors in 2018. Don't worry if you're a lover not a fighter—the most dangerous weapons you'll encounter here now are rogue selfie sticks.

Bring . . .

Mary Beard's
SPQR: A History of Ancient Rome

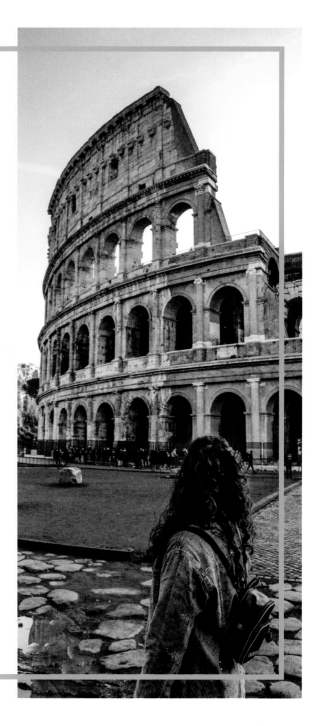

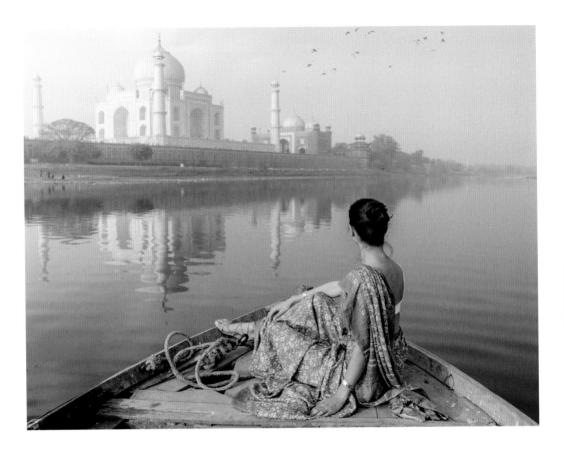

▲ U can't Taj this

Built by Mughal emperor Shah Jahan for his beloved wife Mumtaz Mahal, the Taj Mahal mausoleum is a true monument to love. The emperor recruited some 22,000 laborers, artists, and stonemasons, at a cost of 50 billion rupees ($800 million) in today's money. This might push your boo to get more than a card for your birthday.

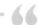

The problem with the world is we draw our circle of family too small.

MOTHER TERESA

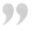

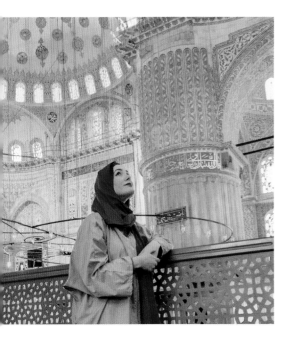

◄ Witness East meeting West in Turkey

Istanbul's two most famous landmarks—the Hagia Sophia and the Sultan Ahmed Mosque—are separated by only a five-minute walk. The latter is nicknamed the Blue Mosque because of the intricate seventeenth-century mosaics adorning its walls. The Byzantine Hagia Sophia has a more muted interior, decorated with ornate Arabic calligraphy. It has been used as a church, mosque, and now a museum.

Istanbul's Blue Mosque

► Practice your falsetto in Sydney

You needn't be an opera fan to recognize Sydney's Opera House. One of the twentieth century's most distinctive buildings, it's visited by millions every year. But it's far from being the only interesting part of Sydney. Climb nearby Sydney Harbour Bridge, stroll through Australia's oldest botanic gardens, or catch a train out to Bondi Beach.

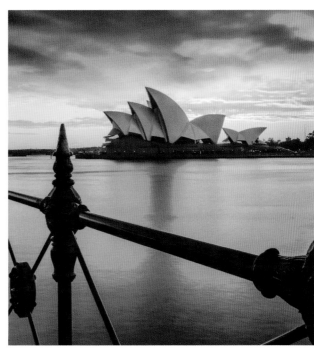

Sydney Opera House

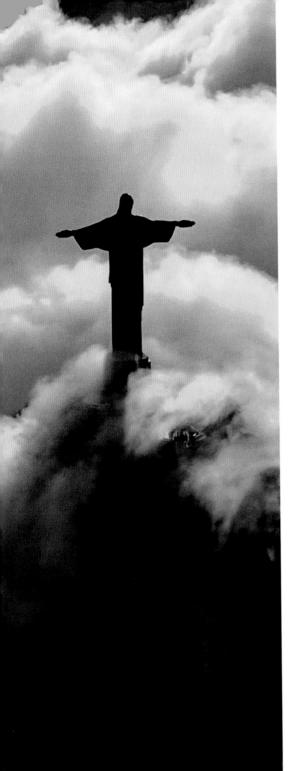

◄ Redeem yourself in Rio

In under a hundred years of existence, Rio de Janeiro's Christ the Redeemer has achieved more than most statues. It's now a recognized symbol of Christianity, and one of the New 7 Wonders of the World. Climb to the top of Mount Corcovado to admire it up close. But for the best photo angles, try the Mirante Dona Marta viewpoint, the Lagoa Rodrigo de Freitas boardwalk, or the highest peak of Tijuca National Park.

See Mali's hedgehog mosque

Djenné is minuscule compared to most of the cities mentioned here, but it deserves a mention as the home of the Great Mosque. The giant adobe structure is a World Heritage Site and one of Africa's most distinctive buildings—French journalist Félix Dubois called it a cross between a hedgehog and an organ.

Christ the Redeemer

Say Bahá'í to Delhi

The Bahá'í Faith, established in 1863 by a Persian religious leader, isn't widely known, but one of its churches is—Delhi's Lotus Temple. Its distinctive shape consists of twenty-seven marble petals gleaming against the Indian night sky. All visitors are welcome, regardless of their beliefs.

Climb the cathedral in Cologne

Cologne Cathedral was proclaimed a World Heritage Site in 1996 and is currently Germany's most visited landmark. This Gothic church is the Archbishop of Cologne's official seat and welcomes roughly 20,000 people every day. Skip the gym and climb its 500 steps to enjoy the view.

Vacation alla Milanese

Milan Cathedral is Italy's largest church and perhaps most impressive religious landmark—no small feat in a country so full of history. Mark Twain described it as "so grand, so solemn, so vast," but the British playwright Oscar Wilde labeled it an "awful failure." Ouch! Visit and judge for yourself.

Bring . . .

SPF 50 sunscreen and a hat

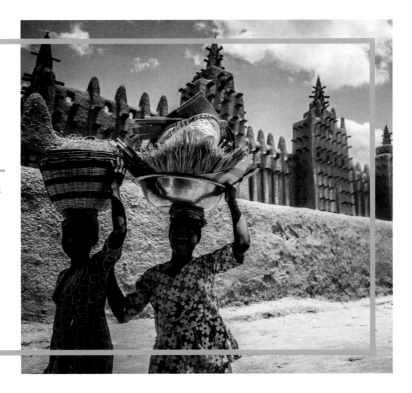

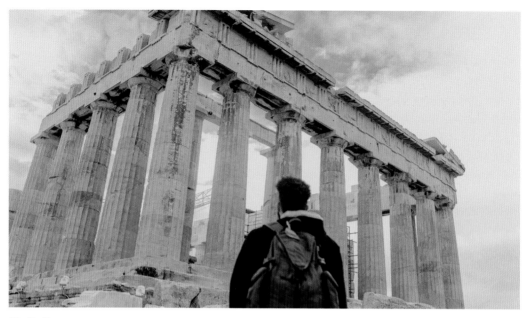

The Parthenon

▲ Get your Parthenon in Greece

Standing over the city of Athens, the Parthenon is a throwback to a bygone era. Completed in 438 BCE and dedicated to the goddess Athena, the city's patron, it's an enduring symbol of democracy and Western civilization. The Parthenon perches on the Acropolis hill, so pack walking shoes and enjoy a view of Athens from the summit.

Spend seven days in Tibet

Tibet remains a source of contention, but it's incredibly spiritual and beautiful. Lhasa's Potala Palace was the Dalai Lama's residence until his fourteenth incarnation, Tenzin Gyatso, fled to India in 1959. The palace is now a museum and UNESCO World Heritage Site. Visiting isn't easy, but it's well worth the effort.

Split and go to Croatia

Diocletian's Palace in Split is not so much a palace as a sprawling fortress. It covers half the old town and includes everything from the Roman emperor's residence to buildings that once housed the military. Diocletian had it built in the fourth century CE for his retirement. Clearly it's never too early to think about your 401(k).

Trek China's 13,000-mile wall

You can't actually see China's Great Wall from space—that's a myth. But you can look at it up close and even camp on it. The Wall isn't one structure, but a series of fortifications, some dating back to the seventh century BCE. The most famous sections lie within easy reach of Beijing, with Badaling slightly closer but Mutianyu a little less crowded.

Bring . . .

sturdy shoes that won't slip—the Wall is steep!

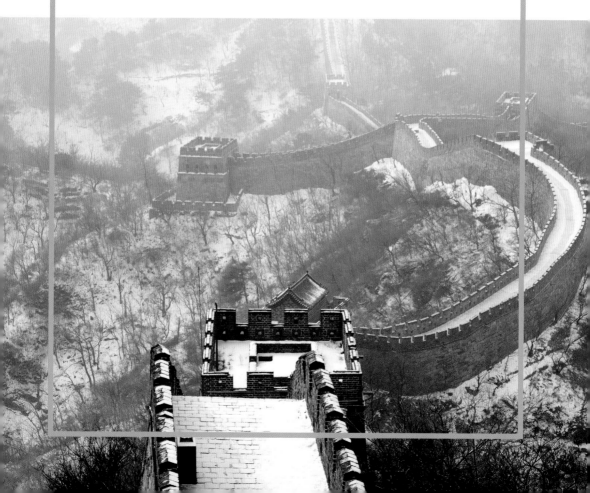

▼ Worship at a modern mosque

Iconic architecture doesn't have to be old. Abu Dhabi's Sheikh Zayed Grand Mosque was completed in 2007, but it has become one of the top tourist attractions in the United Arab Emirates. Its courtyard's floral design is one of the world's largest marble mosaics, while the interior boasts gigantic chandeliers studded with Swarovski crystals.

You'll be Baal-back

The Lebanese city of Baalbek has some of the largest, best-preserved remnants of the Roman era—the Temple of Bacchus and Temple of Jupiter, possibly dating as far back as 15 BCE. The complex that contains both temples was declared a UNESCO World Heritage Site in 1984. Political unrest in the Bekaa Valley has curtailed visitor numbers, but they're recovering.

Sheikh Zayed Grand Mosque

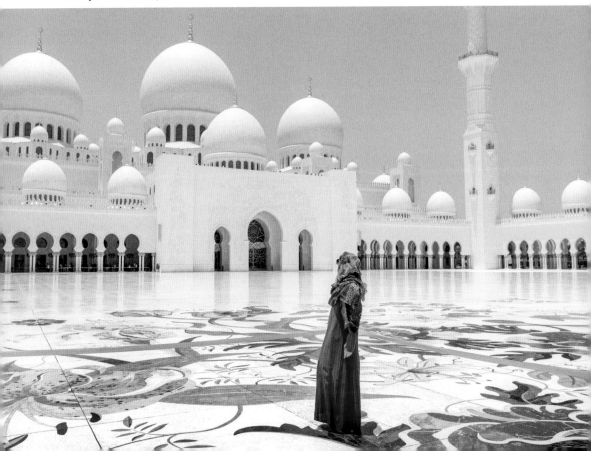

► See high Kual-ity architecture in KL

Although Kuala Lumpur's Petronas Towers are no longer the tallest in the world, they still captivate visitors' imaginations. They are striking after dark, silver and shiny against the night sky. Their postmodern design is the work of Argentine architect César Pelli and features Islamic motifs, reflecting Malaysia's official religion.

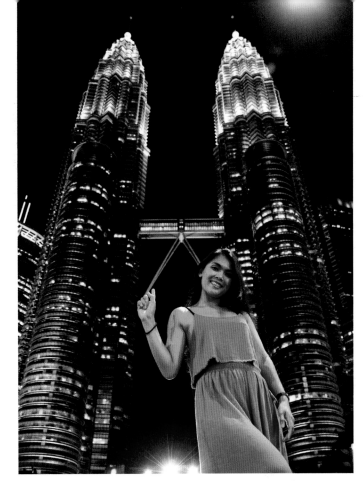

Petronas Towers

Don't let the Terracotta Army hold you back

The Terracotta Army in China's Xi'an, was one of the twentieth century's most significant archaeological excavations. Its scale is overpowering, with some 8,000 soldiers, alongside chariots and horses, created to protect first Emperor of China, Qin Shi Huang, in the afterlife. That's quite the bodyguard detail!

See the Dome that rocked

The gold-plated Dome of the Rock was built by Umayyad caliph Abd al-Malik in the seventh century, atop Jerusalem's Temple Mount. The hill is one of the holiest sites for three major religions—Judaism, Islam, and Christianity. Adherents of all faiths can visit, albeit through different entrances, highlighting the region's uneasy political divisions.

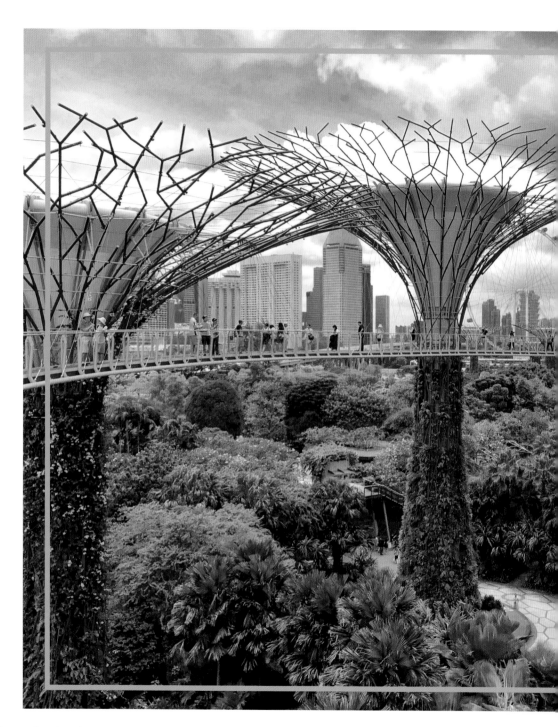

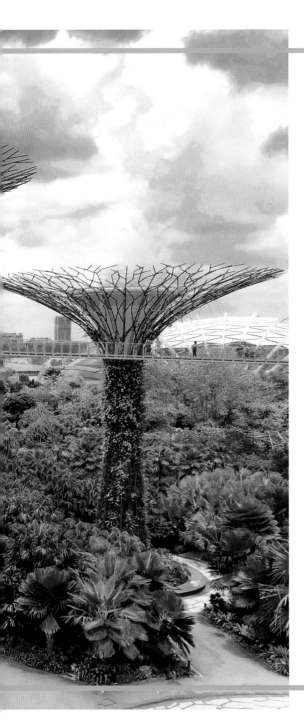

Sing Singapore's praises

Singapore's Gardens by the Bay are a uniquely ambitious project. Part of the city's sustainability efforts, the park is both beautiful and functional. Towering "supertrees" are fitted with solar photovoltaic systems that can produce clean energy, while two conservatories preserve biodiversity; one—the Flower Dome—is the largest glass greenhouse in the world.

When . . .

February, for sunshine and cheap flights

#colorful corners

Bo-Kaap

▲ Rock up to South Africa's Bo-Kaap

Bo-Kaap is Cape Town's oldest surviving residential neighborhood, but the main reason for the former township's popularity are its colorful houses. After the emancipation of 1834, liberated slaves painted their facades bright shades to express their newfound freedom.

▶ Feast your eyes on gingerbread

Amsterdam is often perceived as full of vice, with its red-light district and marijuana-selling coffee shops. But the Dutch capital has a serene side, best seen on a canal tour. Admire its narrow gingerbread houses—particularly in De Negen Straatjes (Nine Streets)—as you glide by.

Central canal, Amsterdam

▶ Snap a royal palace in technicolor

You'll struggle to find a building more colorful than Pena Palace. This nineteenth-century masterpiece is sometimes used for state business by the Portuguese president, but it's open to the public all year. The palace is located in Sintra, a short drive from Lisbon.

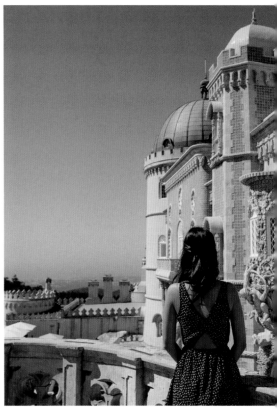

Pena Palace

◀ Succumb to wisteria hysteria in London

Violet wisteria adorns the townhouses of Notting Hill in April/May. The neighborhood was made famous by the eponymous 1990s movie starring Julia Roberts and Hugh Grant. Nowadays it's all pastel facades, antique stores, and Caribbean restaurants.

Notting Hill

▶ Admire Australian colors

Melbourne's Hosier Lane is an alleyway full of graffiti and giant murals, painted by international artists. After exploring it, take the train to nearby Brighton Beach for more color—Victorian bathing boxes, painted in vibrant shades.

No rain on your Romanian parade

Bucharest's Pasajul Victoria gets a lot of Instagram love. This picturesque passageway, covered in rainbow-colored umbrellas, is perfect for an afternoon tipple. There is even a hidden underground bar!

Melbourne's Brighton Beach

Explore the Med in Wales

British architect Bertram Clough Williams-Ellis loved the Italian Riviera and used its aesthetic when designing Portmeirion in North Wales between 1925 and 1975. You may recognize the surreal village as the set for TV's *Doctor Who* and *The Prisoner*.

Explore the tunnel of love

Dubai's Miracle Garden, the world's largest natural flower garden, was launched on Valentine's Day in 2013. It features over 150 million flowers. Don't forget to snap a photo of the famous heart-shaped tunnel, and visit its indoor butterfly garden, housing 15,000 specimens!

See Burano's true colors

The small, colorful island of Burano in Italy has a long history of lace production and fishery, but its main source of income today is tourism. Located 45 minutes from Venice by boat, it gets extremely crowded, so arrive early to enjoy it in solitude for a few hours.

Bring . . .

spare batteries for your camera— and patience

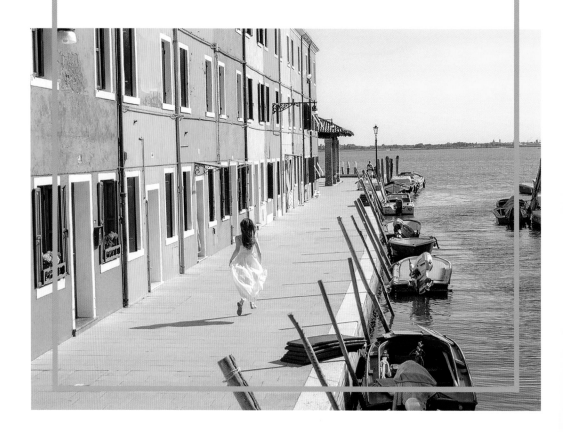

I didn't know where I was going until I got there.

CHERYL STRAYED, *American writer*

▶ La vie en rose in India

The capital of Rajasthan, Jaipur wears its royal heritage on its sleeve—or its stucco. Its Old City was painted terracotta pink in 1876 to welcome the future King Edward VII, and it stayed that way. Its most picturesque building is Hawa Mahal (Palace of the Winds), with its intricate balconies.

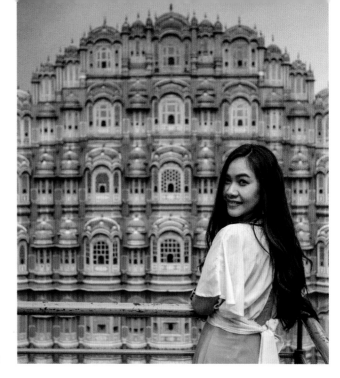

Hawa Mahal

◀ Sing a song of ice, fire, and color

Iceland boasts many natural wonders, but for an onslaught of color look no farther than its capital and largest city, Reykjavík. Ascend to the top of Hallgrimskirkja—an expressionist parish church—for a sweeping view of bright rooftops against a backdrop of snowy hills and navy waters.

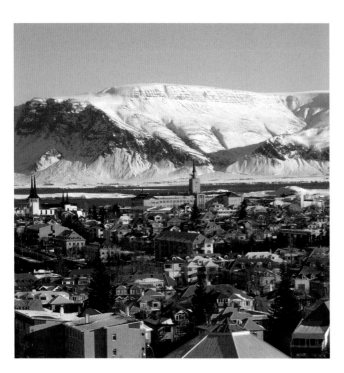

Reykjavik rooftops

◄ Feel the blues in Chefchaouen

This Moroccan town may have a hard-to-spell name, but it's easy on the eyes. No one is sure why it was painted blue. Romantics think it represents heaven. More cynical souls believe it was turned cerulean in the 1970s to attract tourists. If so . . . it worked!

Chefchaouen facades

◄ Walk on rainbows in Turkey

The story behind Istanbul's—now slightly faded—Rainbow Stairs is beautiful. Retired forestry engineer Huseyin Cetinel spent four days and $800 transforming the massive staircase. His reason? "I did it to make people smile." We definitely need more people like Huseyin!

Rainbow Stairs

#underrated capitals

▶ Become a people person in Dhaka

Often overshadowed by neighboring India, Bangladesh has plenty to offer visitors. Its capital Dhaka is the third most densely populated city in the world, full of Mughal architecture and colorful markets. Throw yourself into the hustle and bustle, ride around in a rickshaw, then wind down with some milky *cha* (tea).

Dhaka cha

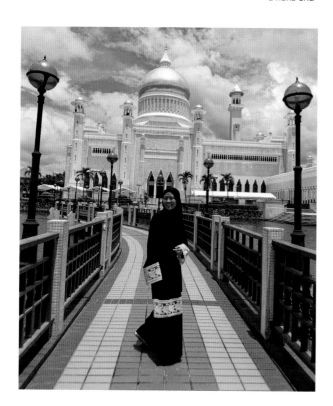

◀ Discover the Abode of Peace

Brunei shares the island of Borneo with Indonesia. But while the latter is the world's biggest Muslim country, Brunei is among the smallest, allowing you to enjoy everything its capital, Bandar Seri Begawan, offers in just a few days. Witness the Omar Ali Saifuddien Mosque's opulent chandeliers and lagoon, or visit the world's biggest stilt village at Kampong Ayer.

Omar Ali Saifuddien Mosque

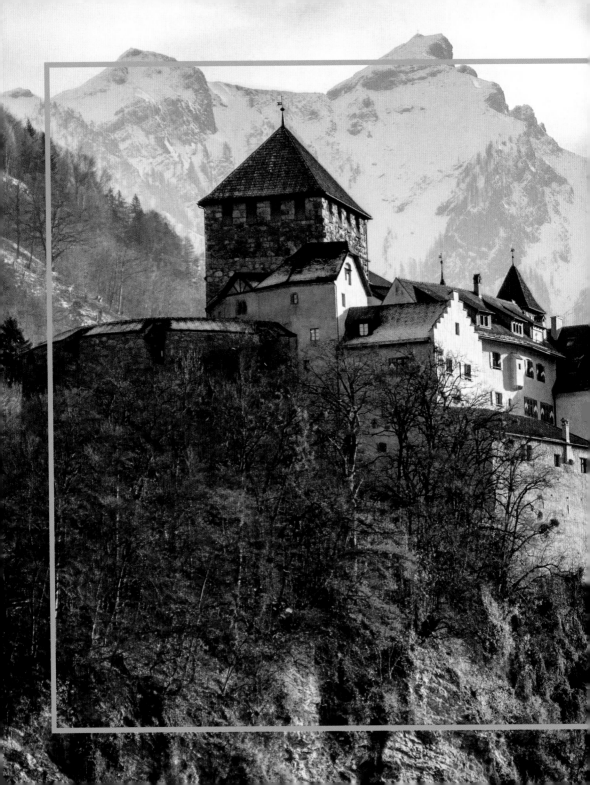

Vaduz going on?

Liechtenstein may only measure 62 square miles (160 square km), but it packs a punch. Surrounded by ski slopes and hiking trails, the capital Vaduz is the perfect base for outdoor enthusiasts. Throw in some medieval castles, modern galleries, and the fact this is one of Europe's least visited countries, and you've got the perfect year-round getaway.

Bring . . .

hiking boots in summer; skis in winter

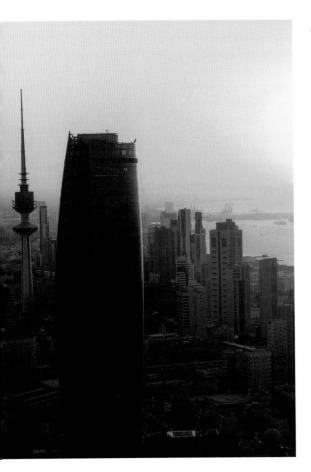

People forget years and remember moments.

ANN BEATTIE, *American author*

◄ Don't wait for Kuwait

Most foreigners go to Kuwait City for work—from hospitals to construction sites—but that doesn't mean it isn't a wonderful travel destination. From the splendor of the Grand Mosque to the buzz of Souk Al-Mubarakiya, it was made for culture lovers. For some non-urban fun, try a night in the desert.

Kuwait City

Witness progress in Rwanda

Despite its fraught past, Rwanda boasts one of Africa's fastest growing economies. Its capital is a hub of progress, with newly built buildings and roads galore—witness, for example, the Kigali Convention Center. Then stroll around the nearby Kacyiru roundabout and soak up the modern vibe.

Fall in love with Djibouti

Djibouti may have mainland Africa's smallest population, but it has plenty to offer. Its eponymous capital has an impressive European Quarter, filled with French colonial and Moorish-inspired architecture. Before you leave, purchase souvenirs at the labyrinthine Les Caisses Market.

Visit George(town) of the jungle

Most people visit Guyana for its natural wonders, but the capital is worth your time, too—around 80 percent of Guyana's population call Georgetown home after all! St. George's Cathedral is one of its most iconic buildings and possibly the world's tallest wooden structure. Another landmark worth visiting is Starbroek Market, with its cast-iron structure and nineteenth-century clock tower.

▼ See the castle on the hill

Officially titled the Most Serene Republic of San Marino, this city-state is perfect for a peaceful getaway—a green oasis surrounded by Italy from every side, yet unique in character. Explore its many museums, and if you're still feeling energetic, climb Mount Titano for the best view in town. And fill your suitcase with tax-free goodies before heading for the airport!

Mount Titano

See beyond doom and gloom in Moldova

Moldova is one of the least visited countries in Europe—perhaps because most people have never heard of it, and those who have might remember it was deemed the world's unhappiest country in a 2008 poll! But it isn't all gloom. Capital Chişinău has lovely parks, wineries, and Communist-era architecture.

Run wild in the Garden City

Belmopan was founded as a planned community in 1970, making it one of the world's newest capital cities. But it's not lacking in character. Surrounded by nature, it's the perfect base for all your Belize adventures. Try a canopy zip-line tour, cave tubing, or a night at the rustic Monkey Bay Wildlife Sanctuary. Alternatively, enjoy a hike through St. Herman's Blue Hole National Park.

◄ Enjoy Asia's happiest country

Bhutan is supposedly one of the world's happiest nations. Watched over by a giant Buddha Dordenma, Thimphu city offers respite from stress. Get your zen on and check out its many temples and monasteries. Or if you fancy action, try some archery—the national sport.

Buddha Dordenma

Bring . . .

a bikini for a dip
in St. Herman's
jungle pool

◄ Run away to Iran

Don't let the lengthy process
of obtaining an Iranian visa stop
you from visiting Tehran. It's
loud, chaotic, and smoggy, but
it's also got old-world Persian
charm, with bazaars and
exquisite mosques at every
turn. Tehran offers a unique
insight into Iran's past, present,
and future.

Downtown Tehran

3

Cultural Immersions

#art and design

◄ Bilbao down to modern art

New York's Guggenheim has received plenty of praise since opening in 1939. But the more recent Guggenheim Museum Bilbao (1997) is a powerhouse in its own right. Considered one of the world's most impressive works of contemporary architecture, it will astound you even before you enter. Once inside, you can admire works by Picasso, Rodchenko, and Braque, among many others.

▼ Leave it all in Budapest

Budapest doesn't lack remarkable buildings. The Hungarian Parliament is one of Europe's oldest legislative buildings, Matthias Church is famed for its colorful roof, and the hill of Buda provides exceptional views over Budapest's bridges. When you're exhausted from sightseeing, head to Széchenyi—medicinal baths with a gorgeous neo-Baroque arcade. Their thermal springs will revive tired feet in no time.

Budapest's Liberty Bridge

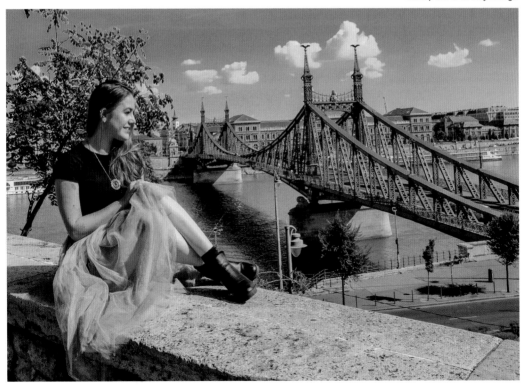

◄ Peking at Chinese hipsters

Beijing's 798 Art District—or Dashanzi—is the definition of hip. Housed in a disused military factory, it features art galleries, cafes, boutiques, and outdoor sculptures. Mingle with stylish locals, sample Chinese street food, and get artsy shots for your Instagram.

Dashanzi, Beijing

Florence and the time machine

There isn't an art lover in the world who won't find something in the Italian city of Florence to admire. Weaving in and out of crowds of tourists gets tiring, but Florence is like an outdoor gallery, with statues by Renaissance masters scattered throughout its piazzas, free for passersby to enjoy.

Vatican you believe it?

The Creation of Adam, painted by Michelangelo in the early sixteenth century, is one of the world's most famous works of art. This fresco forms just one section of the magnificent painted ceiling in the Vatican's Sistine Chapel. While here, you can also view the almost equally famous *Last Judgment*, on the far wall.

Mother of dragons in Ljubljana

The Slovenian capital will bring out your inner mother of dragons— these creatures appear everywhere, from bridges to balustrades. Aside from the coolest city symbol ever, Ljubljana boasts some stunning buildings—from its Franciscan Church of the Annunciation to its hilltop castle.

▶ Ich bin ein Berliner

Germany's Berlin Wall symbolizes liberty's triumph over oppression—worn concrete blocks bear witness to generations fighting for freedom and others trying to rob them of it. It's now also a de facto art gallery. Don't miss Dmitri Vrubel's famous mural of Leonid Brezhnev and Erich Honecker kissing.

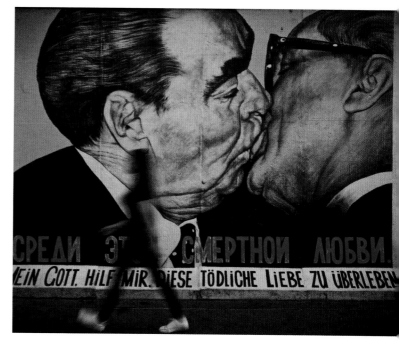

Berlin mural

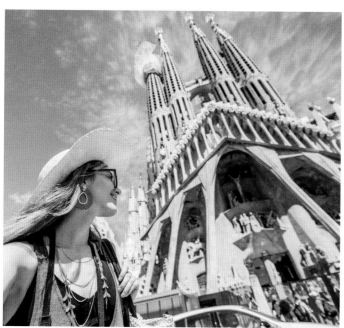

◀ Gaudí not gaudy in Spain

Few architects have shaped a city to the extent that Antoni Gaudí shaped Barcelona; from the unfinished Sagrada Família to Park Güell, he injected whimsy into its beating heart. You needn't be an avid design fan to appreciate his fantastical creations.

Sagrada Família

> **"**
> # I try to give people a different way of looking at their surroundings. That's art to me.

MAYA LIN, *American artist*

"

Harajuku girls just wanna have fun

There's much more to Tokyo's Harajuku district than what we've seen in Gwen Stefani's videos. Head to Takeshita Street for *kawaii* souvenirs and people-watching. Populated by fashion-forward teenagers, it's the perfect spot to don trends you've been too shy to try back home.

Bring . . .

your high-school Hello Kitty accessories

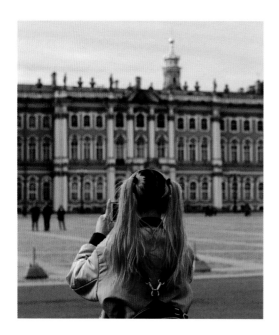

◄ Don't be a recluse at the Hermitage

St. Petersburg was directly inspired by Venice and Amsterdam, resulting in a city crisscrossed by canals and bridges, with a refined European look that distinguishes it from other Russian cities. For a sophisticated experience visit the Hermitage Museum—housing over a million works of art.

The Hermitage

► Get Prague-matic in Czechia

The Czech capital is nicknamed the city of a hundred spires, but there are actually more like a thousand. One of the most famous belongs to Prague Castle, the ninth-century seat of the president. If that's not enough history, visit the 600-year-old—functioning—Astronomical Clock outside the Old Town Hall. At 2,224 acres (900 hectares), Prague's historical center is the largest on the UNESCO World Heritage List.

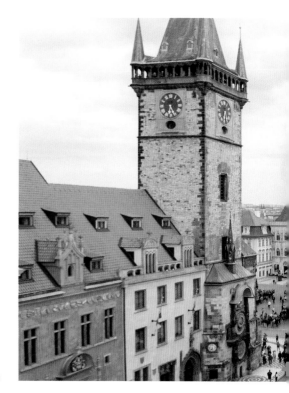

Prague spires

▶ Wash away your sins in California

Salvation Mountain attracts free spirits from around the globe. This substantial art project was created in the California Desert by local Leonard Knight (1931–2014)—a man-made mountain smothered in half a million gallons of paint and uplifting Bible quotations, intended as a reminder of God's love.

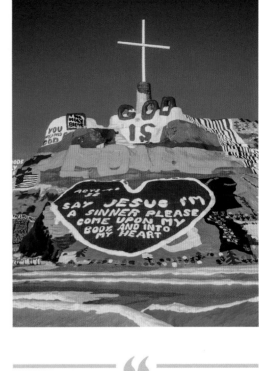

Salvation Mountain

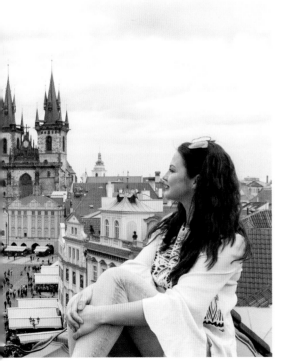

> **The use of travelling is to regulate imagination by reality, and instead of thinking how things may be, to see them as they are.**

SAMUEL JOHNSON, *English writer*

Paris, je t'aime

Paris may be an unoriginal choice, but it's popular for good reason. You could spend months here without scratching the surface. Visit the Eiffel Tower, Louvre, Musée d'Orsay, Champs-Élysées, and the famous Gothic cathedral of Notre-Dame—seriously damaged by fire in 2019, but still standing.

When . . .

the cheaper winter months

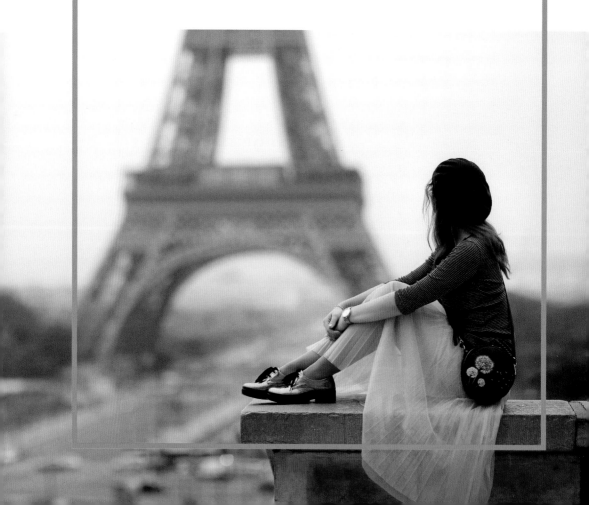

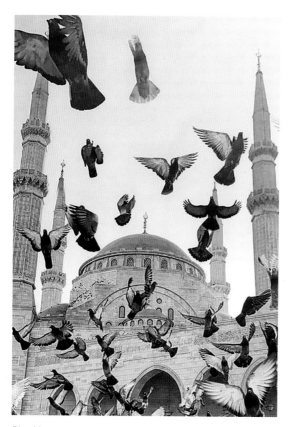

Blue Mosque

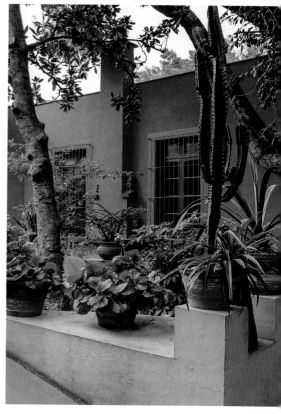

Casa Azul

▲ Break up the Bei-routine

Beirut isn't the city you visit for relaxation—you visit when your life needs a complete shake-up! This Lebanese metropolis buzzes with activity, from waterfront restaurants along Zaitunay Bay and hipster bars in the Gemmayze neigborhood to crowds of worshipers at the 2008 Mohammad Al-Amin Mosque, or Blue Mosque.

▲ You Coyoacán do it

The Frida Kahlo Museum in Coyoacán, Mexico, provides a unique insight into the artist's life, being housed in the Casa Azul, where she was born, lived with her husband Diego Rivera, and died. The memories in its walls draw 25,000 monthly visitors, keen to see her artworks and memorabilia.

► All I do is wyn, wyn, Wynwood

There's more to Miami than glitzy South Beach nightlife. Once-underprivileged Wynwood has evolved into Florida's most happening neighborhood. Open-air museum Wynwood Walls attracts crowds of international talented creatives. They come for art but stay for the Cuban food and edgy fashion boutiques.

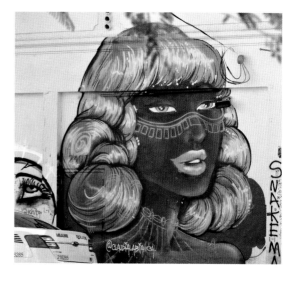

Wynwood art

This world is but a canvas to our imagination.

HENRY DAVID THOREAU, *American poet*

◄ Amster-dam you're cultured!

Party central Amsterdam in the Netherlands has a serious side. Its Museumplein (Museum Square) houses the Rijksmuseum, Stedelijk Museum, and Van Gogh Museum. The latter holds the world's largest Van Gogh collection, including his masterpiece, *Sunflowers*.

The Rijksmuseum

▼ Take a chance on Stockholm

Home of IKEA, Sweden's minimalist aesthetic has become a worldwide hit, but it's not limited to flat-packed furniture. Enjoy modern art at Moderna Museet, by local painters alongside the likes of Picasso and Dalí, then head to the interactive ABBA museum for lighthearted entertainment. Or soak up the Stockholm skyline—a work of art in its own right.

The concrete jungle where dreams are made

Love museums? New York will satisfy you with MoMA, the Met, and the Guggenheim. Prefer street art? Check out the Bushwick Collective or the 100 Gates Project. An architecture enthusiast? Choose between skyscrapers or the Beaux Arts beauty of the Grand Central Terminal and the Public Library.

Stockholm skyline

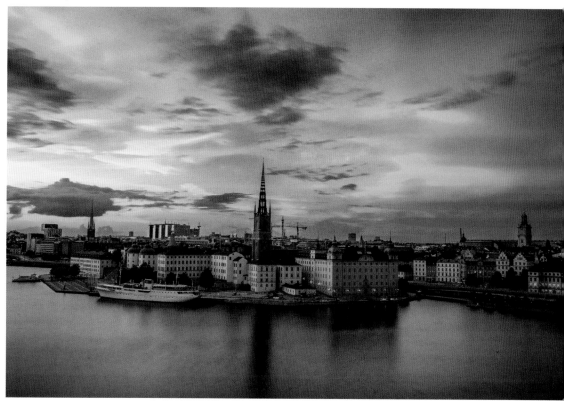

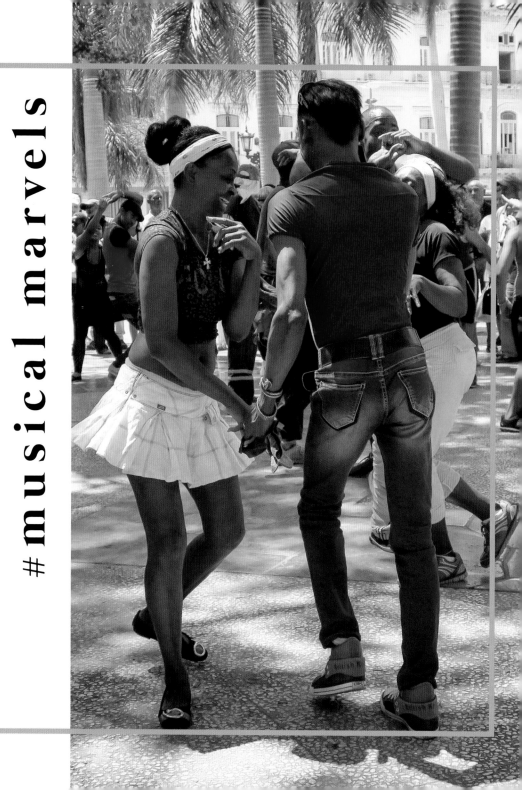

musical marvels

▶ Dirty dancing in Havana

Nobody could blame you for leaving your heart in Havana. The Cuban capital has loads of old school charm, with red Chevrolets cruising its narrow streets and cigar smoke hovering in the air. Explore the old quarter like Ernest Hemingway used to do, dancing the night away to live music with a daiquiri in your hand.

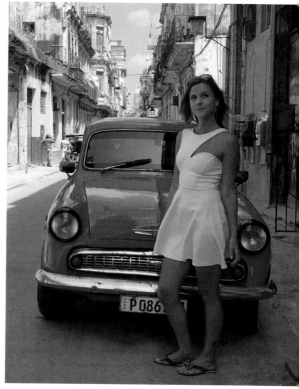

Chevrolet in Havana

◀ Emoji-onal times in Seville

You know that popular dancing lady emoji? She's performing flamenco! Perfecting this dance was a real team effort, influenced by the Romani, Castilians, Moors, and Sephardi Jews who all lived side by side in Andalusia. Capital Seville is particularly famous for its performances and iconic Gitana dresses.

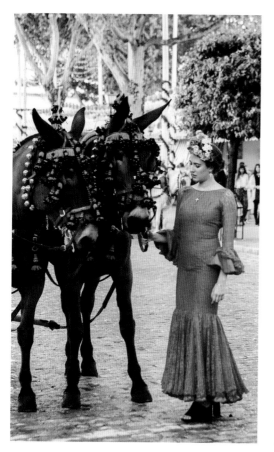

Flamenco dancer in Seville

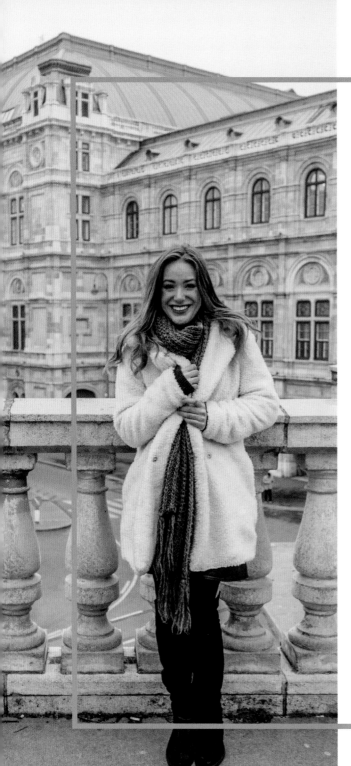

Go for Baroque in Vienna

Consistently voted the most livable city in the world, Vienna is worth visiting whether you're a music fan or not. But classical music aficionados will be particularly charmed by the elegant Austrian capital and its opera house. Famous for its association with Mozart, it stages both instrumental concerts and operas.

Bring . . .

a digital copy of
Before Sunrise

▼ Gal-the-way to Ireland

Ed Sheeran's "Galway Girl" helped put this harbor city on the map as the perfect place to meet your own fiddle-playing love interest. Galway's full of charming pubs with live music, which attract a young local crowd. If you visit in September, you can enjoy those traditional tunes with a side of delicious fresh seafood during the International Oyster Festival.

▼ Rocking trip from start to Finnish

If it's been ages since you were in a mosh pit, take a vacation to Helsinki. According to Finnish president Sauli Niinistö, "Finland has perhaps the most heavy metal bands in the world per capita and also ranks high on good governance—I don't know if there's any correlation there." Attend a Nightwish or Children of Bodom concert and decide for yourself.

Galway city

Helsinki outdoor concert

Find your choir purpose in Italy

If you fancy yourself a bit of a connoisseur, get thee to Milan immediately. La Scala is one of the world's best opera houses, and has hosted the likes of Luciano Pavarotti and Andrea Bocelli. Inaugurated in 1778, the interior's velvet curtains and golden balconies will make you feel like a VIP.

Make brazen moves in Brazzaville

Not to be confused with your zumba class, Congolese rumba is a genre of African dance music that originated in the Congo basin in the 1930s, particularly in Brazzaville. The city is now a UNESCO City of Music, making it the perfect place to shake your tailfeather!

◄ Write a rave review of Hamburg

Berlin is known for techno parties, but Hamburg rivals its party credentials. Explore the hedonistic Reeperbahn district, with its burlesque shows, dance in bars once frequented by the Beatles, or for something more intense, sample a true German rave.

Reeperbahn district

◄ NY state of mind

Hip-hop was born in the Bronx when DJ Kool Herc threw a party in Sedgwick Avenue on an August afternoon in 1973. The genre has since become mainstream, after a decades-long evolution. You'll find pockets of hip-hop and rap history across New York, from Harlem to Queens.

Queens culture

► Meet the pied bagpipers of Edinburgh

A kilt-clad man playing bagpipes is as Scottish as it gets! Whether you're obsessed with *Outlander* or not, you'll discover magic in the streets of Edinburgh— J. K. Rowling certainly did, creating Harry Potter there (see page 135). If traditional performers don't appeal, the many contemporary acts will.

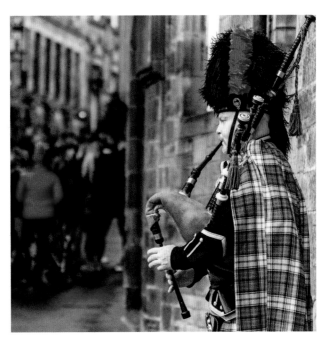

Edinburgh bagpiper

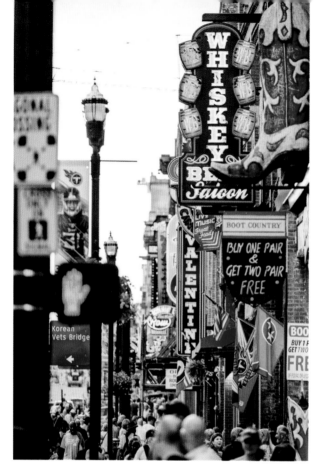
Downtown Nashville

Less shopping, more Chopin

Visit Warsaw to retrace the steps of Fryderyk Chopin. The Polish virtuoso spent his childhood here and you can learn about him at the Fryderyk Chopin Museum. To hear his music, head to his monument in Royal Łazienki Park, where international pianists stage free concerts for onlookers.

▲ Take the country road to Nashville

Nashville will strike a chord with country music fans, whether it's the Country Music Hall of Fame, the Grand Ole Opry, the Ryman Auditorium, or the Johnny Cash Museum. To view Nashville through an artist's eyes, visit RCA Studio B, where Dolly Parton and Roy Orbison recorded hits.

Jailhouse rock in Memphis

Although Elvis Presley died more than fifty years ago, he lives on in our consciousness. There's no better place to learn about him than at Graceland—his ranch on the Memphis outskirts, where he was buried. Later, head to Sun Studio where Elvis recorded his hits, and get a picture with his microphone!

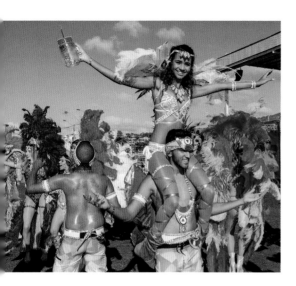

◄ Let the dogs out in Trinidad and Tobago

Soca was developed in the 1970s by marginalized communities in Trinidad and Tobago. Founding father Lord Shorty is known as the Love Man, which tells you everything you need to know about these rhythmic Afro-Caribbean beats. "Who Let the Dogs Out?" is one of the genre's best-known songs.

Harts Carnival, Trinidad

Bring . . .

dancing shoes to cut a rug on Honky Tonk Row

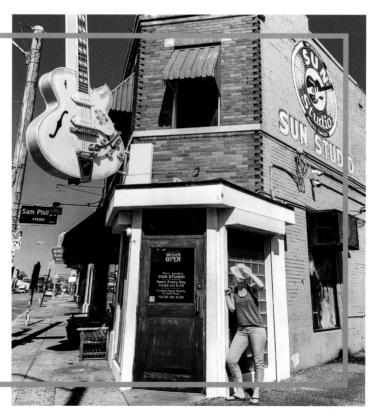

▶ Dip to Cali for spicy salsa

Salsa originated with the Cuban diaspora in New York, but for a dancing bonanza, plan a trip to Cali instead. The uptempo dance was brought to the city by visiting American sailors in the late 1960s, and the Colombians have now made it their own. Put on your dancing shoes and head to a *salsateca* for a night of shimmying.

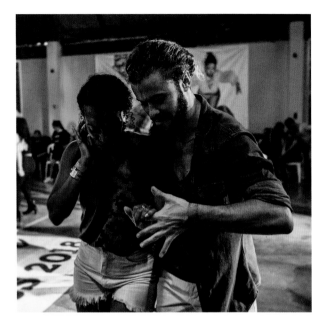

Colombian salsa

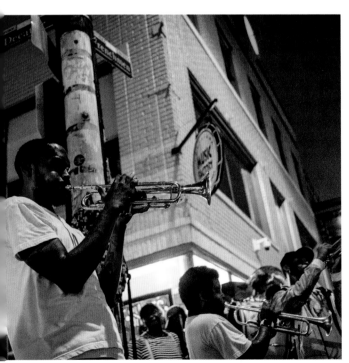

◀ Majazztic tunes in New Orleans

When it comes to live jazz, New Orleans is second to none, being its birthplace. Skip touristy Bourbon Street and head to nearby Frenchman Street in the Faubourg Marigny neighborhood. This bar-studded stretch is an ode to New Orleanian musical talent, from performances at the cozy Apple Barrel to jam sessions by street performers.

Frenchman Street

Ohio didn't see you there

Ohio may not be high on your bucket list, but there is no place quite like the Rock and Roll Hall of Fame. A celebration of many guitar-strumming, TV-smashing rock legends, inductees include Eric Clapton, Aerosmith, and Tina Turner. Aside from permanent installations and temporary exhibits, the museum hosts live music events.

▶ Oppa Gangnam style!

Psy's hit single "Gangnam Style" conquered the world in 2012 and became the first video to reach a billion YouTube views. It also introduced K-pop to mainstream audiences. If you have been swept away by the Korean Wave, Seoul will be your ideal vacation spot. Don't miss its quirky cafes, including a poop-themed one!

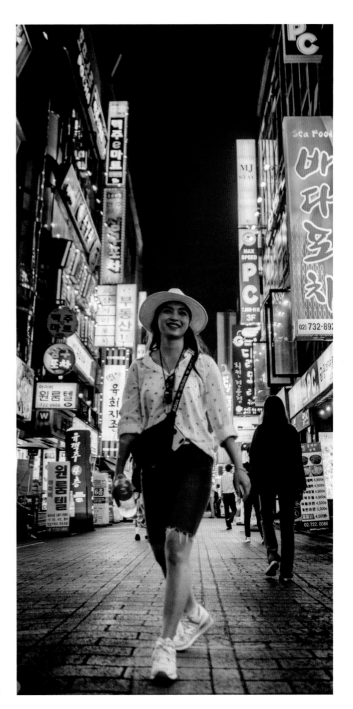

Nighttime Seoul

literary haunts

> "
> # The real voyage of discovery consists not in seeking new landscapes, but in having new eyes.
>
> MARCEL PROUST, *French writer*
> "

▼ Channel J. K. Rowling in Edinburgh

Harry Potter fans must visit the Elephant House, the Scottish cafe where J. K. Rowling wrote the earlier books. Once you've finished your coffee (or manuscript!), head to Victoria Street—a pretty street believed to be the inspiration behind Diagon Alley. Fittingly, it has a store selling Hogwarts paraphernalia.

Victoria Street

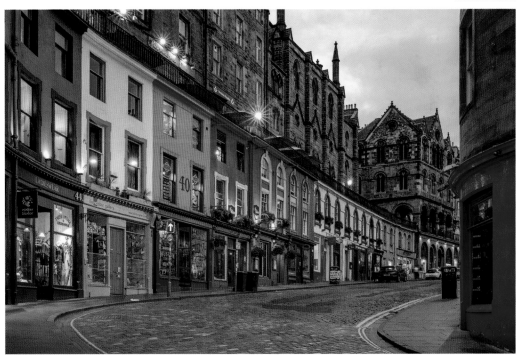

The heights of Isla Negra

To better understand Nobel Prize laureate Pablo Neruda, visit one of his houses in Chile. You have three to choose from—La Chascona in Santiago, La Sebastiana in Valparaíso, and his home on Isla Negra. The last is where he and his wife Matilde are buried. Visit on Neruda's birthday (July 12) for a wide array of events, including readings of his works.

A gondola full of books in Italy

Think books and water don't mix? Venice's Libreria Acqua Alta proves that wrong. This bookstore keeps whimsical volumes in waterproof cases, bathtubs, even a gondola. It also has a staircase constructed from piles of water-damaged books. The store is often full of stray cats and, like the rest of Venice, budding Instagrammers.

◄ London your feet in England

When it comes to London, it's impossible to limit yourself to one literary location. From Shakespeare's Globe Theatre to Daunt Books in Marylebone High Street, it's bookworm heaven. Off the beaten path, try Watkin's Books in Cecil Court. London's oldest esoteric bookstore, it provides fodder for mind, body, and spirit. Discover what epiphanies lurk within its tomes.

Daunt Books

Bring . . .

**a suitcase for
your purchases**

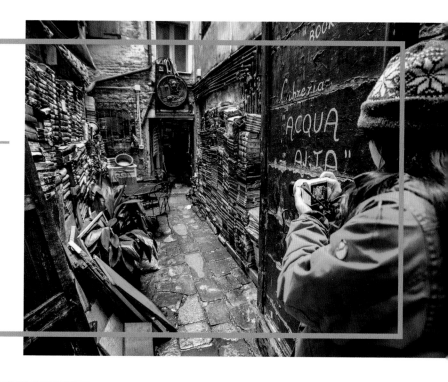

◄ We should all be in Lagos

Novelist Chimamanda Ngozi Adichie
brings her homeland to life in her
stories. She claims, "the best of
Nigeria's contemporary culture—
music, film, fashion, literature, and
art—is tied in some way to Lagos."
The mega-city is the beating heart
of the entire continent; one in every
five sub-Saharan Africans is Nigerian.
Lagos alone has 21 million inhabitants.

Lagos life

▼ Polish your Portuguese in Rio de Janeiro

The Royal Portuguese Cabinet of Reading is frequently cited as one of the world's most beautiful libraries. It's renowned for housing the largest collection of Portuguese works outside of Portugal. Where better to revise your language skills?

> ❝
>
> # I soon realized that no journey carries one far unless, as it extends into the world around us, it goes an equal distance into the world within.
>
> LILLIAN SMITH, *American writer*
>
> ❞

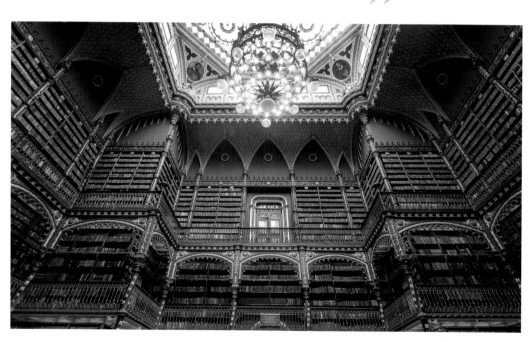

Portuguese Cabinet of Reading

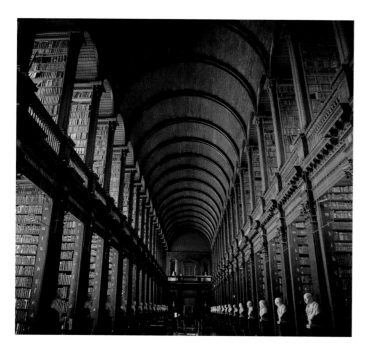

◄ A library fit for a Jedi

Dublin's Trinity College library allegedly inspired the Jedi Archives in *Star Wars: Episode II–Attack of the Clones*, and its interior is guaranteed to stir any book lover's heart. It houses 7 million volumes, so book a one-way ticket to Ireland— you might be a while!

Trinity College library

► Visit the bard of Bengal

The creative industries are lacking in diversity, so it's important to celebrate writers of color. Kolkata is the birthplace of Rabindranath Tagore (1861–1941), the first non-European winner of the Nobel Prize for Literature in 1913. Kolkata also holds the annual Apeejay Kolkata Literary Festival, offering visitors the perfect opportunity to immerse themselves in wordsmanship while discovering India's cultural heritage.

Apeejay Kolkata Literary Festival

▶ Book a Porto vacation

Livraria Lello & Irmão, in the Portuguese city of Porto, has become an Instagram sensation, with its much-photographed forked staircase. Founded in 1869, it showcases Portuguese literature and frequently tops lists of the world's best bookstores.

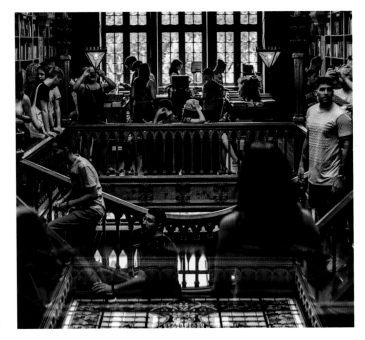

Livraria Lello & Irmão

◀ Look like Hemingway in Florida

Love literature but not libraries? Try Key West's Hemingway House and Museum. Follow up with an outing to the annual Ernest Hemingway Look-Alike contest at Sloppy Joe's, a bar the writer once frequented. The competition attracts many white-bearded hopefuls with an appreciation of his artistic legacy.

Hemingway House and Museum

Read, sleep, repeat in Japan

Never mind a bookstore you can have a leisurely coffee in—Tokyo's Book and Bed has taken things to the next level with a bookstore you sleep in! We all know how hard it is to put down a good book. Luckily, here you don't have to.

▶ Czech out an old Prague monastery

Lovers of philosophy and theology will adore the Strahov Monastery. Founded in 1143, it boasts two lavishly decorated libraries, containing an impressive 200,000 volumes. If the texts leave you cold, the intricate stucco decorations will make your visit worthwhile.

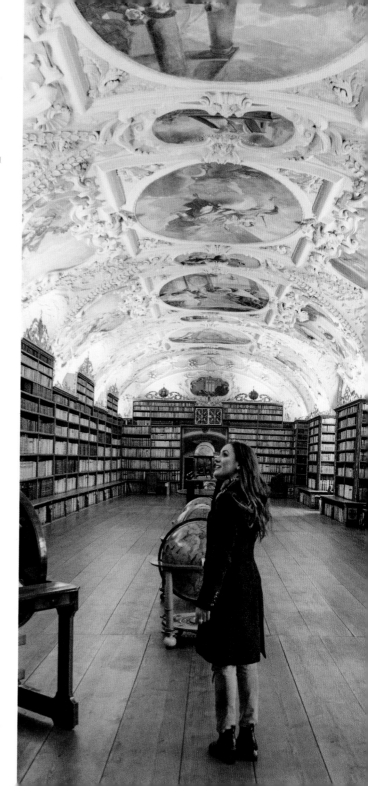

Strahov Monastery

▶ Melbourne to be a reader

Australia's Melbourne is a UNESCO City of Literature, with lots to offer book enthusiasts—including over 300 bookstores, the Victoria State Library, and the Wheeler Centre, established by Lonely Planet founders Tony and Maureen Wheeler. Visit during the Melbourne Writers Festival in August/September, which attracts renowned speakers like Zadie Smith and Margaret Atwood.

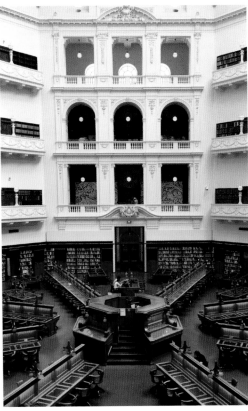

Victoria State Library

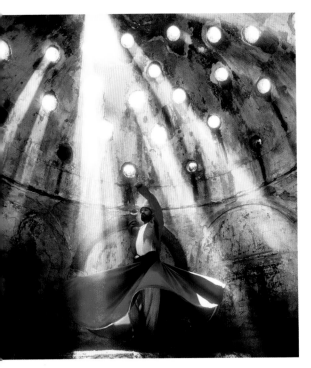

◀ Rumi-nate in Konya

If you're inspired by Rumi's writings, visit Konya in Turkey to see the poet's tomb at the Mevlâna Museum. Or attend the December Whirling Dervish festival, where spinning dancers perform a ceremony representing man's journey toward God. This thirteenth-century poet's wisdom resonates across the religious spectrum.

Whirling dervish

Enjoy the small things in Kerala

If Arundhati Roy's Booker Prize–winning *The God of Small Things* stole your heart, you'll enjoy Kerala. This southerly Indian state has mountains, beaches, rainforests, and peaceful backwaters. With the highest literacy rate in India, you'll find plenty of fellow bookworms.

When . . .

During the Kerala Literature Festival

Wye not visit Wales?

The Hay Festival in Hay-on-Wye is a literary event you shouldn't miss. Past speakers include heavy hitters Louis de Bernières, Salman Rushdie, and Ian Rankin. Pack a notebook and umbrella, and prepare to exercise your brain cells in rainy Wales.

Everyone's Russian to Moscow

Dostoyevsky, Pushkin, Nabokov, Gogol . . . Russia has never lacked talented writers. But Mikhail Bulgakov's twentieth-century masterpiece *The Master and Margarita* captivated audiences worldwide. Visit the Bulgakov Museum, inside his communal Moscow apartment, for background.

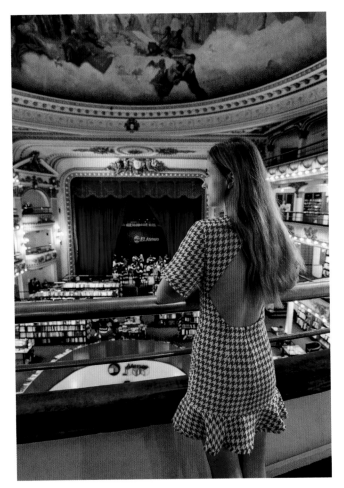

◄ Grand and splendid in Argentina

With its ceiling frescoes and burgundy curtains, El Ateneo Grand Splendid bookstore certainly lives up to the "grand" and "splendid" in its name. Dubbed the world's most beautiful bookstore by *National Geographic*, this former Buenos Aires theater welcomes a million visitors a year.

El Ateneo Grand Splendid

▶ Shakespeare and Company in Paris

This bookstore on Paris's Left Bank may be tiny and crumbling, but what it lacks in size it more than makes up for in stature. It was the was the favorite hangout of writers so famous they don't need a first name—Hemingway, Fitzgerald, Kerouac, Nin, and others.

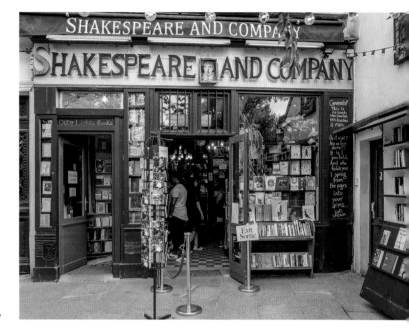

Shakespeare and Company

◀ Fables from Green Gables

L. M. Montgomery's *Anne of Green Gables* has been translated into at least thirty-six languages and sold 50 million copies. To see the world through the red-haired orphan's eyes, take a journey to Green Gables House in Canada's Prince Edward Island National Park.

Green Gables House

cultural festivals

◄ Ice, ice baby in China

Don't miss the Harbin International Ice and Snow Sculpture Festival—the largest festival of its kind in the world. Its name says it all. Expect painstakingly detailed ice palaces and re-creations of landmarks like the Egyptian Sphinx. The 2019 edition featured more than a hundred works, and millions of cubic feet of ice and snow.

Harbin ice palaces

► Yes we Cannes in France

A-listers flock to the French Riviera in May to attend the annual Cannes Film Festival. If you've always dreamed of "accidentally" running into your celeb crush, this is your chance. Pack oversize sunglasses and a wide-brimmed hat—someone may just mistake you for a movie star!

Cannes Film Festival

▼ Get fired up in Nara

The inhabitants of Nara in Japan have found a way to set a mountain on fire without committing arson. It's uncertain how the Wakakusa Yamayaki festival evolved—some believe it was to drive away wild boar; others think it resulted from a border conflict among local temples. View the event from Nara Park, among its free-roaming sacred deer.

Sundance the night away

The largest independent film festival in the US, Sundance appears on every indie cinema lover's calendar. Having popularized cult movies such as *Saw*, *Donnie Darko*, and *Napoleon Dynamite*, you never know what gems are waiting in store! Sundance has held festivals in London and Hong Kong, but the January event in Salt Lake City reigns supreme.

Nara Park deer

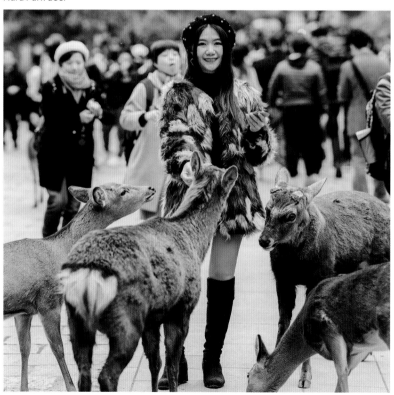

▶ Have a Ve(ry)nice vacation in Italy

Venice is a surreal destination regardless of when you go. But visiting during Carnivale di Venezia really ups the ante. Thousands of performers take to the streets in period costumes, reveling in the freedom provided by hiding behind the elaborate masks Venice is famous for. Carnival happens before Lent each year, ending on Shrove Tuesday.

Carnivale di Venezia

◀ Admire balloons in Albuquerque

What's better than a hot air balloon, lazily floating in the sky? Five hundred balloons! To witness this spectacle, head to the Albuquerque International Balloon Fiesta in New Mexico, which takes place in early October and attracts a global audience.

Albuquerque balloons

An English cultural week away

1 Bank on Banksy in Bristol

Bristol is the birthplace of the artist Banksy. Its Stokes Croft neighborhood is covered in graffiti and thought-provoking murals, including Bansky's *Mild Mild West*. Once your legs tire, head to Gloucester Road, Europe's longest street of independent stores.

Most Instagrammable spot
People's Republic of Stokes Croft Outdoor Art Gallery

2 Yoko Ono love Liverpool

John, Paul, George, and Ringo. Few people can be identified solely by their first name, but the Beatles are among them. If you've caught Beatlemania there's only one place for you—Liverpool. The city has also been home to contemporary acts like Frankie Goes to Hollywood and Atomic Kitten.

Most Instagrammable spot
The Beatles statue on the Waterfront

3 Then God made Manchester

The John Rylands Library was founded in 1900 by Enriqueta Augustina Rylands in memory of her husband. This Manchester landmark houses an impressive collection of early European publications, including a Gutenberg Bible and Papyrus P52—possibly the oldest surviving New Testament text.

Most Instagrammable spot
The historic Reading Room

4 Pride and Prejudice in Bath

Romantics love Bath. Although born in Winchester, novelist Jane Austen spent a few years here in the early nineteenth century. Sample the waters as Jane did, and let Bath's Roman architecture bring out the literary hero in you. In the fall, you can attend the annual Jane Austen Festival.

Most Instagrammable spot
The Paragon townhouse where Jane once lived

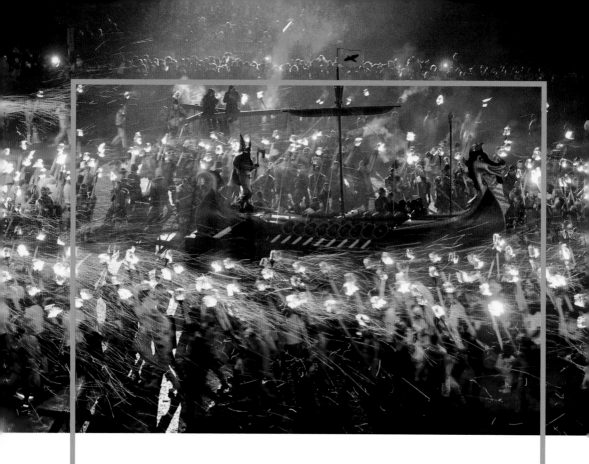

Live it up in Lerwick

In the Scottish midwinter, the Shetland Islands are aflame. This isn't a natural catastrophe—it's Up Helly Aa, the fire festival marking the end of the Yule season. Thousands of costumed guizers (participants) march through the streets of Lerwick with torches, before setting a giant longship alight, then singing traditional songs.

When . . .

the last Tuesday of January

Where day and night collide

In St. Petersburg the day never ends. The former Russian capital lies close to the Arctic Circle, which means a few short nights during which the sky never reaches full darkness. The August White Nights Festival celebrates this phenomenon with plenty of music and free-flowing vodka!

You do voodoo in Benin

Looking for an experience to tell the grandkids about? Try Benin's Ouidah International Voodoo Festival. Voodoo is growing in popularity in this small West African country. Expect singing, dancing, and rituals by local chiefs and shamans.

▶ You Canute miss this festival

The JORVIK Viking Festival celebrates England's rich Norse heritage. Did you know some of the days of the week were named after Norse gods? Thursday, for example, is named after Thor, god of thunder. Head to York to discover more.

JORVIK Viking Festival

◄ Taiwan to go to Pingxi

Taiwan's Pingxi Sky Lantern Festival might make you believe in magic. It occurs in late February or March, marking the last day of Chinese New Year. Thousands of paper lanterns are released to symbolize releasing the past and starting a new chapter.

Pingxi lanterns

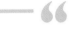

Travel far enough, you meet yourself.

DAVID MITCHELL, *English novelist*

◄ Sufi-ciently spiritual in Jodhpur

The World Sacred Spirit Festival in Jodhpur's fifteenth-century fort in India constitutes a spiritual journey. This intimate Sufi celebration is lit by oil lamps and accompanied by soulful Indian music. Leave with a clear head and a full stomach!

Mehrangarh Fort

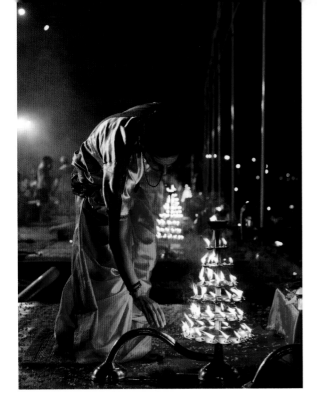

Diwali, New Delhi

◄ Sari not sorry in New Delhi

Diwali is celebrated by Hindus, Jains, Sikhs, and Newar Buddhists worldwide. But in India, New Delhi takes the festival of lights to another level. Stop by a *mela*—fairs where artisans sell saris and artworks, then enjoy a *langar* (communal meal) at a *gurdwara* (Sikh place of worship).

Kenya tell we love Mombasa?

Multicultural Mombasa is East Africa's largest port. Its Carnival brings together influences from China, Portugal, Persia, and the Arab world in a spectacular display of diversity, with street food, dance moves, and African customs.

◄ You're Gonder have an epiphany

For a celebration of Jesus' baptism— Epiphany—head to the city of Gonder. The Orthodox Tewahedo celebration of this holiday (Timkat) lasts two days, with many colorful parades.

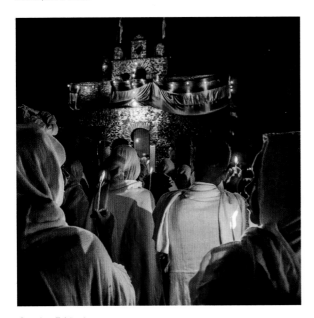

Gonder, Ethiopia

LGBT friendly

#

San Francisco

▲ Harvey Milk your time in San Francisco

San Francisco's Castro District has been an LGBT hangout since the 1970s. Full of rainbow flags and lively bars, it accepts people from all walks of life. For a lesson in queer history, visit the GLBT Historical Society, where you'll learn about Harvey Milk's assassination and the many contributions made by gay women and people of color.

"

Broad, wholesome, charitable views of men and things cannot be acquired by vegetating in one little corner of the earth all of one's lifetime.

MARK TWAIN, *American writer*

"

◄ The best gayborhood in Germany

Berlin is a diverse, tolerant city that welcomes everyone, no matter whom they're attracted to. Explore the Schöneberg neighborhood (or is it gayborhood?), the center of Berlin's LGBT scene since the 1920s. In terms of top-ranking events, visit Berlin Pride, Kreuzberg Pride, and the Dyke March.

Berlin Pride

► Visit England's LGBT capital

Brighton has attracted LGBT folk since the early 1800s—unsurprisingly, it's now Britain's gay capital. If you want to paint the town red or just openly hold hands with your partner, Brighton has your back.

Brighton Pride

◄ Drag your friends to Gran Canaria

For a flamboyant show, visit Gran Canaria between February and March, when the island hosts a Carnival that includes Drag Queen galas and contests. Full of feather boas, and rhinestones, the events take place in Las Palmas and Maspalomas and attract international partygoers.

Las Palmas

► Mountains of love in Nepal

Kathmandu will soon become a regular name on LGBT travel lists. Nepal recently became the eighth country in the world to officially recognize a third gender and it's now in the process of legalizing same-sex marriage.

Third gender people, Kathmandu

Never mind I'll find San Juan like you

Puerto Rico may be the most LGBT-friendly Caribbean island. In 2017, Hurricane Maria claimed some of the gay community's meeting points, but you'll still find buzzing nightclubs and underground parties outside Old San Juan, in Condado and Santurce.

Greek out in Mykonos

The Greek islands generally attract a diverse crowd of partygoers, but Mykonos is particularly LGBT-friendly. With cotton-candy sunsets followed by all-night ragers, this hideaway is equal parts romantic and hedonistic. For fun in the sun, both Super Paradise and Elia beach are popular with gay vacationers.

Have Valletta fun in Malta

Malta takes a strong stance against LGBT discrimination, being one of a handful of countries that upholds gay rights at a constitutional level. So, instead of worrying about being accepted, you can focus all your energy on exploring the Blue Lagoon (see page 40) and admiring St. John's Co-Cathedral.

◄ Sydney meets your koala-fications

Sydney's Gay and Lesbian Mardi Gras is a top tourist attraction. First held in 1978 as a gay rights parade, it maintains that political character, although issues like same-sex marriage are sometimes overshadowed by glitter and floats.

Sydney's Mardi Gras

Tel Aviv Israeli gay-friendly

Nowhere in the Middle East is as
exuberantly gay-friendly as Tel Aviv.
This city makes no secret of its atittude,
treating locals and visitors to safe spaces
that include queer beaches, restaurants,
and gyms. And its nightlife is unbeatable.

When . . .

**the second week of
June, for numerous
LGBT events**

4

Spaces
to Roam

#flora

▶ Have a blooming good time in NZ

Lupins are not native to New Zealand, and are considered a weed by locals, but they are a photographer's delight! For a symphony of pinks and purples, journey to Milford Sound on the South Island between November and December.

Milford Sound

◀ Soothe your senses in France

Lavender grows as far afield as Japan and Australia, but nowhere competes with Provence for scale or popularity. The most impressive farms are found around Aix-en-Provence and Marseille, and the best time to visit is between mid-June and early July.

Provence lavender

◄ Fall asleep beneath flowers in India

Uttarakhand's Valley of Flowers National Park attracts flower lovers, photographers, trekkers, and bird watchers. Visit this UNESCO World Heritage Site between May and October for fields of pink and yellow, against a backdrop of glaciers and waterfalls.

Valley of Flowers

No garden variety vacation in South Africa

The Garden Route is only 125 miles (200 km) long, but driving it takes longer than expected: from the coastal village of Mossel Bay to Africa's oldest marine reserve (within Tsitsikamma National Park), there'll be plenty of pit stops! Pack hiking boots to explore the forests at the foot of the Outeniqua and Tsitsikamma Mountains.

When . . .

in spring, for fynbos flowers in bloom

◄ Two daisies not enough in Furano

In spring, the popular Japanese skiing resort of Furano erupts with daisies, poppies, and tulips. Head to Tomita Farm to purchase lavender products or take a tractor-pulled cart ride around Flower Land Kamifurano, a center boasting views of the Tokachi Mountains.

Furano fields

Don't be blue in Belgium

Hallerbos's Blue Forest gets its name from the carpet of bluebells that covers it every April. A short drive from Brussels, it's straight out of a medieval fairy tale. And out of bluebell season, you can admire its giant sequoias.

Celebrate a budding romance in Mallorca

Visit this Spanish island between January and March for an alternative white winter—white almond blossoms. To fully enjoy the landscape, take ten days to hike the Serra de Tramuntana.

▶ Poppy over to Italy

With rolling hills, sprawling vineyards, and rustic villas, Tuscany's countryside is a popular getaway spot year-round. But during April and May it becomes especially beautiful with abundant wildflowers. Visit Maremma for sunflowers and the Lago dell'Accesa for poppies before hitting the flower markets of Chianti.

Tuscan poppies

◀ Fun times flor-all in Medellín

Flower lovers flock to Medellín each year for the Feria de las Flores. The event also includes an automobile procession, a horse parade, and music. But the most poignant element is the uphill Silleteros Parade, bearing flower arrangements to commemorate the end of slavery in Colombia.

Medellín Flowers Festival

◄ Enjoy a bed of roses in Morocco

Even if you've never visited Morocco's M'Goun Valley, you'll know what it smells like. Its damask roses are used by French perfume houses for high-end scents—1.6 million flowers are required for a liter of oil. Visit during the Festival des Roses to buy them from local women who gather them before dawn.

Moroccan rose market

► Feel bouquet in Keukenhof

Tulip season in the Netherlands has been serious business since the seventeenth century. Today, Keukenhof—the world's largest flower garden—displays 7 million flowers between March and May, while the Flevoland province boasts 5,000 hectares (12,355 acres) of tulip fields on the original Zuiderzee seabed.

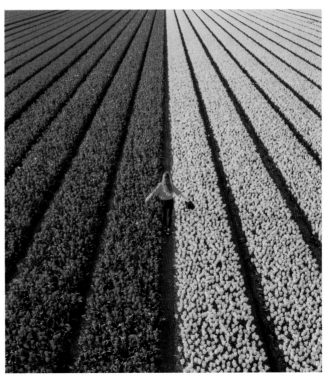

Dutch tulip fields

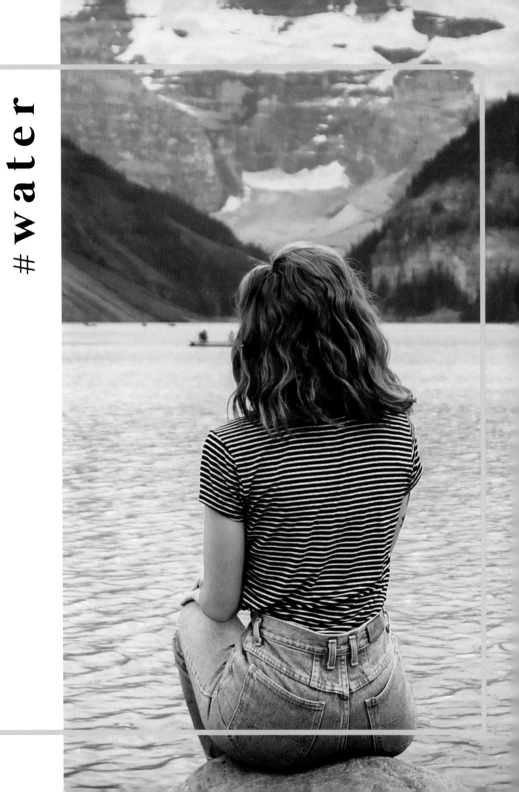

#water

Visit Afghanistan's Grand Canyon

Afghanistan's Bamyan Province was made famous by the giant sixth-century Buddha statues that were tragically destroyed by the Taliban in 2001. But there's still plenty to see, from the Hindu Kush Mountains to Band-e Amir National Park—a series of six deep blue lakes, described as Afghanistan's Grand Canyon and attracting thousands every year.

▶ Still waters run deep in Siberia

Lake Baikal is a world-class giant. It's the deepest, largest freshwater lake on Earth, containing more water than North America's Great Lakes combined. It might also be the oldest, dating back 25 to 30 million years. Pack a scarf and coat, because the average winter temperatures hover around −2°F (−19°C).

Lake Baikal

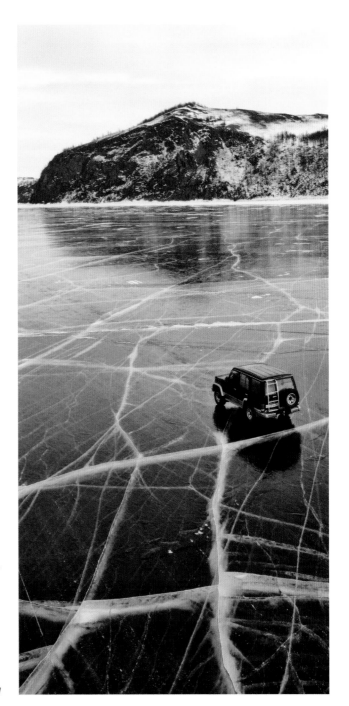

> ## People don't take trips, trips take people.

JOHN STEINBECK, *American novelist*

▶ Rock the boat in Xingping

Not far from the metropolis of Guilin is Xingping—a town so picturesque that it features on the back of the 20 yuan bill! To see it up close, take a raft trip down the Li River. If you'd prefer a bird's eye view, climb Laozhai Mountain instead.

Xingping, China

▶ Como-n down to Italy

George Clooney was so charmed by Lake Como that he bought a villa here. James Bond is also a fan; parts of *Casino Royale* were filmed here. Mingle with high society cruising in their convertibles, or give your boots a chance to shine, by climbing Mounts Grigna and Resegone.

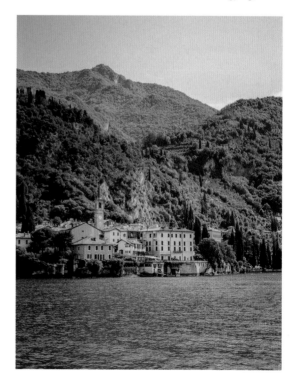

Lake Como

▶ Be a small fish in a big pond in Hangzhou

Hangzhou's scenic West Lake is in the heart of a Chinese metropolis with nearly 10 million inhabitants. But it provides peace and quiet to these citizens, miraculously never seeming crowded. Jog along the lake, enjoy a boat ride, or eat lotus shortbread at one of its cafes. Don't miss the picturesque Long and Broken Bridges, or the romantic Su Causeway.

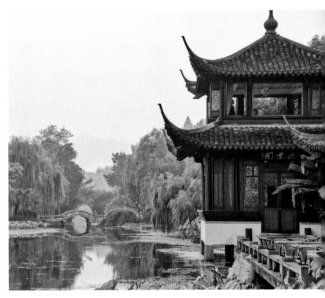

Hangzhou tea house

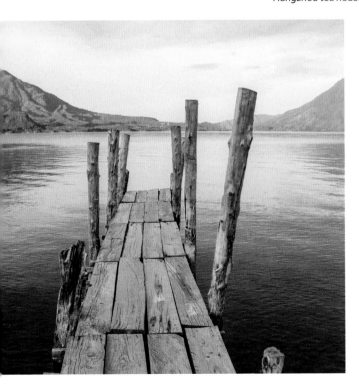

◀ Go against the tide in Guatemala

According to local Mayans, Lake Atitlán ("belly button of the world") has energy fields running through it. Whether you feel the connection or not, you'll want to stay. The lake has many different faces, from the yoga-loving village of San Marcos to raucous San Pedro La Laguna. Soak up the views by climbing sacred La Nariz.

Lake Atitlán

▶ Journey through Myanmar's water world

The serene Inle Lake is one of the most unique places in Myanmar. Don't miss this unusual destination in a rush to get to more famous Bagan (see page 252). You'll be rewarded with a beautiful landscape, dotted with stilt houses and Buddhist temples. The most notable is Nga Hpe Kyaung, a wooden structure dating back to 1890, which is widely known as Jumping Cat Monastery for its trained cats.

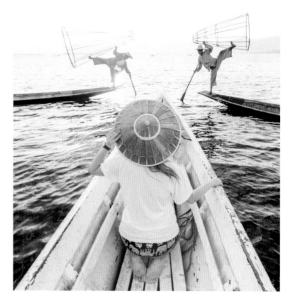

Inle Lake fishermen

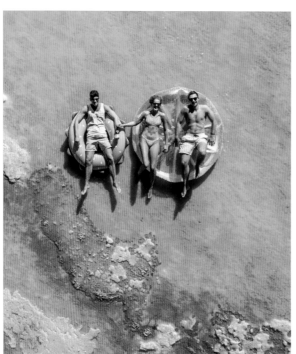

◀ Feel pretty in pink in Western Australia

Hutt Lagoon isn't huge, or home to a diverse fish population. What makes it special are its rosy waters, caused by carotenoid-producing algae. It's a popular tourist destination, especially between July and September when the region is covered in wildflowers. The lagoon is a six-hour drive from Perth.

Hutt Lagoon

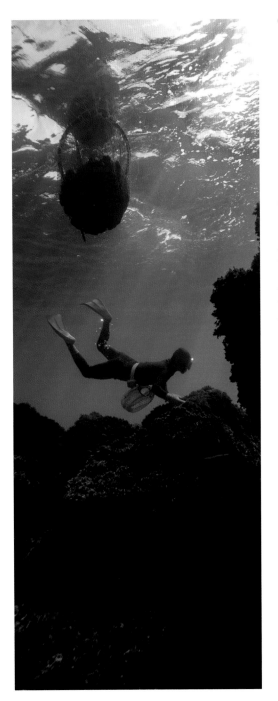

> ## If you think adventure is dangerous, try routine: it is lethal.
>
> PAULO COELHO, *Brazilian novelist*

Lose your head in Venezuelan clouds

As the world's highest waterfall, Angel Falls features on many a bucket list. Make your visit different by climbing nearby Auyán Tepui (a *tepui* is a tabletop mountain), and trekking through Canaima National Park. If you're brave, try rappeling down the falls, at 3,212 ft (980 m)!

◄ You shore will enjoy Jeju Island

Jeju is South Korea's largest island, popular with vacationing locals and international travelers, attracted by its stunning beaches and black lava rock cottages. It's also famous for its female free divers (*haenyeo*), who gather mussels and abalone daily.

Jeju haenyeo

Peyto play in Alberta

Glacial Lake Peyto in the Canadian province of Alberta, with its turquoise waters, may be North America's most beautiful body of water. Surrounded by Banff National Park, it's a popular trekking spot. Enjoy a short 3.8-mile (6-km) round-trip hike to the Bow Summit Lookout, for stunning panoramic views.

When . . .

early morning, to avoid tourist crowds

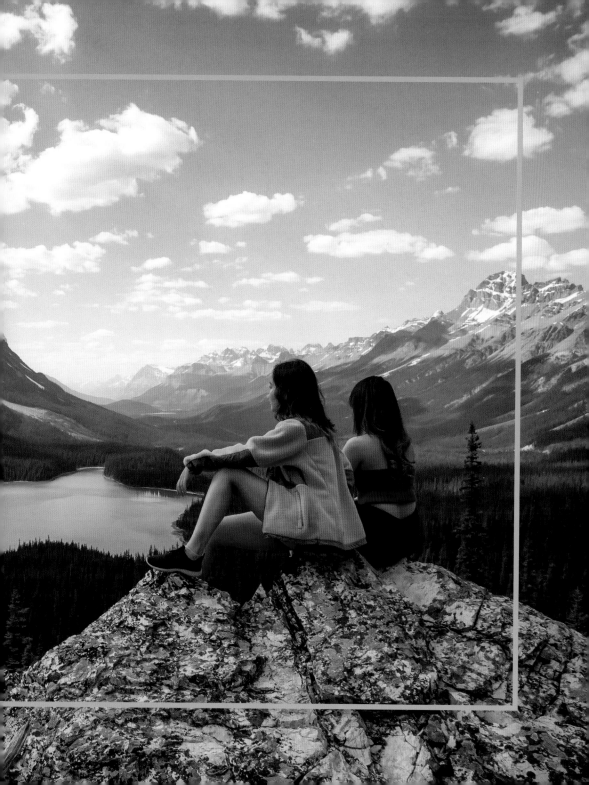

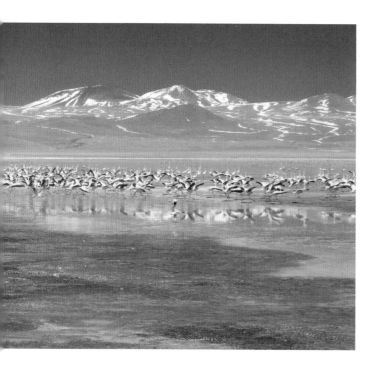

◄ Have a surreal good time in Bolivia

The shallow salt lake of Laguna Colorada is a unique sight. Its blood-red waters, smooth rock formations, and hundreds of flamingos are like a Surrealist painting. According to Andean legend, the water contains the blood of the gods. Scientists beg to differ, saying it's caused by algae and minerals.

Laguna Colorada

► Forget your fish-ues in Croatia

Plitvice Lakes is Croatia's most popular tourist attraction. The national park gets busy in summer, so go in the fall—the cerulean water looks stunning against a red and orange backdrop. Swimming is forbidden, but you can spend hours soaking up the surroundings. Visit on a day trip from Zagreb or Split.

Plitvice Lakes

▶ Go float yourself in the Dead Sea

If you're feeling down, visit the Middle East's Dead Sea—the lowest point on Earth, 1,414 ft (431 m) below sea level. It's one of the world's saltiest bodies of water, allowing you to float on its surface—swimming, reading, and working on your tan all at once! For some unique pampering, lather yourself in its healing mud.

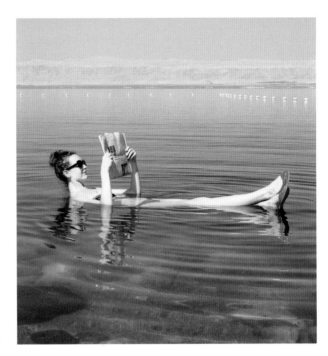

Dead Sea

Make a wish at China's magical lake

Five Flower Lake in China's Jiuzhaigou National Park gets its name from its ever-changing colors. Locals consider it sacred because of its resilience— it doesn't freeze on cold days and its water levels never dip in the absence of rain. The bottom of the lake is covered in ancient fallen trees, visible in its clear waters.

▼ Go with the flow at Iguazú Falls

Twice as wide as Niagara, Iguazú Falls must be seen to be truly understood. Their sheer power and noise awaken all the senses. The falls lie on the Argentine–Brazilian border, and can also be reached from nearby Paraguay. This is a popular spot, but don't let the crowds deter you—it's a visceral experience you won't soon forget.

Paddle your own canoe in the Philippines

Puerto Princesa in Palawan is the world's longest navigable underground river. You can travel 2.4 miles (3.8 km) of it in a canoe with just the boatman's headlamp lighting the way, gliding through a series of vast chambers to the chirping of swallows and rustling of bat wings.

Iguazú Falls

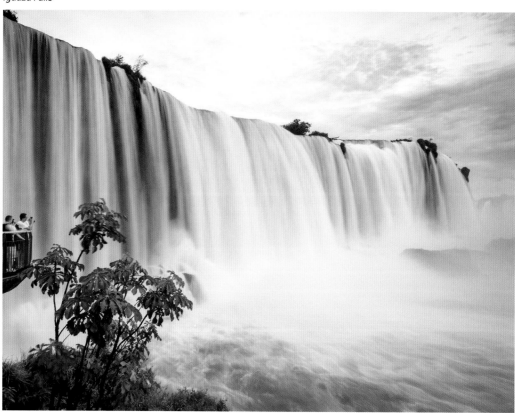

► You wood not believe Kazakhstan's underwater forest

If you're experiencing hard times, Lake Kaindy demonstrates that beauty can emerge from disaster. After a 1911 landslide, the earth formed a natural dam that filled with rainwater, submerging the trees that stood there. Visit on a trip from Kazakhstan's capital, Almaty.

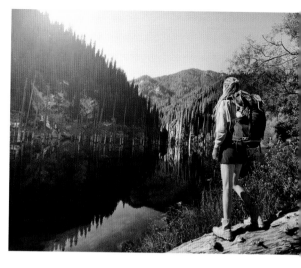

Lake Kaindy

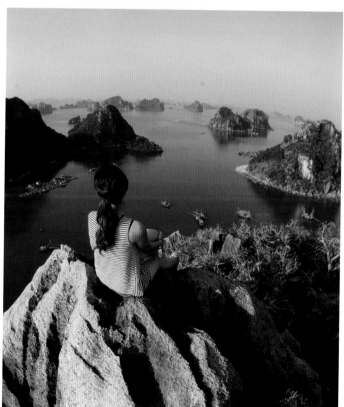

◄ Say "so long" to Ha Long

Ha Long Bay in Vietnam is a UNESCO World Heritage Site and one of the New 7 Wonders of Nature. Unregulated tourism is changing the bay's character, with thousands of cruise ships threatening fauna and flora, but its waters are as appealing as ever. For an alternative, try Lan Ha Bay—just as beautiful but quieter.

Ha Long Bay

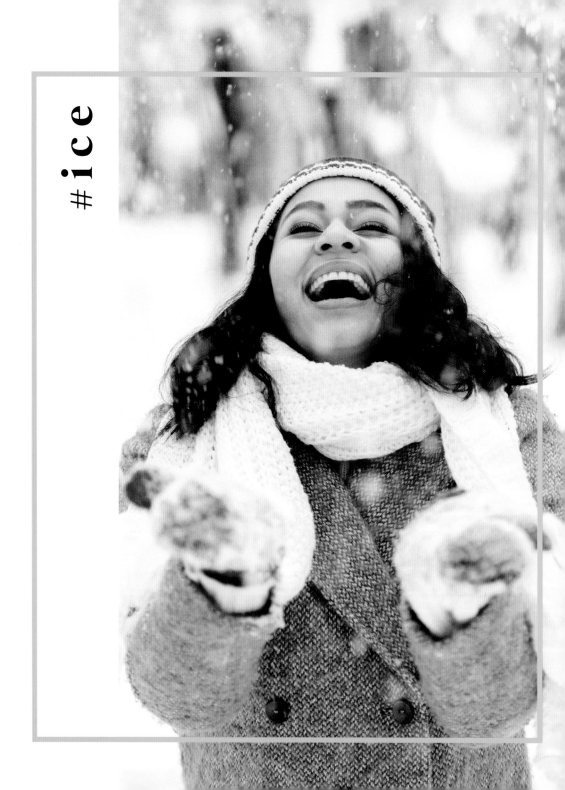

#ice

▶ Sleigh in your lane in Finland

Don't wait for Santa to come to you—make your way to Rovaniemi. This Finnish town is home to Santa Claus Village, a treat for children and adults alike. The moody half-light and snow-dusted trees add to the Christmas atmosphere in this Lappish version of the North Pole. Don't miss the chance to enjoy a sleigh ride with Rudolf!

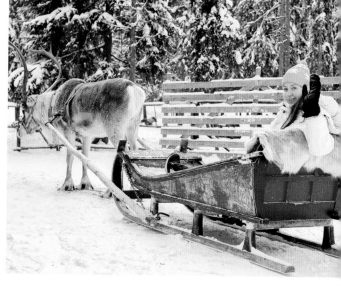

Rovaniemi reindeer

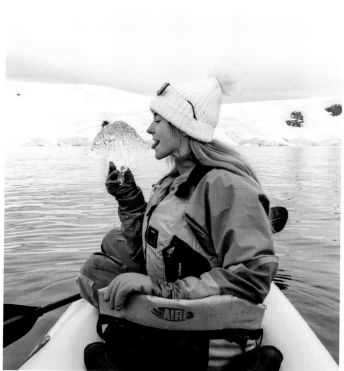

◀ Break the ice in Antarctica

Antarctica isn't a budget getaway—cruise prices start at $5,000. But it guarantees a once-in-a-lifetime experience. No place in the world can compare to the icy wilderness you'll encounter, with the white gleam of snow, towering icebergs, and adorable penguins.

Antarctic ice

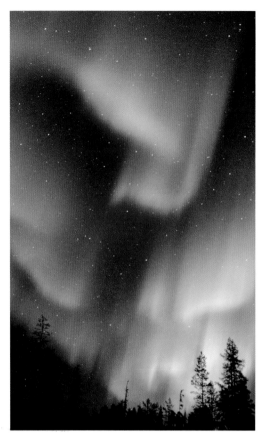

◄ See your true colors in Norway

The Northern Lights are one of nature's most spectacular performances. To increase your chances of seeing this unpredictable phenomenon, try Tromsø in Norway, which is also full of cozy pubs and restaurants specializing in Arctic delicacies.

Northern Lights

Have a fairy good time in Pakistan

Dubbed the Fairy Meadows, this grassland region is among the most popular hiking spots in Pakistan. Reaching the Fairy Meadows—Joot, to locals—is no joke. The path is straightforward, but the combination of high altitude and stunning views of Nanga Parbat ("Naked Mountain") will leave you breathless.

What's Zermatt-er, Matterhorn?

The Matterhorn is an Alpine celebrity—the Swiss peak even has its own roller coaster at Disneyland! The real deal stands 14,592 ft (4,448 m) tall and poses a challenge to even experienced climbers. If scaling it sounds too intense, admire it from afar over cheesy fondue or raclette in the resort town of Zermatt (see page 267).

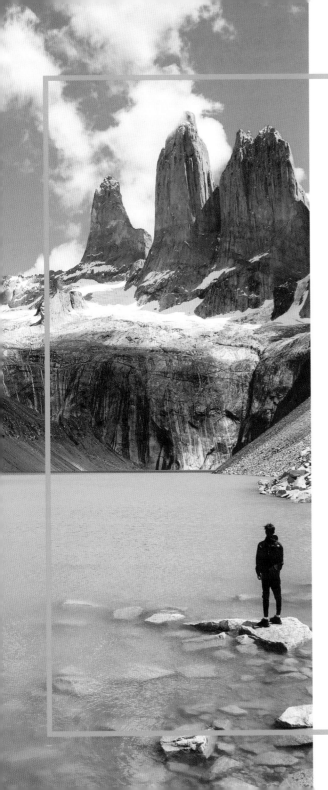

No Paine no gain in Chile

The beauty of Torres del Paine National Park—*torres* is Spanish for "towers," and *paine* means "blue" in the native Tehuelche tongue—will bring out the poet in you. Savor the feeling of complete insignificance in the face of nature in this UNESCO World Biosphere Reserve. You can kayak among giant icebergs, go sailing on Grey Lake, or admire wildlife ranging from foxes and Andean deer to pumas.

Bring . . .

thermals for when it gets, well, "Chile"!

◄ Take an Afghanistan-d in Pamir

The Wakhan Corridor is surrounded by the impressive Hindu Kush, Karakoram, and Pamir ranges, the latter largely untouched since Alexander the Great approached in 329 BCE. Enjoy the unspoiled wilderness of Wakhan National Park, meet semi-nomadic communities, and see a part of Afghanistan spared in the recent war.

Wakhan Corridor

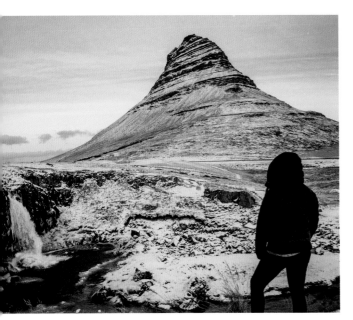

◄ Get an ice of the action at Kirkjufell

Kirkjufell ("Church Mountain") is the most photographed peak in Iceland, especially since appearing in the seventh season of *Game of Thrones* as Arrowhead Mountain. Nearby fishing town Grundarfjörður provides a beautiful view from the top. Climbing the 1,519-ft (463-m) peak is best done with a guide, but you can easily follow the hiking trail around Kirkjufell for an afternoon walk.

Kirkjufell's summit

◄ Blow off steam in Russia

During the Cold War, the Kamchatka Peninsula was off limits to everyone but Soviet personnel with special military clearances. In 1991, it was opened to visitors. Grizzlies still outnumber people, but this rugged spot is perfect for an adventure-packed trekking expedition, where you can witness thirty active volcanoes and wash your face in salmon-filled streams.

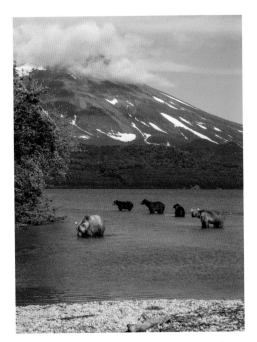

Kamchatka volcano

You Kurd not miss this mountain

Fly into Iraq's Kurdish capital of Erbil to explore the warmth of the Kurdish people, before heading to the Zagros Mountains to tackle the 11,834-ft (3,607-m) peak of Mount Halgurd. You don't need technical experience, just fitness and determination.

◄ Ice things up in Canada

Icefields Parkway links the mountain town of Jasper to Lake Louise in Alberta Province—rated one of the world's most beautiful road trips by *Condé Nast Traveler*. Its 144 miles (232 km) pass mountain peaks, waterfalls, and glaciers at the Columbia Icefields. Include a pit stop to admire Peyto Lake's crystalline waters (see page 176).

Icefields Parkway

#sand

Deadvlei thorn trees

Wander where Wi-Fi is weak in Australia

Munga-Thirri National Park's ocher sands form the world's longest parallel dunes. There are no towns here, so you must bring fuel, food, and water, but you'll find excellent bushwalking, birdwatching, and perfect solitude. Don't miss Nappanerica (Big Red), the desert's tallest dune at 131 ft (40 m).

▲ Sand your friends photos from Namibia

Photographers love Deadvlei for the contrast between its white pan floor and the skeletons of dead camel thorn trees. Bring a tripod, plenty of water, and fight your urge to climb the trunks—they've been preserved in this climate for 900 years, so make sure they keep going strong!

◄ Visit outer space in Yemen

Socotra island is perhaps the most alien-looking place on Earth—37 percent of its flora cannot be found elsewhere, including its dragon trees. These are named for their red sap, which is used by locals as nail varnish. Reaching Socotra isn't easy, due to Yemen's ongoing conflict, but you can typically get there on a flight from Cairo.

Dragon trees

► Witness a mirage in Huacachina

The tiny Peruvian village of Huacachina is South America's only natural oasis, built around a small palm-lined lake. Get your adrenaline pumping with a dune buggy ride or some sandboarding. Or simply enjoy the lake's healing waters and therapuetic mud.

Huacachina's oasis

Test your dry humor in the Sahara

Northern Africa's Sahara is probably
the first place that comes to mind when
thinking about deserts. At 3.6 million
square miles (9.3 million square km) it's
our planet's largest hot desert. Camp out
underneath the night sky, listening to old
Amazigh (Berber) tales while tucking into
a camel tajine.

Bring . . .

**a good book, and
a solar-powered
reading light**

Go on an expedition in Iran

Follow in the footsteps of Marco Polo by trekking across Iran's Lut Desert; not much has changed since he crossed this unforgiving landscape in 1271. The desert is still dry, barren, and merciless, so join a reputable tour—you'll need backup to meet this test of patience and stamina.

Bring . . .

an experienced guide—this isn't the time for spontaneity!

► Take a US road trip that doesn't succ

Who said nothing grows in the desert? The Sonoran Desert covers much of California, Arizona, and northern Mexico, and offers much more than sand. Visit in winter to see poppies or lupines in bloom. You'll also find classic Joshua trees, yucca, and cacti.

Sonoran Desert

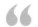

> # There are no foreign lands. It is the traveller only who is foreign.

ROBERT LOUIS STEVENSON, *Scottish writer*

Give the Sinai the benefit of the drought

Egypt's Sinai Peninsula, linking Africa with Asia, has been inhabited since prehistoric times. Named after the moon god Sin, its clear night skies will surprise you. Break bread with local Bedouin tribes, then lie awake until the early hours studying its constellations and pondering life's biggest questions.

Let down your garden Colorado

Poet Helen Hunt Jackson described National Natural Landmark the Garden of the Gods in Colorado as possessing the "strange look of having been just stopped . . . in the very climax of some supernatural catastrophe." Witness red sandstone hills, against the backdrop of snow-capped Rockies' giant Pikes Peak.

▶ The undeserted desert of South Asia

Not all deserts are empty. The Thar Desert is home to an impressive 215 people per square mile. It covers much of Rajasthan, and contains some of India's most colorful cities, from the golden hues of Jaisalmer to the blue streets of Jodhpur and pink palaces of Jaipur.

Jaipur palace

▶ Make waves in Arizona

The colorful Arizona sandstone formation known as the Wave has been . . . making waves on Instagram! But to re-create these photos in your newsfeed you'll have to enter a lottery run by the Bureau of Land Management. About 150,000 people compete for 10,000 annual permits. If you're unlucky, visit the Valley of Fire State Park near Las Vegas or the Candy Cliffs in Utah for similar formations.

The Wave

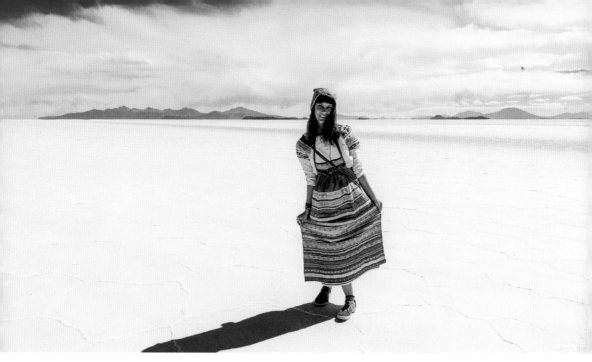

Salar de Uyuni

▲ Feel salty in Bolivia

Bolivia's largest desert isn't sand—it's a glistening field of salt. Salar de Uyuni was once covered in a prehistoric lake but all that remains are the world's largest salt flats. Exploring these 4,633 square miles (12,000 square km) on foot isn't possible, so hire a 4x4 or join a tour. If you're craving luxury, stay at El Palacio de Sal, a hotel made of salt.

Gobi yourself in Mongolia

The Gobi Desert, spanning southern Mongolia and northwestern China, is best known as Genghis Khan's thirteenth-century empire. Although without much of its former glory, it's still full of life, with snow leopards, Siberian ibex, and Bactrian camels. That's how it's been for 100,000 years, as evidenced by dinosaur fossils.

Explore Canada's pocket desert

The Nk'Mip Desert in Canada's British Columbia is not technically a desert, but extremely arid shrub-steppe. You could be forgiven for thinking otherwise, with its sand, cacti, and coyotes. Visit the Osoyoos Indian Band's cultural center to learn about its endangered ecosystem and First Nations culture.

fauna

Photographing wild animals

From cheeky monkeys to playful elephants, we all agree that animals are awesome. So awesome, in fact, that most of us desperately want a snap of every creature we encounter. But there are rules! Steer clear of activities that hold wild animals captive or use them as tourist bait. Never venture too close to wild animals, or treat them as Instagram accessories. This is for their well-being and your safety, protecting you both from injury and disease.

There's Norway you should skip Svalbard

Head to the Norwegian archipelago of Svalbard for an Arctic safari, complete with endangered walruses. They have established several colonies in Svalbard, with the most famous on Prins Karls Forland and Moffen Island. If you visit in summer, you might also encounter polar bears, whales, and breeding birds.

▶ Puffin or nuffin in the Faroes

Clown-faced puffins are among the most lovable members of the animal kingdom. Head to Mykines in the Faroe Islands, where you'll encounter some 500,000 pairs in summer! This island is home to a whopping 305 bird species, including kittiwakes, skuas, and gannets.

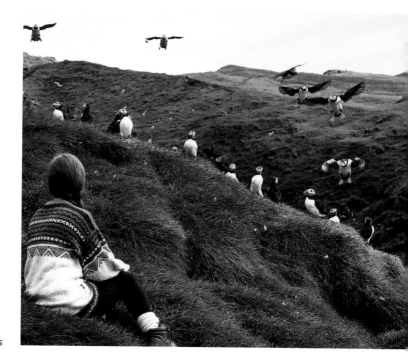

Mykines puffins

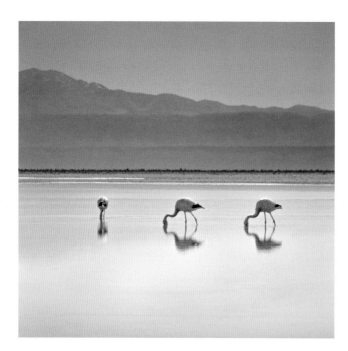

◄ Chile out with flamingos

Flamingos are proof that you are what you eat. These birds aren't born with pink plumage—they get it from the carotenoid pigments in their shrimp-heavy diet. To see flamingos in the wild head to Laguna Chaxa in Chile, an otherworldly landscape of giant sand dunes and salt flats.

Laguna Chaxa

► Grin and bear it in Alaska

An Alaskan cruise is worlds away from a boozy mega-ship. You will glide across still waters, witnessing whales in icy bays and grizzlies on shore. Stretch your legs by cycling Anchorage's Coastal Trail or hiking through Denali National Park and Preserve. From North America's tallest peak to the Hubbard Glacier, Alaska will wow you with its sheer scale.

Alaskan grizzly

▶ Free Willy in Canada

Orcas are nicknamed killer whales, but they hardly deserve it. They possess brains five times larger than ours, and according to MRI scans, they are more emotionally complex than humans. Head to British Columbia to see them in the wild—always avoid parks that keep these endangered giants captive.

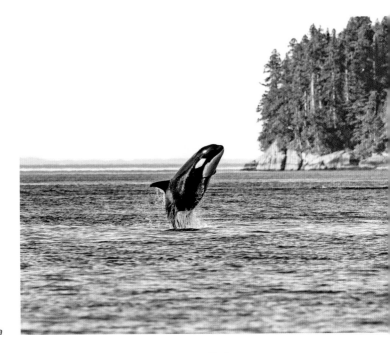

Canadian orca

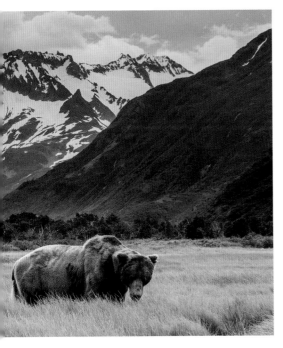

> **Where no one knows you and you hold your life in your hands all alone, you are more master of yourself than at any other time.**

HANNAH ARENDT,
German-American philosopher

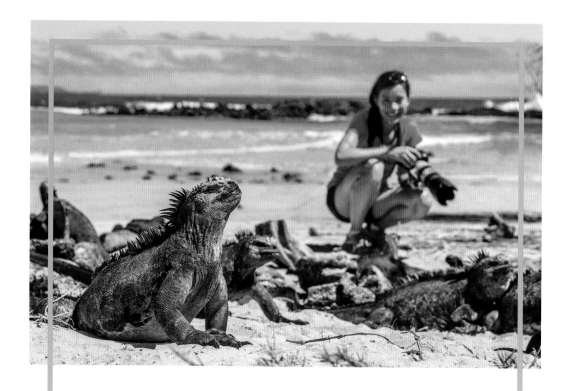

You're iguana love the Galápagos

If you love wildlife, add the Galápagos Islands to your bucket list. This remote Ecuadorian volcanic archipelago is one of the most biodiverse regions on Earth. The local animals—from giant tortoises to penguins and iguanas—are completely unfazed by humans, due to the lack of predators here.

When . . .

seasons are either warm and wet (December—June) or cool and dry (June—November)

"

If we were meant to stay in one place, we'd have roots instead of feet.

RACHEL WOLCHIN,
American writer

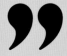

▶ Seal your fate in the Falklands

There aren't many places where you can experience silence, but the Falkland Islands qualify. This remote archipelago is an unspoiled wilderness, inhabited by albatrosses and petrels. But the real draw is a National Nature Reserve known as Sea Lion Island, where these clever giants laze on kelp-covered beaches.

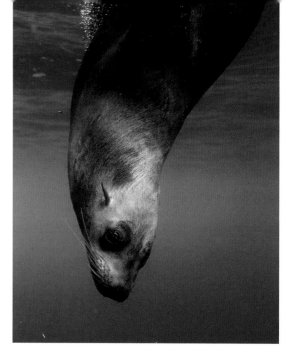

Falklands' sea lion

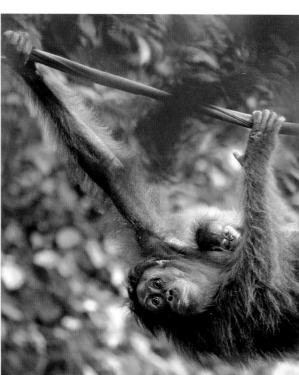

◀ Hang out with Borneo's orangutans

To see orangutans in their natural habitat, travel to their ancestral home on the island of Borneo (shared by Indonesia and Malaysia). Seeing animals in the wild is never guaranteed, but increase your chances by traveling along the Kinabatangan River. The area boasts plenty of other wildlife, too, from endangered pygmy elephants to long-nosed monkeys.

Bornean orangutan

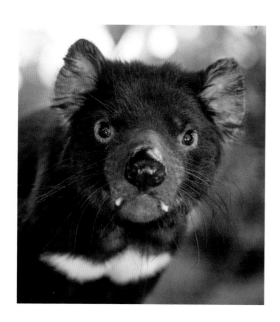

◄ Go crazy in Tas-mania

The Australian island of Tasmania has a famous inhabitant—the Tasmanian devil. These small carnivorous marsupials look cute, but they didn't get their name for nothing. Their bloodcurdling screams kept explorers of yesteryear awake at night. With dwindling populations, you're best off viewing them at a nature park.

Tasmanian devil

► It be-hooves you to visit Belarus

The Belovezhskaya Pushcha National Park isn't just any old forest, although it's undeniably old; it's the largest remnant of the primeval forest that once covered the European Plain. It is also home to about 800 European bison— the buffalo's herbivore cousin. These gentle giants once roamed the continent, but have been hunted into near extinction.

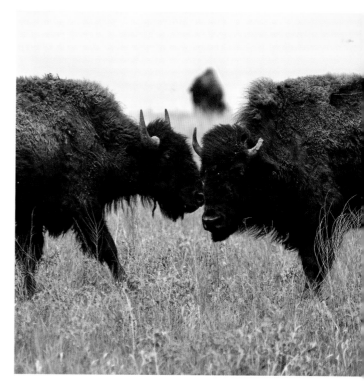

European bison

Take time out for an African safari

1 Pack your trunk for Zimbabwe

You can see wild elephants all over the world, but walking with these giants in Zimbabwe's Hwange National Park is an experience you can't replicate elsewhere—it has 200 times more elephants than visitors! You'll also spot lions, zebras, giraffes, and buffalo.

When to go

The dry season, April to October

2 Monkey around in Bwindi

Watch *Gorillas in the Mist* and be inspired by Dian Fossey's journeys through Rwanda and Uganda. Poaching is still an issue, but there are many silverbacks in Bwindi Forest and the mountains spanning both countries. Treks are available year round.

When to go

Avoid the wet season (February to June)

3 Don't be a cheetah in Botswana

Cheetahs are nature's answer to a Ferrari, reaching 70 mph (113 kmh). Botswana has around 1,700—one quarter of the world's wild individuals. The Kgalagadi Transfrontier Park and Central Kalahari Game Reserve are the best places to spot them.

When to go

March to May, when animals gather at waterholes

4 Stick your neck out for Kenya

If you dream of seeing giraffes up close but aren't keen on camping, book the Giraffe Manor in Nairobi—a herd of endangered Rothschild's giraffes roam freely within its forest, in a partnership with a local program for endangered wildlife.

When to go

Year round, but book well in advance

wood

◄ Have a Wild time on the Pacific Crest Trail

The Pacific Crest Trail is no insignificant hike, stretching from Campo, on the US–Mexico border, to the edge of Canada's Manning Park, British Columbia. It was popularized by Cheryl Strayed's memoir *Wild* and the 2014 movie adaptation, starring Reese Witherspoon. Find yourself on its 2,650 miles (4,265 km)!

Pacific Crest Trail

► Get a new profile Picchu in Peru

Sure, you could take the train to Machu Picchu for a romantic journey. But for something more rugged and adventurous, take the road less traveled—on foot! Climbing Huayna Picchu doesn't require any skills, just a head for heights and determination to reach the summit's Inca citadel.

Machu Picchu

▶ See China's Avatar mountains

Are the cliffs of Zhangjiajie giving you déjà vu? Maybe because you've seen them on the silver screen—in 3-D! The makers of *Avatar* were inspired by this forest and its otherworldly karst spires. Located in China's Hunan Province, it attracts around 20 million visitors every year.

Zhangjiajie National Forest Park

◀ Improve your Table manners in South Africa

You cannot leave Cape Town without climbing Table Mountain. The easiest route takes under two hours, but it's the least exciting. Instead, hire a guide and follow the Skeleton Gorge from the Kirstenbosch National Botanical Garden. Your thighs won't thank you, but your Instagram followers will!

Table Mountain

Cook up an adventure in New Zealand

Aoraki/Mount Cook National Park has it all—glaciers, lakes, and fern-filled forests. Whether you're planning a short walk or a mountaineering expedition, you'll witness nature in its rawest form. This area is part of New Zealand's only International Dark Sky Reserve, perfect for stargazing.

Bring . . .

a tripod, for all your astrophotography needs

◀ Take a hike in Japan

There's no better way to admire the Land of the Rising Sun than from Mount Fuji at dawn. This active volcano is Japan's tallest peak and its most recognizable symbol. Around 200,000 people ascend to its snow-capped summit annually, especially in the spring when cherry trees are in bloom.

Mount Fuji

▶ May the forest be with you in Tennessee

For a Southern outdoorsy trip, try Gatlinburg. Spend the daytime exploring the Great Smoky Mountains National Park, witness an unforgettable sunset, then return for a night on the town. Gatlinburg offers go-karting, mirror mazes, the 407-ft (124-m) tall Gatlinburg Space Needle and a Disneyesque outdoor shopping complex.

Gatlinburg sunset

▶ Have a *Jungle Book* adventure in Myanmar

Rudyard Kipling described Myanmar as "unlike any land you know about." Venture into the forested mountains of Nagaland, near the Indian border; hike to the top of Mount Saramati; or learn about Naga culture from friendly locals.

Camping in Nagaland

You're not Guinea believe your eyes

Papua New Guinea is fast becoming a viable travel destination, and its Kokoda Track is the hiking experience of a lifetime. The challenging 60-mile (97-km) journey takes ten days, passing through dense rainforest to a 7,000-ft (2,134-m) peak. On your ascent, pay respects to the 600 Australians killed here by Japanese forces in 1942.

Get Madagascar-ried away

Madagascar may not resemble the movie version, but it's no less magical. Known for towering baobab trees, rainforests, and deserts, the island is an outdoor enthusiast's dream. Travel downriver on two-person rafts ("hot dogs"), climb Pic Boby Mountain, or hike through Andringitra National Park.

When . . .

the dry season, April to October

You moss book a trip to Texas

If a swamp vacation doesn't appeal, perhaps you've never been to Caddo Lake State Park—think towering cypress trees draped in Spanish moss, dragonflies buzzing in the air, and alligators lurking in the bayou. Cruise around the shallow waters in a Go-Devil boat and soak up the stillness.

Estonia is a real tree-t

When in need of greenery, head to Estonia; more than half of it is covered in forest, home to wolves, lynxes, and bears. In the south you'll find the Järvselja Primeval Forest. At the country's opposite end is Lahemaa National Park. Its boggy marshes, towering pines, and ancient rocks are the stuff of European fairy tales!

◄ Take a gap year in Panama

Trekking through the rainforest dividing North and South America is an expedition only intrepid souls undertake, but Panama's Darién Gap offers a true adventure. Spot 5,000-year-old petroglyphs and have your very own Indiana Jones moment, trekking and wild camping your way to the Pacific Coast finish line.

Darién jungle

5

Conscious
Traveling

sustainable stays

Ubud terraces

English hut

▲ You will never forget Ubud Bali

Elizabeth Gilbert introduced Ubud to the masses with her book *Eat Pray Love*, so it's no hidden gem—just a wonderful spot for practicing yoga and clearing your head while staying at a classy eco resort. There's nothing wrong with following the crowd, especially if it leads to an oasis among rice fields.

Yoga and chill in Mexico

Tulum, on the Yucatán Peninsula, has undergone a makeover, transforming itself from a laidback hippie hangout into an Instagram sensation. But don't avoid it because it has lost its off-the-beaten path charm. With sustainably built hotels and juice bars everywhere, it's still perfect for some holistic relaxation.

▲ Go on an adventure worth Tolkien about

The Shire may be in New Zealand, but you can spend the night in a hobbit hole in England, too. It's where Tolkien wrote *Lord of the Rings* after all. Fan or not, these wooden huts provide a lovely rustic getaway. They are dotted across the country, from the romantic Lake District to relaxed Cornwall.

▼ Embrace the Costa Rican pura vida

Costa Rica is a top ecotourism destination, having converted a quarter of its territory into national parks and wildlife reserves. Manuel Antonio National Park and Monteverde Cloud Forest Reserve are among the most famous, widely known for their incredible biodiversity. Costa Rica is also en route to becoming totally fossil fuel free!

▼ Fly the nest in Cabarete

Outdoor yoga, kite-surfing, eco-friendly hotels—if these are what you expect from a good vacation, you'll love Cabarete. This resort town in the Dominican Republic is popular among flower children from all walks of life, including Richard Branson! For water sports, head to Cabarete Bay or Kite Beach. For secret lagoons and underground rivers, check out El Choco National Park.

Monteverde Cloud Forest

Dominican Republic Beach

You Tibet you'll love Ladakh

India delivers complete sensory overload, but that melts away as you approach Ladakh. It's one of the country's least populated areas, with deep ties to Tibet. Enjoy a Himalayan village homestay against the backdrop of prayer flags and *gompas* (monasteries).

When . . .

July to September, for flower-filled valleys

▼ Get igloo-d to the view in Finland

A night in a glass igloo watching the Northern Lights (see page 184) doesn't come cheap, but it's worth it! The igloo village near Sirkka features on many a Pinterest board, or for something more private head to Levi's Golden Crown Glass Igloos.

Fall in love with S-love-nia

Slovenia was dubbed the world's most sustainable country by *National Geographic*, and Garden Village, near Lake Bled, exemplifies this reputation. This getaway location boasts treehouses, a natural swimming pool, and an organic restaurant.

Have an in-tents experience in NZ

Camping is rugged fun. But to get in touch with nature in comfort, there's another option—glamorous camping, or glamping. From minimalist lake cabins and remodeled wagons to tree houses with hot tubs, New Zealand will convert you.

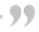

A journey of a thousand miles begins with a single step.

LAO TZU, *Chinese philosopher*

Sirkka igloo

Iceland's Blue Lagoon

Gräno treehouses, Sweden

▲ Spring for a ticket to Iceland

Iceland is the world's first country to run on fully renewable energy—mostly geothermal—harvested from hot springs. To experience them visit the Blue Lagoon or Mývatn Nature Baths. For something cooler, try ice climbing. With 4,500 square miles (11,655 square km) of glacier, Iceland's name isn't false advertising.

Enjoy delightful times in Turkey

The food industry has a huge carbon footprint. If you like your meals sustainably produced, check out Fethiye on Turkey's Turquoise Coast. The Taste of Fethiye project connects farmers to large hotel chains in the area, creating a delicious ecosystem that'll fill your belly and quieten your conscience.

▲ Climb the ladder in Sweden

Have you ever wanted a treehouse? You can fulfill that childhood fantasy! Treehotel in Lapland has seven to choose from. There's one shaped like a bird's nest, a futuristic mirror cube, and a cabin resembling a flying saucer. If you'd prefer traditional, treehouses are also available elsewhere in the country.

#volunteering

Ethical volunteering

Volunteering isn't always the best way to give back—done improperly, it can do more harm than good. Here are some general rules . . . Make sure the project includes locals in all decision-making, valuing their input, and treating them like equals rather than beneficiaries. Avoid tasks that take jobs away from workers in the area. Offer genuine value instead of doing this for yourself. If you can only stay for a short period of time, avoid jobs where you form close bonds with vulnerable individuals or children. Growing attached to volunteers then repeatedly watching them leave, can be extremely damaging.

> "
> # Wherever you go becomes a part of you somehow.
>
> ANITA DESAI, *Indian author*
> "

▼ Stray from the path in Costa Rica

Dog lovers, listen up! Territorio de Zaguates—Land of the Strays—is a 378-acre (153-hectare) outdoor space in the mountains of Costa Rica, which is home to roughly 900 stray dogs. You can go for a visit and even bring your own pooch. If you're currently dog-less, most rescues are available for adoption.

Territorio de Zaguates

▶ Have a turtley spe-shell time in Nicaragua

Endangered sea turtles flock to Nicaragua's beaches by the thousands to lay eggs. As a volunteer, you'll get to witness this incredible event—an *arribada*—then observe the hatching babies up close. You'll also learn about conservation from trained biologists, spend days with your toes in the sand, and definitely improve your Spanish!

Nicaraguan turtles

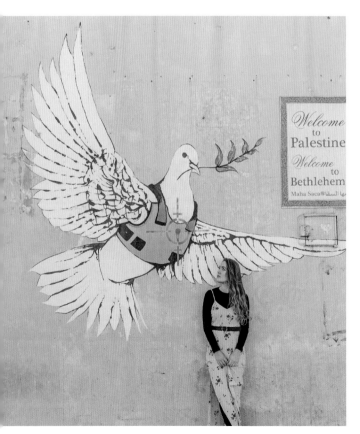

◀ Green thumbs up for Bethlehem

If you love being outdoors, WWOOFing might be worth trying. "World Wide Opportunities on Organic Farms" involves working in exchange for food and accommodation. It runs worldwide, but Bethlehem offers a truly authentic experience and incredibly friendy locals. While there, don't miss Banksy's iconic street art.

Banksy in Bethlehem

Navajo country

Elephant Nature Park

▲ Discover American Indian traditions

Apache, Comanche, Sioux, Navajo . . . American Indian tribes are much more than a historical footnote. Their culture has been overlooked for centuries, but they've remained faithful to their traditions. Volunteer at a reservation to help preserve their customs and to gain a fresh perspective on American history.

Help out in Greece

You needn't be a humanitarian worker to assist those in need. Greek refugee camps rely on grassroots organizations and volunteers to help run programs, with roles in anything from food distribution and informal childcare to yoga and English tuition. Indigo Volunteers will connect you with an organization matching your skills.

▲ Spend elephantastic weeks in Thailand

Riding elephants is a big no-no, but that doesn't prevent you observing them up close. Chiang Mai's Elephant Nature Park is a sanctuary for rescued animals where you can volunteer for weeks. For a moderate fee, they'll provide you with vegetarian food and accommodation— in exchange you help care for their big-eared buddies.

Palau dolphinately deserves a visit

Head to the Pacific archipelago of Palau for Robinson Crusoe–style escapism, with around 250 small islands to choose from. Enjoy Kayangel Island's pristine beaches or scuba dive around the Rock Islands. Conservation volunteers help preserve Palau's diverse marine life, from limestone forests to hundreds of coral species.

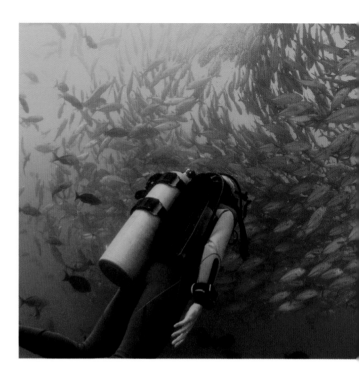

Bring . . .

authentic American snacks for your students

◄ Seas the day in Mexico

Around a million seabirds are killed by pollution each year. To help with marine conservation, head to Mexico's Caribbean coast. You will assist with coral reef monitoring, carrying out underwater surveys and collecting data. While you do your bit, you'll also be working on your PADI certification.

Diving in Mexico

Volunteering in Nepal

Get English lit in Korea

Traveling the world needn't be expensive, but turning your passion into a lifestyle requires a plan. As a native English speaker you can use what you know—with just a TEFL certificate and your passport. South Korea is one of the most popular destinations, with high wages and low costs.

▲ Bring your Nepals to the Himalayas

In 2015, Nepal was struck by an earthquake that killed nearly 9,000 and injured more than 20,000. The Himalayan nation is still recovering and welcomes volunteers who are willing to help with rebuilding efforts, installing sanitation facilities, and assisting with education programs.

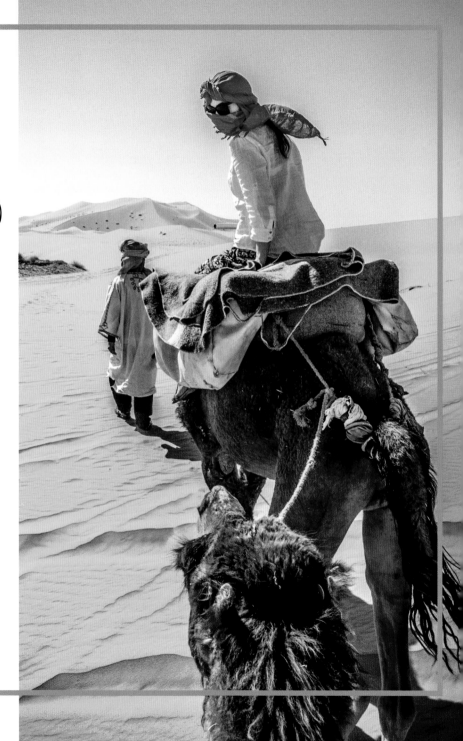

#indigenous

This wasn't a strange place; it was a new one.

PAULO COELHO, *Brazilian author*

Sámi reindeer

Visiting indigenous communities

Make sure the community you're visiting is open to visitors and that profits from tourism go to them rather than a third party like a tour operator. When taking photos of locals, always ask for consent. If you're going to share images online, make sure you get explicit permission for that, too. Take particular care when photographing children. Would you photograph a stranger's child back home and post it online? Probably not. The same standards should apply in another country.

▲ Make a deer friend in Lapland

The Sámi are the indigenous inhabitants of northern Europe. They live in Sápmi (Lapland), stretching across Norway, Sweden, Finland, and Russia's Kola Peninsula. Sámi people traditionally made their living through reindeer herding, fishing, and fur trapping, and many still do.

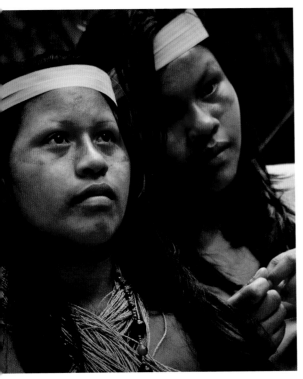

Huaorani girls

First Nation totem poles

▲ Do some Amazon shopping in Ecuador

The Huaorani are the native inhabitants of Ecuador's Amazon region. To visit, you'll need to embark on a strenuous journey into the rainforest. Not all communities are open to visitors— at least five tribes reject contact with the outside world—but some will be happy to show you their ancestral lands and their way of life.

▲ Don't ask for reasons Gwaii

Canada's indigenous people consist of three main groups—Inuit, Métis, and First Nations. There are more than 3,000 First Nations reserves, among the most popular being the Gwaii Haanas National Park Reserve on Haida Gwaii, an archipelago in British Columbia. Here you will find centuries-old totem poles and some of the last remaining examples of a First Nations reserve.

Have you herd of the Dukha?

The Dukha people are the world's last nomadic reindeer herders. They have inhabited the forests of northern Mongolia for thousands of years, undisturbed by modernity, but their way of life is under threat; the tribe has shrunk from 200 to 40 families. Many rely on tourism, so will welcome your visit.

Bring . . .

no electronics—enjoy a slower pace of life without them

▼ Find out what's Sa Pa in Vietnam

Visit the Vietnamese hill tribes in Sa Pa, a trekking base overlooking the Muong Hoa Valley rice terraces. The Hmong people don't shy away from visitors and will gladly show you around. Hire a guide to reach the peak of 10,326-ft (3,147-m) tall Phang Xi Pang—the Roof of Indochina. Or relax with a coffee at the Cafe in the Clouds instead.

March to the beat of your own bongo in the Congo Basin

In the Congolese jungle are the Pygmies, living in villages throughout the region and following ancient hunter-gatherer customs. Some communities will let you join them for a short period. Reconnect with nature by witnessing their deep connection with the forest.

Sa Pa mountains

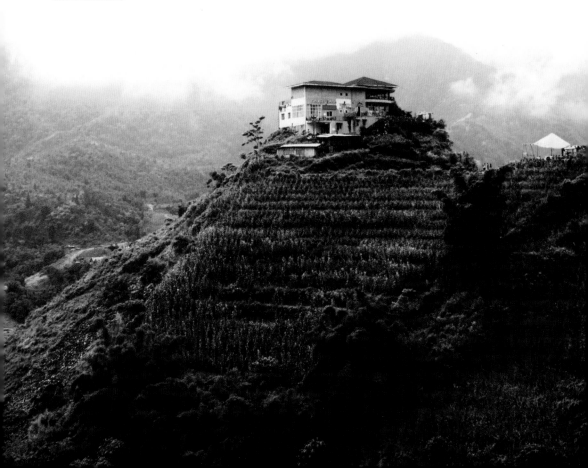

◄ Have an Amazigh time in Morocco

Escape the excitement of Marrakech by heading to rural Imintanoute. There you'll discover the Berber Cultural Center at the foot of the High Atlas Mountains. Its owners—members of the North African Amazigh ethnic group—will introduce you to their slower way of life. Learn how to make tajine, bake bread, and fetch well water with the help of a donkey.

Amazigh donkey

► Serengeti-n the car and drive to the airport

With their red robes and intricate necklaces, Maasai tribes have captivated outsiders' imaginations for decades. Travel to their homeland to witness their jumping rituals and lion-hunting rites of passage. You can visit in several locations in Kenya and Tanzania, including the Serengeti or Maasai Mara.

Maasai dancing

indigenous 233

▶ Book a Sudan trip to Africa

Venture north from Sudan's capital Khartoum and you'll find yourself in the Bayuda Desert. It may look unforgiving, but some Bedouin tribes still call it home, navigating their camels across the hot sand and sleeping underneath starlit skies. Visit to learn more about the ancient Meroitic civilizations and their pyramids—Sudan has more than Egypt!

Meroe pyramids

◀ Set your mind at freeze in Greenland

Greenland is the world's largest island, but it's no beachy getaway. Three-quarters are covered by the only permanent ice sheet outside Antarctica. A resulting lack of infrastructure makes Greenland expensive to visit, but splurge on some helicopter rides to witness magnificent landscapes.

Icy Greenland

Back it up in the Outback

Australia's giant sandstone formation Uluru
has fascinated humans for thousands of years.
Archaeologists have found paintings here
dating back millennia, but you'll also discover
caves, springs, and waterholes. Uluru is
sacred to the Aborigines, so out of respect,
don't climb the rock or photograph sections
used for rituals.

When . . .

**the cooler months,
May to September**

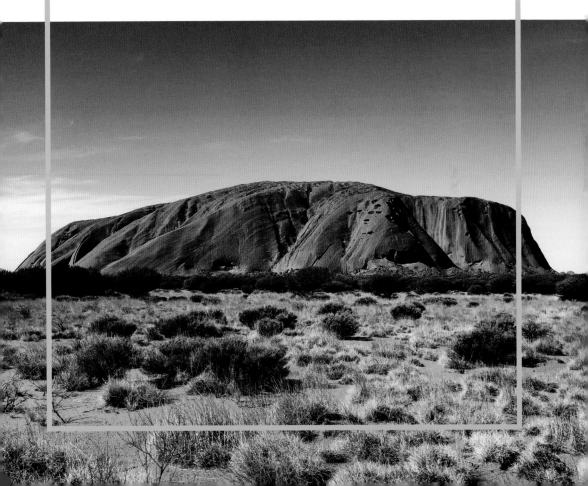

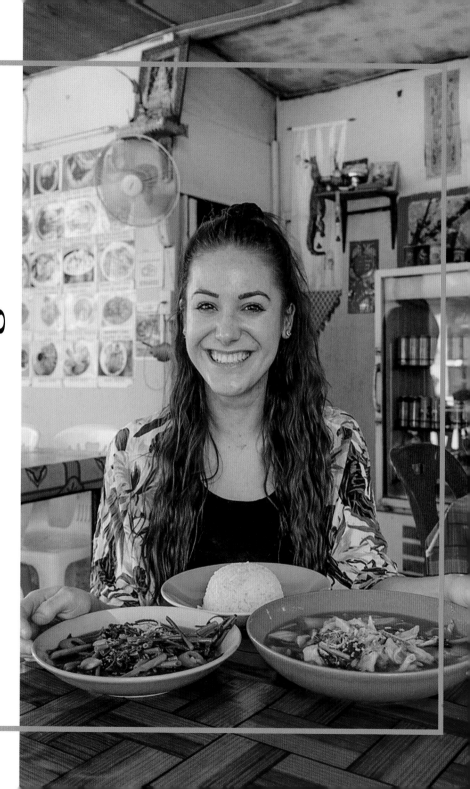

vegan food

► Ready, set, Glasgow!

Scotland doesn't have a reputation for healthy food—most guidebooks recommend the deep-fried Mars bars and meaty haggis! But Glasgow was named the UK's most vegan-friendly city by PETA. Thanks to its vibrant, politically engaged student population, it has become a destination for all things alternative.

Korean bowl, Glasgow

◄ Get avocontrol in London

The cosmopolitan British capital always has its finger on the pulse, and pulses on its mind! London is any vegan's dream, serving up delicious plant-based fare at Michelin-starred restaurants like Pied à Terre and Pollen Street Social. Or to keep costs down, try its thriving food markets— Borough Market is one; Broadway Vegan Market is another.

Borough Market

Bali breakfast bowl

◄ Try un-Bali-evable bowls

If you enjoy food with all your senses—sight in particular—visit Bali. This island caters heavily to Instagram-obsessed millennials, with its breakfast bowls and avocado roses on toast. Canggu is the perfect foodie spot, where you can surf during the day and devour vegan ice cream at night.

Visiting Portland is not a missed steak

The US's vegan capital is not resting on its laurels. New eateries pop up continually, including the world's first vegan mini mall. There's even a plant-based tattoo parlor and vegan strip club—no fur, leather, or silk here! Portland's plant-based roots extend back to the 1800s, courtesy of the Seventh-Day Adventist Church.

Bring . . .

a comfortable flannel shirt and an appetite

▼ Live to eat in Tel Aviv

With more than 400 plant-based kitchens, Tel Aviv in Israel is the vegan capital of the world. You'd need years to sample all of its cruelty-free dishes. September hosts Vegan Fest—one of the largest vegan festivals in the world. Combining fresh ingredients with international recipes, Tel Aviv will broaden your culinary horizons.

Outdoor dining in Tel Aviv

Plant food, Singapore Botanic Gardens

▲ Be a good human bean in Singapore

According to PETA, Singapore is Asia's second most vegan-friendly city, behind Taipei. If you're secretly curious about specialties such as fish head vermicelli or chicken rice, Singapore's strength is re-creating traditional meat dishes with plant-based alternatives.

▼ Taters gonna hate in Texas

Texas may be the land of beef brisket and fried chicken, but Dallas doesn't play by anybody's rules. From vegan 1950s diners to restaurants serving plant-based Chicharrón burritos, this laidback city challenge stereotypes. Dallas is also home to the country's largest contiguous Arts District and the Texas Veggie Fair, running for more than a decade now.

On Wednesdays we eat vegan

If you're vegan, you'll love Wednesdays and Fridays in Ethiopia, when local Orthodox Christians avoid meat, dairy, and eggs. Ask for the fasting menu or simply order a *yetsom beyaynetu* at any Addis Ababa restaurant. This giant sharing platter comes with the ubiquitous *injera* flatbread, chickpea-based *shiro*, and a variety of veggie stews or salads.

▼ Turnip in Chiang Mai hungry

Remote Thai villages can challenge vegans, but finding a plant-based meal in Chiang Mai is incredibly easy. Home to many digital nomads, the city has adapted to its cruelty-averse clientele. Enjoy the *pad thai*, papaya salad, and *khao soi*—just remind the staff that you don't eat fish sauce, which is typically used in these dishes.

Dallas food truck

Chiang Mai street food

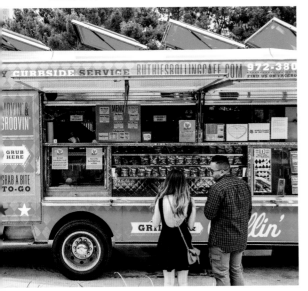

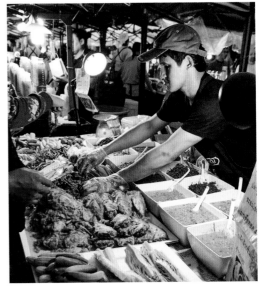

Fresh coconut in Amsterdam

Bangalore curry

▲ Go coconuts in Amsterdam

Traditional Dutch cuisine may not be vegan-friendly, but Amsterdam is truly cosmopolitan. Soak up beachy vibes at Coffee & Coconuts or head to trendy Food Hallen, a food market with plenty of plant-based options. Amsterdam is also famed for Surinamese takeouts, featuring vegetarian dishes like roti rolls or deep-fried plantain with satay sauce.

Taipei to eat what Taiwan

Taiwan is full of delicious plant-based food, if you know where to look and what to avoid—you will find meat lurking in some very unexpected places, like pork floss on top of baked goods! But with a few Mandarin phrases, you'll find a city of vegan wonders. Check out Keelung Night Market for hot noodle soups, veg stir fries, and grass jelly desserts.

▲ Food galore in Bangalore

Bangalore in India is an impressively vegetarian-friendly city in a country renowned for plant-based food. Its distinguishing feature are *darshinis*, roadside cafes serving vegetarian dishes that are great for the environment and your wallet. They're found everywhere, distinguished by round steel tables and plates of curry.

pilgrimage paths

#paths

◄ Spain-d time on the road

The Camino de Santiago—a UNESCO World Heritage Site—is a series of ancient pilgrim routes, stretching across Europe and converging at the shrine of Saint James, in Galicia's Santiago de Compostela. The most popular route is the Camino Francés, spanning 500 miles (800 km) from southern France. Thousands walk it every year, whether for pleasure or for spiritual fulfillment.

Camino de Santiago

► Find nirvana in Tibet

Tibet's Mount Kailash attracts thousands of pilgrims. Hindus, Buddhists, Jains, and Bonpos all believe that walking around the mountain will bring good fortune. The Kailash Range is a part of the Himalayas, so receiving that blessing takes physical determination!

Mount Kailash

▼ Cypress on along the Via Francigena

The Via Francigena was first mentioned by a Bavarian bishop in 725 CE, as a route for those wishing to visit the Holy See. It starts in the English cathedral city of Canterbury, cutting through four European countries—a 1,000-mile (1,600-km) journey following rural dirt roads and cypress-lined tracks right to the Vatican.

Have a moksha moment in India

Vaishnavite Hindus undertake a pilgrimage known as the Char Dham at least once in their lives. It consists of four sacred sites: Puri in the state of Odisha, Badrinath in Uttrakhand, Dwaraka in Gujarat, and Rameswaram in Tamil Nadu. The journey helps believers achieve *moksha*, a form of self-realization.

▼ Head to Japan if the future seems pil-grim

The Kumano Kodō pilgrimage routes have attracted travelers seeking enlightenment for a thousand years. Spanning Japan's Kii Peninsula, the journey takes you through forests, treacherous mountain passes, and holy Kumano shrines. Like Spain's Camino de Santiago (page 243), it is a UNESCO World Heritage Site.

Via Francigena

Kumano shrine

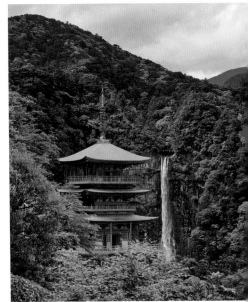

Sneak a peak in Sri Lanka

Adam's Peak is considered sacred by
not one but four religions! Muslims and
Christians believe it bears the footprint
of Adam, left after his exile from the
Garden of Eden; Hindus believe the
mark was left by Lord Shiva; and Buddhists
believe it belongs to Buddha. One thing's
certain—the sunrise seen from the top
is magical!

Bring . . .

Karen Armstrong's *A History of God*

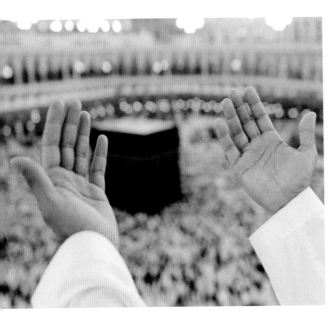

◄ Perform a rite of passage in Saudi Arabia

Millions of Muslims visit Mecca for the annual Hajj. This pilgrimage is one of the Five Pillars of Islam, alongside charitable giving, daily prayers, fasting during Ramadan, and an oath of faith. Hajj occurs during the last month of the Muslim calendar and is a great leveler, bringing together people from all backgrounds.

The Hajj, Mecca

Learn a Lot along the Abraham Path

Abrahamic religions agree on one thing—the prophet Abraham was a paragon of morality. Whether you're Christian, Jewish, Muslim, or you'd simply like to learn more, retrace his footsteps by walking the Abraham Path. It goes from Urfa in Turkey—his birthplace, according to Muslim tradition—to Hebron in Palestine, where he is buried. Don't miss Nablus (right), one of the world's oldest cities.

Bring . . .

modest attire for conservative cities

Celebrate Ashura in Iraq

Although not widely known, Arba'een is one of the world's largest pilgrimage gatherings. It's observed by Shia Muslims, commemorating the martyrdom of the Prophet Muhammad's grandson Husayn. Around 45 million people visit Karbala in Iraq to perform the pilgrimage and pray at the Imam Husayn Shrine, forty days after the Day of Ashura.

> # If you reject the food, ignore the customs, fear the religion and avoid the people, you might better stay at home.

JAMES MICHENER, *American author*

Huar-ry to Peruvian lagoons

The Huaringas are a circuit of fourteen sacred lagoons in the province of Huancabamba. Shamans have performed healing rituals here for centuries— a practice believed to predate colonization by the Spanish. Visit for a touch of Andean mysticism and lush landscapes.

▶ Don't lord it over in Lourdes

Millions of Catholics visit Lourdes in the French Pyrenees every year. They believe that on this site in 1858, the Virgin Mary appeared to Maria Bernada Sobirós—later declared a saint by Pope Pius XI. Pilgrims come to drink from the spring inside the Grotto of Massabielle, to be cleansed of sin, or cured of illness.

A Lourdes volunteer

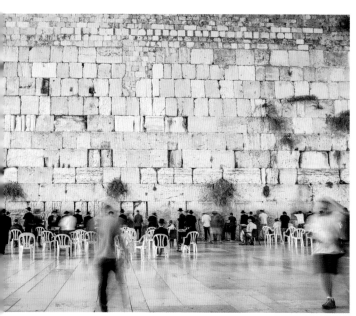

◀ Gotta have faith in Jerusalem

The Hebrew Bible prescribes three annual pilgrimages to Jerusalem—in spring during Passover, followed by Shavuout in summer, then Sukkot in the fall. Most Jews pray at the Western Wall. Muslims consider the nearby Al-Aqsa Mosque their third holiest site, after Mecca and Medina.

Western Wall

◄ Wash your Sinais away in Egypt

Mount Sinai in present-day Egypt is supposedly the site where Moses received the Ten Commandments. Starting at St. Catherine's Monastery, Christian, Jewish, and Muslim pilgrims climb 7,497 ft (2,285 m) to the summit, to visit a mosque, the ruins of a sixteenth-century church, and a Greek Orthodox chapel.

Sinai at dawn

► Feel golden in India

Pilgrimage isn't integral to Sikhism. According to founder Guru Nanak Dev, "God's name is the real pilgrimage place which consists of contemplation of the word of God, and the cultivation of inner knowledge." But Amritsar's Harmandir Saheb—the Golden Temple—has become a pilgrimage site, attracting thousands.

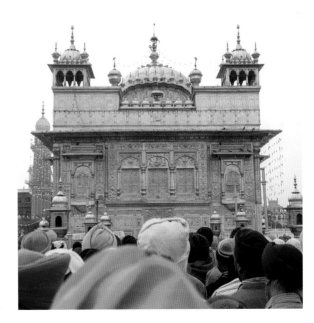

Golden Temple

spiritual zones

▶ Don't bury your feelings in Varanasi

Varanasi is the beating heart of India—no small achievement in a country renowned for spirituality. Thousands of Hindu worshipers walk the city's streets daily, performing funeral rites for loved ones and bathing in the sacred Ganges. Escape the madness inside Kashi Vishwanath (Golden Temple), dedicated to Shiva.

Ganges River

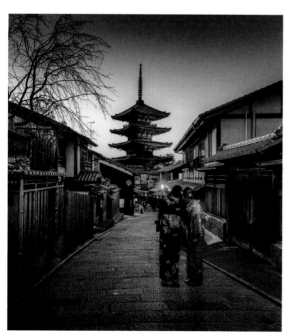

◀ It would be a Shinto skip Kyoto

Japan might be technologically advanced, but it hasn't sacrificed its spiritual roots—particularly in Kyoto, with its Shinto shrines, golden pagodas, and bamboo forests. Don't miss the Fushimi Inari-taisha Shrine, famous for its vermillion walkway, and Kiyomizu-dera Temple, whose roof gets covered with cherry blossoms every spring.

Kyoto locals

A Zen Buddhist retreat week

1 Buddhism in the Highlands

You needn't visit Tibet to immerse yourself in Buddhism. Scotland's Holy Isle is owned by the Samyé Ling Buddhist Community, which run retreats between April and October. This island's spiritual life dates back to the sixth-century hermit, Saint Molaise.

Reading material
Zen and the Art of Motorcycle Maintenance (Robert M. Pirsig)

2 Borobudur is your cup of Java

On the Indonesian island of Java is the ninth-century Buddhist temple of Borobudur, a popular pilgrimage site during Vesak—Buddha's birthday. Its different tiers reflect the three levels of Buddhist cosmology: the world of desire, world of forms, and world of formlessness.

Reading material
Siddhartha (Herman Hesse)

3 You're Bagan love Myanmar's temples

Myanmar's capital between the ninth and thirteenth centuries, Bagan is a cultural treasure chest. Of its original 10,000 Buddhist temples, monasteries, and pagodas, a third still remain. View its extensive network of places of worship from a hot air balloon.

Reading material
The Power of Now (Eckhart Tolle)

4 Raid tombs in Cambodia

You don't need to be Lara Croft to unearth the mysteries of Angkor Wat. At 400 acres (163 hectares), it's the world's largest spiritual complex. Built as a Hindu temple in the twelfth century by Khmer king Suryavarman II, it evolved into a Buddhist sanctuary. Many visitors report a heightened sense of spirituality here.

Reading material
Start Where You Are (Pema Chödrön)

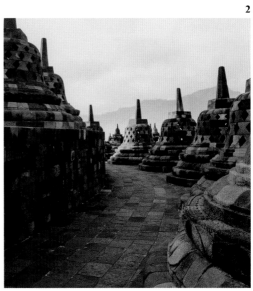

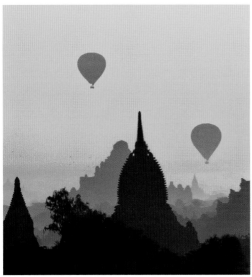

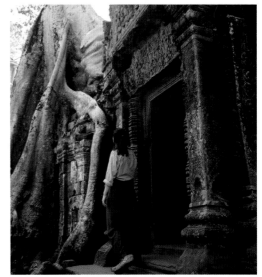

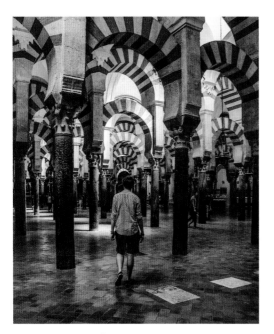

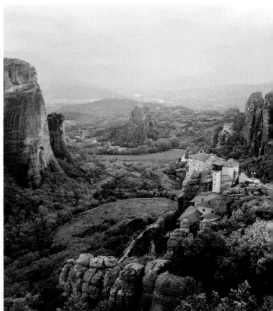

Córdoba's Mosque-Cathedral

Meteora's monasteries

▲ Explore Spain's mixed past

The Mosque-Cathedral of Córdoba has teetered between Christianity and Islam for centuries. In 784, Umayyad prince Abd al-Rahman I converted the original Visigothic structure into a mosque. The Catholic Church made it a cathedral again in 1236. Today, La Mezquita is open to all but only Christians may pray inside.

Channel your inner hippie in Denmark

Freetown Christiania is a hippie commune in Copenhagen. According to its mission statement, its objective is "a self-governing society whereby each and every individual holds themselves responsible over the well-being of the entire community." Founded in 1971, it houses a thousand residents.

▲ Visit the Eyrie in Greece

Meteora is a sprawling complex of Greek Orthodox monasteries, perched on sandstone columns. Six of the original twenty-four still function and house local monks and nuns. This UNESCO World Heritage Site inspired the *Game of Thrones* Eyrie fortress, and has appeared in other classics, from James Bond to Pokémon.

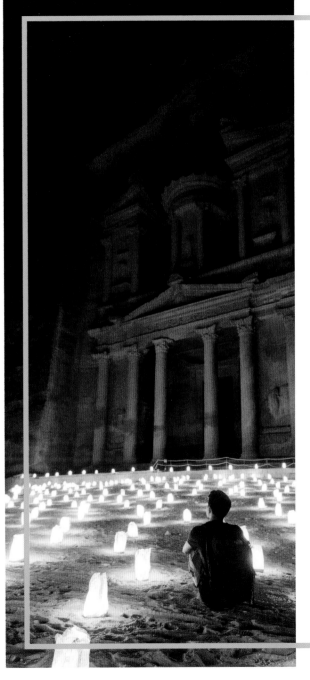

Don't be Petra-fied of visiting Jordan

The desert city of Petra is much more than an *Indiana Jones* filming location. It's the ancient capital of the Nabataean Kingdom. These nomadic Bedouin traders embellished Petra with many buildings, the most spectacular being the sandstone Al-Khazneh (Treasury). Supposedly the mausoleum of ruler Aretas IV, it holds the secrets of this lost metropolis.

When . . .

spring or fall—summer temperatures reach 100°F (38°C)

▼ Downward dog in India

Rishikesh attracts yogis from around the globe, thanks to its reputation as yoga capital of the world. But Hindu sages have been visiting for centuries. Upstream from Rishikesh is Swarg Ashram—a one-stop shop for all your enlightenment needs. Come for the yoga; stay for Ayurvedic wisdom.

Voodoo in NOLA

Voodoo evokes images of black magic and pin-cushion effigies, but there's more to it than voodoo dolls. New Orleans is deeply intertwined with this folk spirituality, originally practiced by enslaved West Africans and deeply rooted in their homeland tradition. Learn more at Marie Laveau's House of Voodoo.

Do monk-y business in Myanmar

Stay at a Buddhist monastery in Myanmar for a night of Dharmic contemplation. Expect no luxuries—most monks bathe outside with cold water and sleep on bamboo mats. But the surroundings certainly compensate, from a mountaintop monastery in Hpa-An to another on the banks of the Irawaddy.

Posing in Rishikesh

▶ Embrace magic in Cappadocia

Exploring the Turkish region of Cappadocia is like traveling to a parallel universe, where houses, churches, and monasteries are carved from stone. Hot air balloons glide by and horses run wild; even the rock formations have an enchanting name—these tuff towers are called fairy chimneys. If you've stopped believing in fairy tales, pay a visit!

Cappadocia's rooftops

◀ Say an Inca-ntation at Lake Titicaca

According to Incan lore, our universe was created by Viracocha, who rose from Lake Titicaca to create the sun, moon, and stars. At the turn of the millenium, archaeologists discovered a giant temple submerged in the lake, adding to its mystery. Perhaps you'll discover the key to Incan mythology here?

Lake Titicaca, Peru

Discover why Lalibela rocks

Lalibela is one of Ethiopia's holiest cities and home to the Church of Saint George, which was cut into the rock, alongside ten others. Built in the twelfth century, they became a pilgrimage site for the Ethiopian Orthodox Tewahedo Church. But anyone can appreciate this magnificent structure—it isn't called the "Eighth Wonder of the World" for nothing!

Bring . . .

a good camera to capture this unique sight

"

Travel makes one modest. You see what a tiny place you occupy in the world.

GUSTAVE FLAUBERT, *French writer*

"

▼ If you're Hampi and you know it clap your hands

In 1500 CE, Hampi was the world's second largest city, rivaled only by Beijing; sixty-five years later it was destroyed in the Battle of Talikota. Luckily its ruins remain; you can visit them in the most spectacular open-air museum you may ever visit. Wander the streets of Hampi, surrounded by hundreds of ancient temples, giant bolders, and lush palm groves.

Welcome the Age of Aquarius in Nimbin

Nimbin entered Australia's consciousness after hosting the 1973 countercultural Aquarius Festival. Many of its 10,000 attendees enjoyed it so much they decided to stay, transforming it into an alternative community. Enjoy psychedelic murals and sustainable cafes, before exploring the Djanbung Gardens permaculture center and the Nimbin Candle Factory.

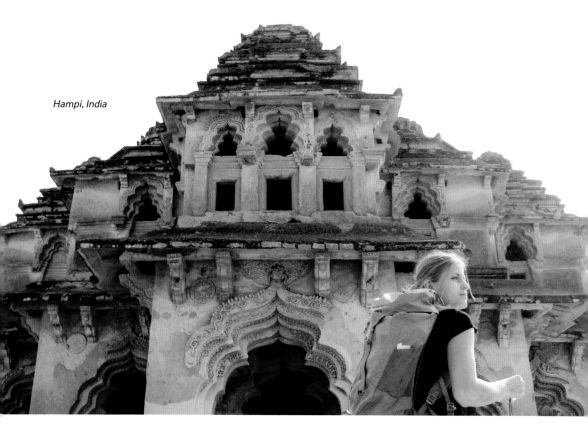

Hampi, India

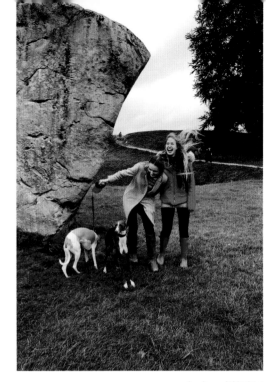

> ## Travel is never a matter of money but of courage.

PAULO COELHO, *Brazilian author*

▶ Leave no stone unturned in Avebury

You've probably heard of Stonehenge, a monument dating back to around 3000 BCE. But visiting this prehistoric landmark can become a hectic experience, so try nearby Avebury. As Britain's largest stone circle it provides space to roam, and it's free.

Avebury, Wiltshire

▶ Look inward in Pakistan

The Islamic tradition of Sufism has a long history in Pakistan. Prioritizing the inner search for God over materialism, Sufis gather at shrines for dhamaal ceremonies, featuring fast-paced dancing and drumming designed to induce a trance-like state. Seek out the Tomb of Shah Rukn-e-Alam in Multan or the Shrine of Lal Shabaz Qalandar in Sehwan Sharif.

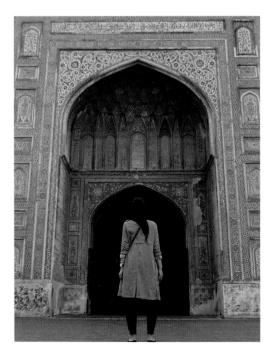

Lahore mosque

train journeys

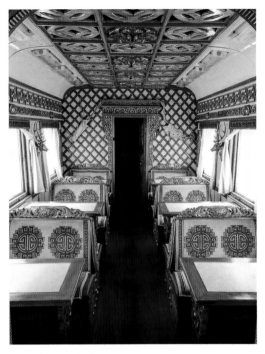

Trans-Siberian Railway

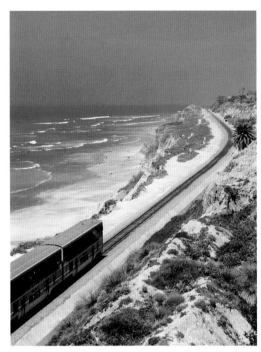

California Zephyr

▲ Travel Trans-Siberian without Russian

The Trans-Siberian features on many bucket lists for obvious reasons—this epic 5,772-mile (9,289-km) journey connects Moscow to Vladivostok, making it the longest railroad in the world. To extend your journey, hop on one of its branch lines, headed to Mongolia, China, or North Korea.

Play make-believe on India's toy train

Kalka–Shimla is one of the three Indian railroads designated a UNESCO World Heritage Site (alongside the Darjeeling Himalayan Railway and Nilgiri Mountain Railway). But the Kalka–Shimla has an advantage—human-size "toy trains" to embellish the mountain vistas.

▲ Fly away on my Zephyr in California

For a new perspective of the US, the California Zephyr travels 2,438 miles (3,924 km), from Chicago to the San Francisco Bay Area. Amtrak's second longest route offers ever-changing scenery, from the lush Colorado River valley to the snowy Sierra Nevada peaks.

◄ Train your sights on the Rupert Rocket

The Canadian Rupert Rocket connects Jasper in the province of Alberta, with Prince Rupert in British Columbia. The trip takes two days, stopping overnight at Prince George. Along the way you'll witness mountainscapes from the Panoramic Dome car, accompanied by commentary and three daily meals.

Rupert Rocket

Potter about in the Highlands

Scotland's West Highland Line from Glasgow to Mallaig is magical in every sense. Potterheads will instantly recognize Glenfinnan Viaduct—where Harry and Ron tried to catch the Hogwarts Express in the Weasleys' flying Ford Anglia. Even if uninterested in wizardry, you'll be charmed by the Highlands' rolling hills.

When . . .

in the fall, for heather- covered hills

▶ Derail your Himalayan trip

Resting at the foothills of the Himalayas, Tibet isn't known for ease of access. But a railroad service connects it to Xining, in China's Qinghai Province. Riding the train to Lhasa will take you through Tanggula— the world's highest railroad station, 16,627 ft (5,068 m) above sea level. You'll also see miles of frozen landscapes and an incredible 675 bridges.

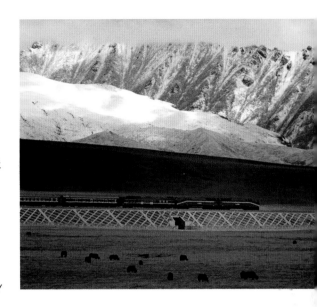

Quinzang–Tibet Railway

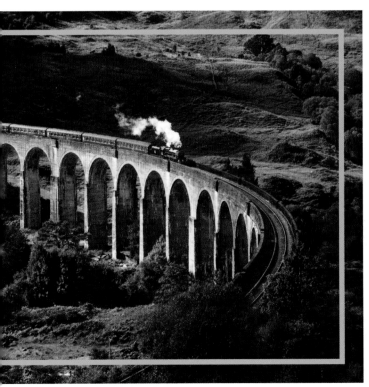

Take a brake on the Rauma Line

Norway's Rauma Line, between Åndalsnes and Dombås, may not be long, but it is spectacular. Spend 90 minutes viewing towering mountains and the green wilderness of Reinheimen National Park. Grab your camera as you approach Kylling Bridge and the Troll Wall—Europe's tallest vertical mountain wall.

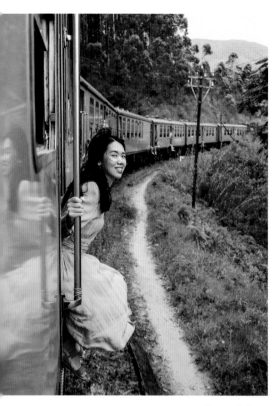

◄ Look for eye Kandy in Sri Lanka

The railroad connecting Ella and Kandy has become an Instagram sensation—scroll hard enough and you'll probably find a variation of this photo in your newsfeed. All you need for this journey across Sri Lanka is five hours and a couple of dollars. Do take extreme care when dangling your legs outside!

Burma Railway

> We wander for distraction, but we travel for fulfilment.

HILAIRE BELLOC, *British-French writer*

◄ Lose your train of thought on the Indian Pacific

Australia's Indian Pacific is a transcontinental affair, connecting Perth and Sydney—from the Indian Ocean to the Pacific. It comprises the world's longest straight stretch of track: 297 miles (478 km) across the Nullarbor. Taking seventy-five hours, it's a great opportunity to finish all those unread books.

Indian Pacific

▶ Get on the right track in Switzerland

St. Moritz and Zermatt are two famous Swiss mountain resorts, connected by the Glacier Express. The journey takes 7.5 hours, incorporating 291 bridges, 91 tunnels, and the 6,706-ft (2,044-m) high Oberalp Pass. You'll even pass the Matterhorn—the world's most photographed mountain (see page 184).

Pay your respects on the Death Railway

The 1943 Burma Railway was built by Japan, with the labor of a quarter-million South Asian civilians and Allied POWs, 100,000 dying in the process. The route is now a third of its original length, connecting Nong Pla Duk and Nam Tok in Thailand.

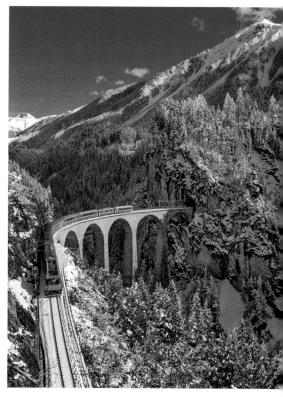

Glacier Express

◀ Explore olive the Douro Valley by rail

Time-travel to the 1900s by catching the old train from Porto to the Douro Valley. This half-day trip enters the heart of Portugal's wine country. The region has a microclimate ideal for growing olives, almonds, and the grapes used to make port wine.

Pinhão, Portugal

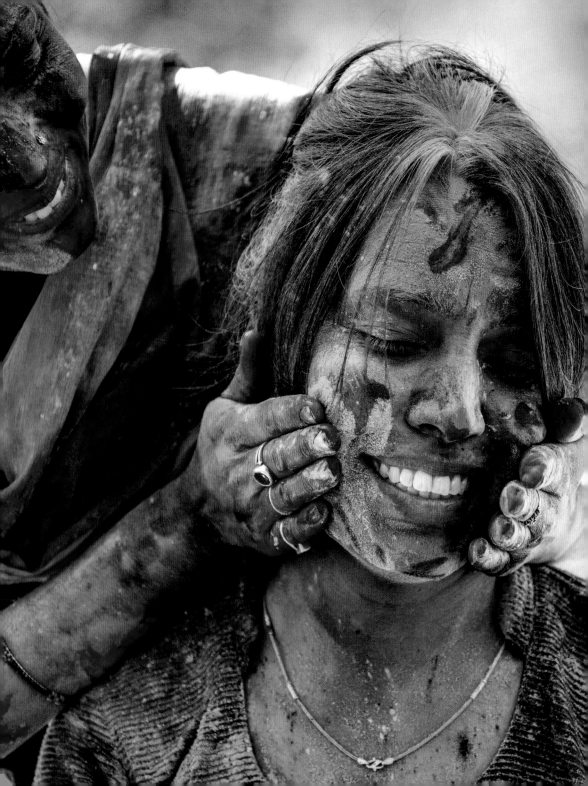

6
Postcards from the Edge

#adrenaline

▶ Improve glacial awareness in Pakistan

Pakistan isn't the obvious choice for glacier walking, but it should be. You'll find the impressive Batura and Passu glaciers in the Hunza Valley, bordering Afghanistan and China. This mountainous region, complete with alpine roses and juniper trees, is also home to the Burusho, an isolated community renowned for its longevity.

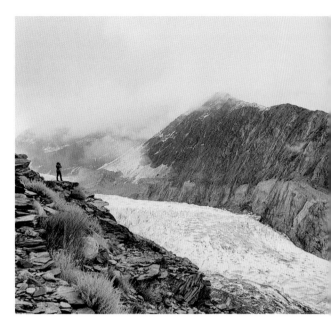

Glacier walking, Pakistan

◀ Learn why Queenstown is a shoe-in

To enjoy New Zealand's snowy plains in isolation, try snowshoeing. With hidden valleys, frozen lakes, and white-capped mountains as far as the eye can see, Queenstown is perfect for this special form of hiking. For a unique experience, try heli-snowshoeing—combining your exploration with a scenic helicopter flight.

Snowshoeing, Queenstown

Paragliding, Turkey

Bungee jumping, Pentecost Island

▲ Fly off the handle in Ölüdeniz

If your dream superpower is flight, paragliding is the perfect sport for you. Visit Ölüdeniz in Turkey to experience one of the world's highest commercial take-off sites—off the 6,500-ft (1,981-m) Babadag Mountain—overlooking the stunning Blue Lagoon. To watch professionals, time your visit to coincide with the International Air Games.

Follow in Thor's footsteps in Scotland

The Scottish Highland Games are a unique sporting event. With disciplines such as hammer throwing, caber tossing, and archery, this Celtic celebration will make you feel like a Norse deity—or at least, fearless Disney princess Merida. Aberdeenshire's Braemar Gathering is one of the most renowned games; the Cowal Highland Gathering is the largest.

▲ Get swept off your feet in Vanuatu

You'll find bungee jumping spots anywhere, but this adrenaline-fueled activity was invented in Vanuatu. It was originally a rite of passage performed by young men jumping off a tower, between 66 and 98 ft (20–30 m) high, with just tree vines around their ankles for safety. Head to Pentecost Island to sample the safer, contemporary version.

◀ Roll on the good times in Rotorua

Invented in New Zealand in 1994, zorbing has spread around the world. But there can only be one original, so visit Rotorua on the North Island for the ultimate experience. For the uninitiated, zorbing involves climbing inside a transparent ball and rolling down a hill. After your exertions, relax in the Waikite Valley's mud pools.

Rotorua zorbing

▶ Get in the car in Qatar

Doha's ultramodern skyline is impressive, but a short drive will leave the skyscrapers in your rearview mirror, replacing them with the stillness of the Qatari Desert. Join locals taking to the sand on the weekend in powerful four-wheel drives— an adrenaline-fueled activity called dune bashing. To feel the sun on your skin, try sandboarding instead.

Sandboarding, Qatar

◄ Dive into Dubai

If leaping from a plane at 13,000 ft
(3,960 m) appeals, try Skydive Dubai.
You'll ascend in a plane, before freefalling
at 120 mph (190 kmh), enjoying bird's-eye
views of Palm Jumeirah island. They also
offer desert jumps, so you can admire dunes
from a new perspective. If tandem skydives
aren't crazy enough, there's always
wingsuiting and BASE jumping.

Skydive Dubai

Coast through life at Cedar Point

If you like roller coasters,
you'll love this Ohio
amusement park. It opened
as a bathing beach and
beer garden in 1870, but
flourished in the 1960s.
The 364-acre (147-hecatre)
park now features 72 rides,
including six roller coasters
taller than 200 ft (60 m).
To increase the fear
factor, go for the October/
November horror-themed
HalloWeekends.

► Horse around in Kyrgyzstan

For days in the saddle
and nights in a yurt, head
to Kyrgyzstan. This central
Asian country isn't
attracting crowds yet, so
take the opportunity to
explore its wilderness
undisturbed. Admire
the imposing Tian Shan
Mountains, bathe in hot
springs, and ride past
the shores of Issyk-kul,
one of our planet's largest
mountain lakes.

Horse-trekking, Kyrgyzstan

▶ Reignite your spark in Italy

Mount Etna is Europe's most active volcano, lighting up Sicily's night sky with bursts of lava. If you're brave, climb to the summit—currently an impressive 10,912 ft (3,326 m) above sea level. Alternatively, take the cable car that runs between 9 A.M. and sunset—but what's the fun in that? Bring warm clothes, sturdy boots, and snacks.

Mount Etna

> ❝
>
> # I travel because seeing photos in brochures wasn't good enough for me. It was to be there, that was everything.

WIREMU RATCLIFFE,
#WhyWeTravel

❞

▶ Never get board in Los Angeles

Head to Venice Beach to soak up quintessential California vibes. This seaside resort will introduce you to an eclectic mix of characters— laidback skater boys and girls, tattooed bodybuilders, and larger-than-life eccentrics. Wealth and modesty, youth and age, health and troubles coexist on this stretch of coastline—a microcosm revealing the contradictions of modern-day America.

Venice Beach

◀ You Huashan't look down in Xi'an

If the rickety plank walk on China's Huashan looks insane, that's because it is! Located an hour from Xi'an, it consists of thin wooden planks bolted into a 7,000-ft (2,134-m) mountainside—understandably dubbed the most dangerous trail in the world. Your guide will check your harness so you can safely reach the chess pavilion on the summit.

Huashan plank walk

Dinner in the Sky

Rickshaw Run

▲ Feel the suspense in Belgium

Dining isn't exactly an adrenaline activity, but how about at a table 100 ft (30 m) in the air? Dinner in the Sky elevates gastronomy to new heights, with a combination of cranes and innovative dishes prepared by chefs right in front of you. The concept developed in Belgium, but has spread globally.

Stare death in the eyes in Bolivia

Bolivia's Death Road is a thrill-seeker's dream. The 40-mile (64-km) path from La Paz to Coroico was cut into the Cordillera Oriental mountain chain in the 1930s. More than 25,000 riders brave it every year, but with 1,500-ft (457-m) vertical drops and no guard rails, it's strictly for experienced cyclists.

▲ Have a naan stop adventure in India

The first Rickshaw Run took place in December 2006, with thirty-four teams racing across India in tuk-tuks. It now attracts thousands, driving rickshaws across 3,000 miles (4,828 km) of rough roads, mountains, and deserts. There are three events a year, connecting Kochi and Jaisalmer.

"
Life is either a daring adventure, or nothing at all.

HELEN KELLER, *American author*

"

Cry for Alp in Tyrol

You needn't be a seasoned climber to conquer Austria's Tyrolean peaks. A *via ferrata* is a protected climbing route, flanked by a steel cable. All you need is a set of carabiners to attach to it. If you're a beginner, choose an A or B difficulty rating—leave the Es to hardened mountaineers!

Bring . . .

a GoPro to capture the action

▶ Rock your trip to Yosemite

If *Free Solo* enticed you to try climbing—good news. El Capitan may be reserved for top climbers, but Yosemite National Park is full of beginner-friendly spots. The Yosemite Mountaineering School runs classes in Half Dome Village and Tuolumne Meadows. Relax your muscles afterward in the Merced River.

Yosemite National Park

◀ Have snow much fun in Argentina

Zip past snowy forests and frozen lakes on a Patagonian snowmobile safari. This sparsely populated region between Argentina and Chile may not be the obvious choice for cold-weather adventure, but it's a winter wonderland. You can also try snowmobiling in Finland, Canada, or Montana's Glacier Country.

Patagonian snowmobiling

▶ Go off-piste in Switzerland

If staying on piste no longer thrills you, kick it up a considerable notch with a day of heli-skiing, accessing untouched slopes via helicopter. The reward? Virgin snow and complete solitude. Try it in Zermatt for some of the world's longest Alpine runs. Heli-skiing certainly doesn't come cheap, but it's an undeniable thrill.

Heli-skiing

◀ Toboggan in Madeira

Sledding needn't be confined to winter—on the Portuguese island of Madeira it happens year-round. Head to the capital Funchal to try the Monte sledge, dating to the 1850s. Once a form of public transportation, these wicker toboggans reach 30 mph (48 kmh)! Once you're downhill safely, explore the rest of this European archipelago, with its volcanic cliffs and lush valleys.

The Monte Sledge

#wild waters

◄ Live life on the edge in Zambia

The Devil's Pool swimming hole sits by one of the world's biggest waterfalls, Victoria Falls. If you're feeling brave, let the current take you all the way to the edge! The pool is usually open from mid-August to mid-January, depending on the Zambezi River's water levels.

Devil's Pool

► Have a 007 moment in New York

Whipping across water on a jet ski makes you feel like a movie star, no matter where you are. But hurtling toward the Statue of Liberty at 65 mph (105 kmh) is an experience of epic proportions. The Manhattan tour with Sea the City lasts 2.5 hours and provides unforgettable views of New York's iconic skyline.

Sea the City

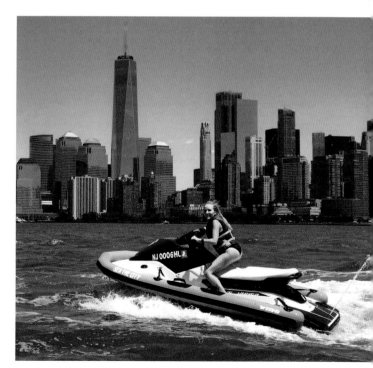

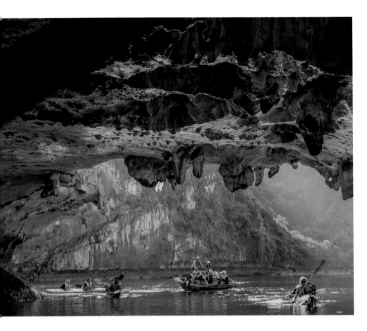

◄ Cave in at Son Doong

Vietnam's Son Doong is ideal for caving. Simply saying it's the biggest cave in the world doesn't do it justice. It has its own localized weather system, it contains a jungle and a river, and you could fit a 40-story skyscraper inside it! Take a dip inside the passage of the Hang Va for the best swim of your life.

Son Doong

Feel wind in your sail in Sri Lanka

Kalpitiya may not be on your travel list, but kitesurfers wouldn't miss it. Two hours north of Colombo, its uncrowded lagoons allow beginners to practice in peace. Once underway, you can progress to the waves of the Indian Ocean. Optimal weather conditions are between May and October, or December through March.

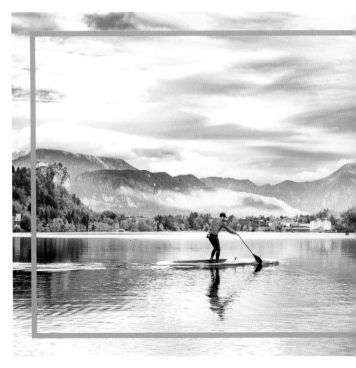

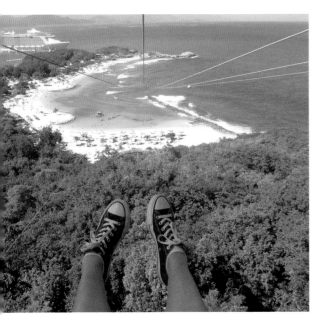

◄ Don't Haiti on ziplining

Adrenaline fiends might consider ziplining too vanilla. But at 2,600 ft (792 m), Haiti's Dragon's Breath Flight Line—the world's longest over-water zipline—definitely gets your heart racing. Labadee is a private Royal Caribbean port, so the zipline is only accessible to cruise-goers. Not your style? Try Ontario's MistRider Zipline, taking you right toward Niagara Falls.

Ziplining, Haiti

Stand up for yourself in Slovenia

Stand up paddleboarding (SUPing) has gained a lot of traction recently, but its roots extend back to Hawaii in the 1900s. This fun offshoot of surfing is incredibly versatile—possible on lakes, canals, ocean waves, and river rapids. For an offbeat experience try tiny but water-rich Slovenia—particularly Lake Bled and Triglav National Park.

When . . .

in the fall, for European fairy-tale vibes

▶ Push the boat out in Baja California

Kayaking is a peaceful affair. But throw a school of gray whales into the mix and it gets pretty exciting! Although close encounters can never be guaranteed, kayaking in Mexico's Baja California is a rare opportunity to paddle among these giants. Between January and April, try cruising the shallow creeks of Magdalena Bay.

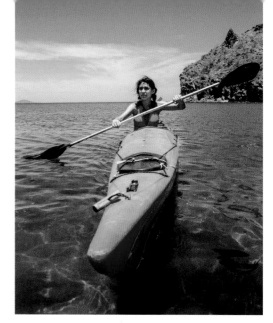

Kayaking, Baja California

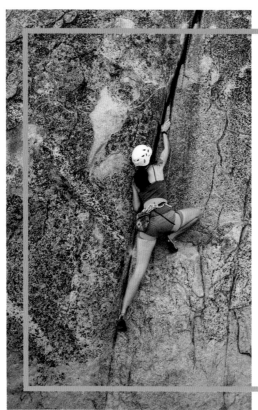

Have a cliff-hanger in Guatemala

Rappelling is far from mainstream, so here's a short description . . . You're dangling 100 ft (30 m) above ground with nothing but a rope for support, slowly descending a vertical cliff. If that doesn't sound crazy enough, try canyoning— rappelling down a waterfall! Guatemala's Santa Rosa waterfall is a top spot.

When . . .

the dry season, November to April

▶ Throw caution to the wind in Bonaire

Less than 100 miles (160 km) off the coast of Venezuela, Bonaire is one of the world's best windsurfing spots. Shallow, sheltered Lac Bay, with favorable winds and turquoise waters, suits both beginners and veterans. The bay hosts the Defi Wind Caribbean and Sorobon Masters windsurfing competition, so you can watch and learn.

Windsurfing, Bonaire

Sail close to the wind in Saint Lucia

Join the Atlantic Rally for Cruisers and sail 2,700 nautical miles across the Atlantic, from Gran Canaria to Saint Lucia in the Caribbean. This event attracts more than a thousand participants, from veterans to families. The crossing takes eighteen to twenty-one days, but speed isn't key. It's about crossing an ocean in a small boat and forming friendships with fellow sailors.

Live in de-Nile in Uganda

Jinja is the historic source of the Nile, and one of East Africa's best destinations for adrenaline lovers. Try quad biking, kayaking, or horseback riding, or the region's biggest draw—white-water rafting. Spend the night in a tent overlooking the Nile at Explorers River Camp, before joining their class 5 rafting expedition. With rapids and currents, it's not for the faint-hearted.

Dive headfirst into Oman

Cliff diving is not for the timid. It takes a dose of courage and a dash of madness. But if you really want to get your adrenaline racing, head to Wadi Shab in Oman. Its natural pools are surrounded by towering red cliffs, practically made for jumping. The finals of the 2012 Red Bull Cliff Diving Series were held here. Make sure you assess the depth of the water before you take the leap.

#abandoned places

◄ Find your Seoul-mate in South Korea

Yongma Land is an amusement park in Seoul, complete with a merry-go-round and bumper cars. The only problem? It was abandoned in 2011 due to low visitor numbers and left to the elements, all its attractions seemingly frozen mid-thought. You can explore the grounds for a fee of 10,000 won per day—if you're lucky, the owner might even turn on the carousel lights for you.

Yongma Land

► Hide in plane sight in Bali

Bali is home to not one but two abandoned planes! The first sits on the south of the Bukit Peninsula. No one knows how it got there, but apparently it was supposed to become a restaurant before its developers ran out of money. The other is 5 miles (8 km) away, in South Kuta—a Boeing 747 parked next to a Dunkin' Donuts store.

Bukit Peninsula

Enjoy China with abandon

Dotted around China are hundreds of state-of-the-art cities, perfect in every way but one—nobody's home! The most famous of these ghost towns is Ordos Kangbashi in Inner Mongolia, built to house 300,000. Contrary to popular belief, it's inhabited (in the tens of thousands) but it still feels deserted.

Bring . . .

a friend,
for company!

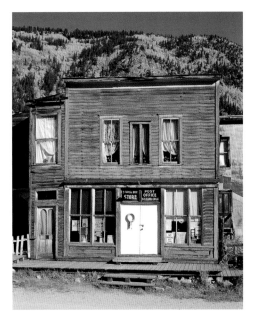

St. Elmo

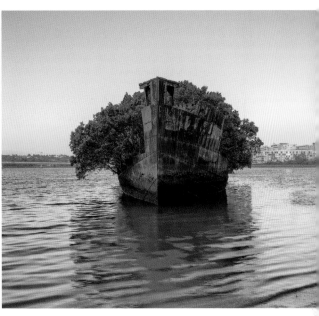

SS Ayrfield

▲ Have a rad time in Colorado

Ghost towns are a dime a dozen in the US, with more than 600 in Colorado alone. Some are just crumbling foundations, but not St. Elmo. Gold and silver miners settled here, recovering $60 million worth of gold, before departing in the 1920s. Frozen in time, St. Elmo is also known for high levels of paranormal activity.

Get pumped up in London

Peek inside some of the British capital's most interesting buildings during September's Open House London weekend. This "architecture festival" provides free access to around 800 buildings that are otherwise off-limits. Abbey Mills Pumping Station is one example—a historical building that featured in *Batman Begins*.

▲ No forest for the wicked in Australia

Ever wondered what a cross between a centenarian ship and a mangrove forest would look like? The 1,140-ton SS *Ayrfield* was left in Homebush Bay after World War II and nature has been reclaiming it ever since. You can visit the Floating Forest year-round, opposite the Archery Centre at the Sydney Olympic Park.

Go on an af-Ford-able trip to Brazil

Henry Ford was a businessman extraordinaire, and a visionary—he wanted to construct a utopian city in the Amazonian jungles of Brazil. But building Fordlândia proved harder than anticipated and the project was scrapped in 1934. You can still visit the abandoned rubber production plant, including a 150-ft (46-m) water tower and the Vila Americana neighborhood. Fordlândia is accessible by boat from the port of Santarem.

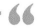

Do not stop thinking of life as an adventure.

ELEANOR ROOSEVELT

Raise the devil in Germany

There is an abandoned listening station atop Teufelsberg ("Devil's Mountain"); shrouded in mist and dark forest, it sends shivers down your spine in any weather. During the Cold War, Teufelsberg was an important spy outpost. Nowadays, it's a go-to spot for street artists visiting Berlin.

◄ Walk the sands of time in Namibia

In the early twentieth century, Kolmanskop housed a lively diamond-mining community, with its own movie theater and casino. But as supplies dried up, the population dwindled. Most of the buildings are now flooded with knee-deep sand. You need a permit to enter, but this desert ghost town is worth the effort.

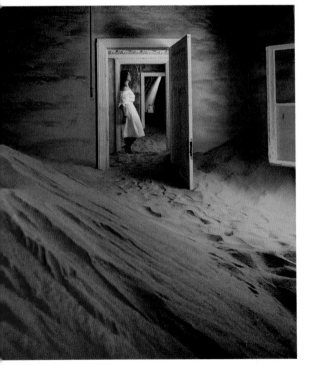

Deserted Kolmanskop

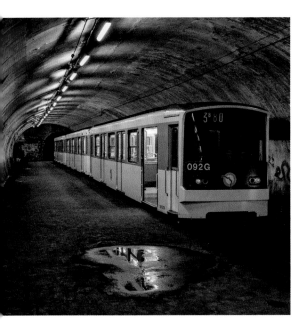

◄ Get to the heart of the Métro in Paris

The Paris Métro has a dirty little secret, in the form of several abandoned stations. Haxo was abandoned after construction; it lies on an unused branch between lines 3bis and 7bis, but you can't access it from the street—the exit was never built. Haxo is now popular among graffitists, who have covered the tunnel in colorful drawings.

Haxo station

► Face the brink of disaster in Pripyat

Three decades have passed since Ukraine's 1986 nuclear disaster, but as drama series *Chernobyl* demonstrates, the memory survives. The abandoned town of Pripyat opened to tourism in 2011, allowing visitors to explore the 18-mile (29-km) exclusion zone. Guides carry Geiger counters to monitor radiation levels, but the amount you'll be exposed to is similar to one long-haul flight.

Abandoned Pripyat

party festivals

▶ Have a Rio good time in Brazil

There is nothing quite like Rio de Janeiro's Carnival. Dating to 1723, it attracts 2 million attendees every year. From elaborate costumes to garishly decorated floats, it's a feast for the eyes. Whether you're a talented dancer or have two left feet, you won't be able to resist the upbeat samba rhythms!

Rio Carnival

◀ Let the good times roll in New Orleans

Traditionally, Mardi Gras ("Fat Tuesday") was about using up rich foods before Lent. But New Orleans has taken it to the next level, in a way that befits the moniker. Prepare for a hedonistic night of tricolored king cakes, float parades, and cheap bead necklaces. If you're lucky, you might even catch one of the beloved Zulu coconuts!

Mardi Gras, New Orleans

Chill out at Snowbombing

What's cooler than being cool? Ice cold! Head to the Austrian town of Mayrhofen for the annual Snowbombing festival—a wild show on snow established in 1999, offering famous DJs, igloo raves, and mountaintop yoga. Hitch a ride up the mountain in a gondola and enjoy the craziest après ski session of your life.

Get . . .

**winter sports
travel insurance**

St. Patrick's Day, Dublin

Holi colors

▲ Try your luck in Dublin

In theory, St. Patrick's Day is a religious celebration commemorating the death of Ireland's patron saint. In practice, it's a wild night of live music, green attire, and indulgence. Head to Dublin on March 17 for this quintessentially Irish experience. Alternatively, try Chicago, across the pond, where even the river turns green!

Get a superhero's welcome in San Diego

Comic-Con may not be a festival in the traditional sense, but this celebration of all things nerdy deserves a shoutout. It began in the 1970s, allowing fans to meet their favorite comic writers, video game makers, and TV directors under one roof. If you don't love comics or anime, you might still enjoy panels held to promote programs like *Westworld*.

▲ Get Delhi-rious at Holi

The ancient Hindu festival of Holi has become popular in the Western world for its colorful rituals. Anyone is fair game in this good-natured fight, where strangers spray each other with water guns and get covered in bright powders. But there's a serious side to it. The night before, Hindus commemorate the burning of demon Holika.

▼ Come back from the dead in Mexico

Skip the trick or treating this Halloween and head to Mexico City for Día de Muertos, or Day of the Dead. This public holiday may sound morbid but it's a fun affair! Families build elaborate altars called *ofrendas*, decorating them with sugar skulls, flowers, and delicious offerings, before sharing heart-warming stories about departed loved ones. The event traces its origins to an Aztec festival.

Stick it to the man in Nevada

Burning Man began in San Francisco in 1986. Built around principles of artistic self-expression, community, and civic responsibility, it started as a liberating getaway for bohemian souls. It is now highly commercialized, with celebrities and digital influencers in attendance, but you may find its original spirit at one of its offshoots, including Nowhere in Spain and AfrikaBurn in South Africa.

Day of the Dead, Mexico

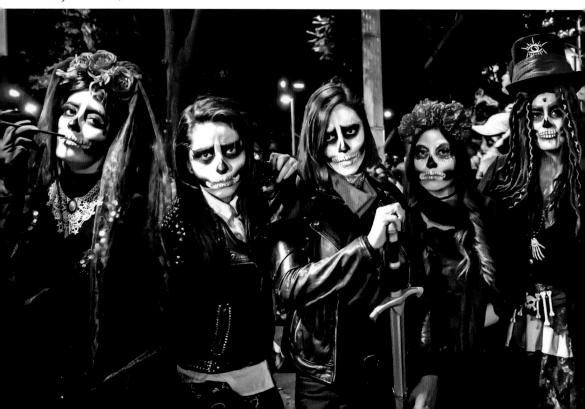

▶ Ring in the New Year at Hogmanay

To welcome the new year in style, head to Edinburgh. Hogmanay—the old Scots word for the last day of the year—is all about celebrating the Scottish way. That means bagpipes, ceilidh dancing, whiskey, and lots of deep-fried food. If you're feeling bold, complete your night with a Loony Dook—a dip in the cold waters of the Firth of Forth.

Hogmanay in Edinburgh

◀ Live for Tomorrowland in Belgium

Tomorrowland is one of the world's most popular music festivals. If you'd like to attend this EDM bonanza next year, subscribe to their newsletter— tickets sell out within minutes. Past performers include DJs David Guetta, Avicii, and Armin van Buuren. Start stockpiling glow sticks and glitter so you're ready to unleash your inner party animal next July!

Belgium's Tomorrowland

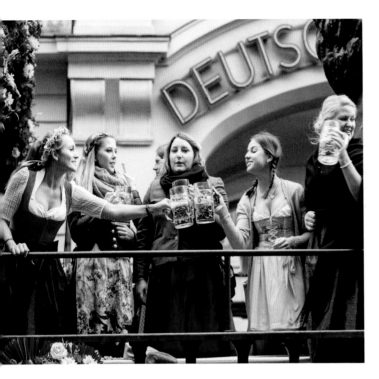

◄ Prepare for the wurst at Oktoberfest

The Munich Oktoberfest may be the world's biggest folk festival. Over the course of two weeks, this German celebration attracts 6 million beer-drinking, pretzel-eating visitors. There are also parades, fairground rides, and lots of dancing. Book months in advance and don't forget to bring a pair of lederhosen or a Bavarian dirndl.

Munich's Oktoberfest

► Get down and dirty in South Korea

The annual mud festival in Boryeong was developed to market locally produced mud cosmetics. The exercise has paid off—more than 2 million visitors attend every year, slinging mud at anyone who crosses their path. The good news is that Boryeong mud is full of healing minerals that will make your skin glow . . . if you can wash it off.

Boryeong mud slinging

Dance like it's Notting in London

When the Notting Hill Carnival was first held in 1966, it was a small affair attended by 500 members of the local West Indian community. It has since become a staple in London's summer calendar, attracting over a million people in one weekend. Expect plenty of dancing, sequin-studded costumes, and Caribbean street fare. Prepare for a party that goes on until dawn!

When . . .

August—bank holiday Monday and the preceding Sunday

Spend the day at a wild Spanish festival

1 Play with fire at Las Fallas

Valencia honors Saint Joseph, patron saint of carpenters, with a festival called Fallas. Neighborhoods create large papier-mâché statues, often satirizing current events, which are burnt in a huge bonfire on March 19. UNESCO includes the celebration on its Intangible Cultural Heritage List.

When to go
During the Feast of Saint Joseph in March

2 Stop wining—start living in Haro

Move over water guns, it's all about the wine jugs! To honor patron saint San Pedro, the inhabitants of Haro in the Spanish Rioja region stage a wine fight known as Batalla de Vino. Come to witness this bacchanalian free-for-all, during which strangers throw bucketfuls of wine on each other.

When to go
June 29, the day of San Pedro

3 Jump start in Castrillo de Murcia

Would you let costumed men put your baby on the floor and take turns jumping over it? A bizarre question perhaps, but one that women from Castrillo de Murcia have asked themselves since the seventeenth century. The celebration traces its roots to a pagan fertility ritual.

When to go
The first Sunday after Corpus Christi

4 Take an aim at La Tomatina

Take revenge on everyone who told you not to play with your food when you were a child by attending La Tomatina. This is the world's biggest food fight, transforming the sleepy Buñol in Valencia into a tomato-filled war zone. Tickets are limited to 20,000 so mark the event in your calendar.

When to go
The last Wednesday of August

1

2

3

4

◄ Phuket your problems at Songkran

Songkran is a celebration of the Thai New Year. To commemorate this fresh beginning, locals purify themselves with water—but not how you'd imagine. Young and old, rich and poor take to the streets for the largest annual water fight in the world. Thousands of tourists travel to join the fun, turning this religious festival into a street party.

Songkran water fight

► Party-cipate at Glastonbury in England

You'd struggle to find a Brit who's never heard of Glastonbury. The five-day event has become a staple on the festival scene, featuring everything from pop stars to comedy, theater, and circus acts. Staffed mainly by volunteers, it's raised millions for charity. Get ready to camp in a muddy field and dance your head off to tunes by the likes of Kylie Minogue and the Killers.

Glastonbury's Metamorphosis Show

Orange is the new black in Amsterdam

Think your last birthday bash was the bomb? Dutch King Willem-Alexander celebrates his birthday along with the whole population, plus a million tourists! On King's Day, April 27, the country gets the day off to join in—dressed in orange to honor the royal family, the House of Orange-Nassau.

Practice your Southern charm in Austin

SXSW (South by Southwest) is hard to describe. Founded in Austin in 1987, it's where creative souls gather to exchange ideas. The festival covers music, film, comedy, gaming, and interactive content, together with conferences on additional topics, from fashion to sport and tech.

▶ Desert the ordinary at Coachella

The inaugural Coachella Valley Music and Arts Festival took place after the conclusion of Woodstock '99. Much like that festival, it has become one of the defining events of a generation, as a quick scroll through your Instagram timeline in April will prove. In addition to sets by artists like Beyoncé or Eminem, you'll find art installations scattered throughout.

Coachella Festival

#unsolved mysteries

▶ Draw a line in the sand in Peru

Peru's Nazca Lines are one of our planet's biggest head scratchers. These geoglyphs depicting animals and plants can only be seen from the air due to their size—some measure up to 30 miles (48 km). Despite extensive study, they are still a mystery. All we know is that they were etched by a pre-Inca civilization between 500 BCE and 500 CE.

Nazca Lines

◀ Bare your fangs in Transylvania

Don't let *Twilight* fool you—vampires are as terrifying as they are ancient. This is particularly true of Bram Stoker's Dracula, a character based on the fifteenth-century Wallachian ruler Vlad Tepes, who allegedly impaled 80,000 enemies. If you're feeling brave, visit the haunted halls of his home, Bran Castle, for spooky fun.

Bran Castle, Romania

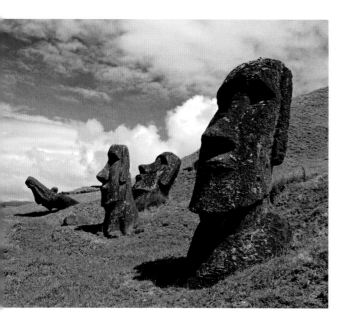

◄ Come back for moai in Rapa Nui

Rapa Nui, or Easter Island, is a remote Polynesian island shrouded in intrigue and guarded by nearly 900 enormous volcanic rock figures (*moai*). They were built by seafarers who came here 1,200 years ago, but no one is sure what they represent. To see them first hand, fly to the island from Santiago or Tahiti.

Rapa Nui figures

► Drop it like it's hot in Turkmenistan

In the middle of the Karakum Desert, north of the capital Ashgabat, is the mysterious Darvaza gas crater, or Gate to Hell. This otherworldly site is a result of a Soviet-era experiment, during which a natural gas field collapsed into an underground cavern. The fire began in 1971 and no one knows when it'll stop.

Gate to Hell

◄ Have a ball in Costa Rica

Costa Rica's enigmatic stone spheres were discovered by United Fruit Company's workers clearing the jungle for banana plantations. Many were destroyed with dynamite after false rumors of hidden gold, and some became prized lawn ornaments, but around 300 remain scattered across the Diquís Delta.

Diquís spheres

► Question society's origins in Turkey

Göbekli Tepe in southeastern Turkey may be the oldest temple ever discovered—possibly dating to the tenth millennium BCE, making it at least 7,000 years older than the Giza pyramids (see page 310). Archaeologists are still excavating, but you can visit on a day tour. Nearby Şanlıurfa Museum displays their findings.

Göbekli Tepe

Solve ancient mysteries in Egypt

Head to Cairo to witness the famous pyramids. We know they were built as tombs for the pharaohs—it's the how that continues to baffle scientists. The Great Pyramid of Giza is the most famous, measuring an impressive 481 ft (147 m). It held its title as the world's tallest building for 3,800 years!

Bring . . .

Kara Cooney's
When Women Ruled the World: Six Queens of Egypt

▶ Explore outer space in Area 51

Tucked away in the Nevada desert lies Area 51—a highly classified military base that is a magnet for alien theorists who believe it's hiding the remnants of crashed UFOs. You can't visit the facility, but you can drive down State Highway 375 (the Extraterrestrial Highway) and stay at the alien-themed Little A'Le'Inn.

Alien accommodation

◀ Start a Star War in Ireland

Jutting out of the sea near the Irish coast is Skellig Michael— home to a medieval monastery. Built in 588 CE, its remoteness discouraged all but the most dedicated pilgrims, leaving it exceptionally well preserved. The tiny crag island also served as a *Star Wars* movie location.

Skellig Michael

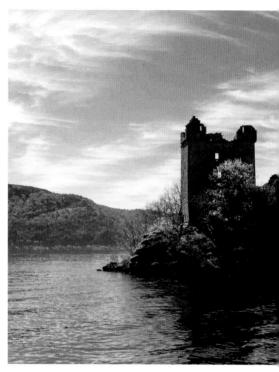

Chichen Itza

Loch Ness

▲ Don't Honduras-timate the Mayans

Mexico's Chichen Itza is a Wonder of the World, and always worth a visit. Alternatively, there are Mayan ruins dotted across Central America, allowing you to dodge the crowds at the region's most visited sites. Head to the smaller but impressive Copán Ruinas in Honduras. Once you've admired this ancient civilization's architectural prowess, stroll through the cobblestoned streets of nearby Copán and meet today's locals.

▲ Have a monster holiday in Scotland

Few mythical creatures enjoy the notoriety of the Loch Ness monster, believed to inhabit the depths of this beautiful Scottish lake. Kick off your visit with some Nessie spotting before exploring the dramatic Highlands scenery, with its solitary castles and heather-covered Munros (peaks topping 3,000 ft/914 m). Nearby Inverness is the region's cultural capital, with its cathedral and sprawling indoor food market.

Plain a trip to Laos

The words "plain" and "jars" don't scream intrigue, but join them and you get one of Southeast Asia's most fascinating sites. Laos's Plain of Jars dates to the Iron Age and was used by inhabitants in burial practices. Only a small portion of this UNESCO monument can be visited because the area was bombed during the Vietnam War, but affordable tours are available from Phosavan.

He who would travel happily must travel light.

ANTOINE DE SAINT-EXUPÉRY,
French writer

▶ Build castles in the air in Florida

Coral Castle in Florida's Homestead is a limestone home that was built single-handedly by Ed Leedskalnin, a 5-ft (1.5-m) tall Latvian immigrant. How did he move 1,100 tons of rock? Apparently he solved the building secrets of the Egyptians!

Coral Castle

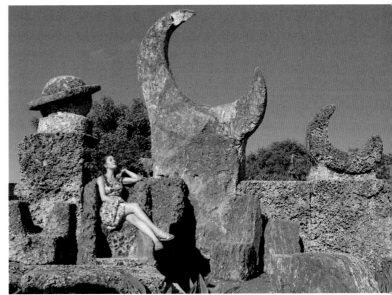

#index

#index

#index

About the Author

Sabina Trojanova is a writer, photographer, and adventurer. She's the creator of Girl vs. Globe—an online community whose aim is to inspire women to be kind to themselves and others around them. With an academic background in political science, Sabina is passionate about refugee rights, sustainability, and equality, regardless of one's gender, income, or religion. She believes travel has the power to promote tolerance and break down barriers. She has lived in five countries, visited fifty so far, and is fluent in four languages. She currently lives in London, UK.

Acknowledgments

Although #wanderlust only has my name on the cover, don't let that fool you—this book was a group effort! Many thanks to wonder women Angela, my incredible editor, and Jane, our hardworking designer, for always having my back. I'm also grateful to every talented photographer who contributed an image to this project, friends and strangers alike. Finally, many thanks to all my loved ones who patiently read through all 500 puns and only made fun of me for half of them.

Photo credits

The publisher would like to thank the following for permission to reproduce copyrighted material:

Shutterstock mimagephotograph: 1; Fede Marinic: 4 ml; Marius Dobilas: 12 tr; Boris B: 13 bl; Michaela Mazurkova: 13 tr; Matyas Rehak: 25 tl; Jose L Vilchez: 25 tr; Inspired by Maps: 26 tl; Discover Marco: 27; sistemalexx: 28; Dragon Images: 29; NeHomo: 30; Keat Eung: 31 bl; Globe Guide Media Inc: 34 br; Ramon Puig Valiente: 39 bl; MagicalKrew: 40 tr; Galina Barskaya: 41 tl; alexilena: 43 bl; Rolf G Wackenberg: 50 tr; Alex Marais: 51 tl; The Visual Explorer: 52 tl; Amateur007: 52 br; MyGlobeAdventures: 65 tr; RudenkoStudio: 67 bl; PR Image Factory: 68; Mike Dotta: 69; Olga_Go: 70; Goran Bogicevic: 76 tr; Habib Sajid: 78 tl; Valerija Polakovska: 90; BalazsSebok: 91; Fokke Baarssen: 95 br; WitthayaP: 100 br; MissRuby: 102; javitrapero.com: 112; Franck Camhi: 114; RossHelen: 115 bl; Alexander Karpikov: 118 tl; Irina Beloglazova: 120; Anton Ivanov: 121 tr; Lesinka372: 124; Jon Chica: 127 bl; Lina Zavgorodnia: 128 bl; Roberto La Rose: 129 br; John de la Bastide: 131 tl; Richie Chan: 135; Diego Grandi: 138; Lindsey Martin Webb: 140 bl; Kazim Kuyucu: 142 bl; Jeff Whyte: 145 tr; Knelsen Photo: 145 bl; Natapat2521: 148 bl; Cynthia Liang: 148 tr; cowardlion: 151 tr; chippics: 151 br; Konstantin Belovtov: 152; canyalcin: 156; Ewa Draze: 158 tl; starry-sky-visual: 158 br; Tamara Kulikova: 159 tl; Nabaraj Regmi: 159 br; ColorMaker: 161; Diego Bonacina: 164; Lakkana Savaksuriyawong: 166; Codegoni Daniele: 167 bl; Grischa Georgiew: 168 tr; NeilTap22: 168 bl; Blue Orange Studio: 174 tr; Kim Wonkook: 175; EB Adventure Photography: 176; ra66: 179 tr; R. M. Nunes: 180; Anna Tamila: 181 tr; Jimmy Tran: 181 bl; LightField Studios: 182; Roman Babakin: 183 tr; Jakub Czejkowski: 186 tl; Dominik Greenwood: 186 bl; Andrey Visus: 187 tl; Michail Vorobyev: 190 tl; ChunChang Wu: 190 br; leshiy985: 192; Brester Irina: 195; Sophie Dover: 197; Robert Frashure: 198 br; Maridav: 200; soft_light: 205 tl; Monkey Business Images: 206; Tobin Akehurst: 207 tl; Peruphotart: 207 br; Wanthida Jittayanantakul: 208 tr; Raphael Rivest: 208 bl; Mawardi Bahar: 209; IamDoctorEgg: 210 tl; jdross75: 210 br; Dimpy Gogoi: 211 tr; Michail Vorobyev: 212; Rafal Chichawa: 213; Brester Irina: 214; Jurate Buiviene: 218 bl; Gerisima: 218 br; Zilcheqs: 219; lenisecalleja.photography: 220; Dmitry Isientev: 221 tl; Scandphoto: 221 tr; Pete Niesen: 224 tr; Lamberto Jesus: 225 tr; Mihai Speteanu: 227 tr; Serge Velychko: 228; Blue Orange Studio: 229; Fotos593: 230 tl; Darryl Brooks: 230 tr; Katiekk: 231; Kanokratnok: 233 br, 234 tr; Filip Gieldra: 234 bl; Paolo Paradiso: 236 bl; stock_photo_world: 240 bl; Radiokafka: 241 tr; Almazoff: 243 br; Stephane Lalevee: 245; ESB Professional: 246 tl; Dyzi0: 248 tr; maziarz: 248 bl; badahos: 249 tl; Zephyr_p: 250; Mikhail Ivannikov: 256 bl; Michail Vorobyev: 258; Ela Trok: 261 br; Chaay_Tee: 262; mbrphoto: 263 tl; Patricia Burilli Fencz: 264 tl; Creative Family: 266 tl; totajla: 266 bl; Alessandro Colle: 267 tr; Magdalena Paluchowska: 267 bl; ImagesofIndia: 268; Fokke Baarssen: 270; Pattanan Phon: 271 tr; Ho Su A Bi: 271 bl; Raimond Klavins: 272 tl; Laszlo Mates: 272 tr; PaddenPhotography: 274 br; Wead: 275 tr; vonnahmed1: 276 bl; Makasana Photo: 279; mountainpix: 281 tr; Ekaterina Pokrovsky: 281 bl; Dudarev Mikhail: 282; Stanislav Beloglazov: 283 tl; Feel good studio: 284 br; VG Foto: 286 tr; Marianna Ianovska: 288; oerb: 289 tl; Cocos.Bounty: 289 br; Craig Milson: 291 tr; Michail Vorobyev: 292; Christopher Moswitzer: 293 br; Quetzalcoatl1: 294; Vergani Fotografia: 295 tr; Larry Zhou: 296; Dave Primov: 297 tl; schlyx: 298 bl; Lee Walker: 299 tr; Ruben Gutierrez Ferrer: 299 bl; Viktoriia Adamchuk: 300 tl; Yochika Photographer: 300 br; Iakov Filimonov: 303 tr; Waraphorn Aphai: 304 tl; Dmitry Islentev: 307 tr; Amy Nichole Harris: 308 tl; Inspired by Maps: 309 tl; Afili production: 309 br; Aysin Ozturk: 312 tl.

Getty Juan Algar Carrascosa: 50 bl; Josh Humbert: 53; Carol Yepes: 96 tr; Alexander Spatari: 118 bl; Dibyangshu Sarkar/Stringer: 139 br; Edouardo Soteras/ATP: 155 bl; Vincent Dolman: 143; Brendon Thorne: 160; Ed Jones: 290.

Unsplash Andrew Ly: 4 tl; Jakob Owens: 8; Romello William: 11; Cosmic Timetraveler: 15 tr; David Svihovec: 15 bl; Chris: 16; Jared Rice: 17; Xavier Crook: 18; Vipin Nair: 19; Mathijs Beks: 20; Facundo Ruiz: 22; Adrian Dascal: 24; Nassim Wahba: 34 bl; Logan Lambert: 35; James Thornton: 37; Kevin Wolf: 40 bl; Denys Nevozhai: 43 tl; Rachael Smith: 43 tr; Joshua Sortino: 44; Jakob Owens: 46 tr; Lode Lagrainge: 47; oneinchpunch: 48; Abigail Lynn: 49; Hakan Nural: 54 tr; Mauro Paillex: 54 bl; Fallon Travels: 58; Vadim Sadovski: 59 tl; Martin Jernberg: 59 br; Ugur Akdemir: 60; Spencer Davis: 63; Michele Orallo: 67 tr; Dirk Spijkers: 67 br; Syed Hussaini: 71 tl; Agathe Marty: 71 br; Luis Quintero: 72 tr; René DeAnda: 73; Nick Karvounis: 74 br; Krisztian Tabori: 75; Mark Billante: 76 bl; Sudarshan Poojary: 77 tr; mnm.all: 77 bl; Victoriano Izquierdo: 81 tr; Rafael Cerqueira: 81 bl; Olia Nayda: 82 tl; Sultonbek Ikromov: 82 bl; LALA: 83; Drew Colins: 84; Liam Pozz: 85 br; Robert Nyman: 86; Elijah Bryant: 88; Andrea Leopardi: 89; Nick Fewings: 92; Claudio Fonte: 95 bl; Josh Withers: 97 tr; Rose Breen: 100 bl; Milad Alizadeh: 101 tl; Henrique Ferreira: 104; JC Gellidon: 106; Lorenzo Castagnone: 107; Karun Giri: 108; Roozbeh Eslami: 109 bl; Jeison Higuita: 115 tr; Joshua Chun: 117; Hassan Saleh: 119 tr; Bruce Warrington: 122

tr; Raphael Andres: 123; Nick Karvounis: 125 bl; Tapio Haaja: 127 br; Kevin Bluer: 128 tl; Drew Hays: 130; Frank Romero: 132 tr; Morgan Petroski: 132 bl; Robson Hatsukami Morgan: 133; Anthony Tran: 134; Ugur Akdemir: 136; Michele Purin: 137 tr; Joshua Oluwagbemiga: 137 bl; j zamora: 139 tl; redcharlie: 140 tr; Christopher Campbell: 142 tr; Robert Metz: 146; Septumia Jacobson: 147 tl; Zhifel Zhou: 147 br; Ingeborg Gärtner-Grein: 149 tr; Austin Neill: 154 tl; Digjot Singh: 154 bl; Manisa Mitpaibul: 155 tl; Ian Schneider: 157; Juliette F: 162; Aneta Foubikova: 165 tr; Artur Aldyrkhanov: 165 bl; Zhang Xiaojun: 167 tl; Taranchic: 169 br; Andrew Ly: 170; Philipp Trubchenko: 171; Jef Willemyns: 172 br; David Veksler: 173 tr; Cameron Wilkins: 173 bl; Giorgia Romiti: 178 tl; Woo Hyeon Kim: 178 br; Lucas Marcomini: 184; Peter Winckler: 185; Ryan Stone: 187 bl; Charles DeLoye: 188; Parsing Eye: 189; Tomáš Malik: 191; Christoph von Gellhorn: 193; Annie Spratt: 194 tr; Gert Boers: 194 br; Ryan Magsino: 196; Alex Wolo: 198 tl; Thomas Lipke: 199 tr; Samuel Scrimshaw: 202 tr; Chris Charles: 202 bl; David Clode: 203 tl; Wolfgang Hasselmann: 203 br; Francesco Ungaro: 205 tr; Harshil Gudka: 205 bl; Artem Beliakin: 216; Radoslav Bali: 217 tl; Jasper van der Meij: 225 tl; Pascal van de Vendel: 225 tr; Yannis H: 226 bl; Hiep Nguyen: 232; Antoine Fabre: 235; Content Pixie: 238 tl; Branden Harvey: 238 br; Avi Naim: 239 bl; Bao Menglong: 240 br; Les routes sans fin(s): 243 tl; Tom Vining: 244 br; Kit Suman: 249 br; Sorasak: 251 bl; Christine Wehremeier: 253 tr; Charlie Costello: 253 bl; Patrick Carr: 253 br; Eliott Van Buggenhout: 254 tl; Valdemaras D.: 254 tr; Alex Azabache: 255; Sandro Ayalo: 256 br; Januprasad: 260; Jack Anstey: 264 br; Travis Yewell: 276 tr; Billy Onjea: 280 tr; Cayetano Gil: 295 bl; Anshu A: 297 tr; Kelly Robinson: 301; Jo Green: 304 br; Andrew Ruiz: 305 br; Ybrayym Esenov: 308 br; Michael: 311 bl; Ramon Vloon: 312 tr.

Pexels Palu Malerba: 26 br.

Instagram Peter Parkorr: 4 bl; Eileen Lahi @eslimah: 10; Taesha Jobson @ taejobson: 14; Kimi Morales @anxywanderer: 31 tr; Jesse Alpert @jessealpert: 36; Gis Bezerra @gisnatrip: 39 tr; Olly and Milly @ unexploredfootsteps: 41 br; Elise Moolenaar @elisemoolenaar: 45; Fatima AlMattar @hello965: 46 bl; Johanna Lebouef @travelingpetitegirl: 55; Victoria Brewood @pommietravels: 56; Sophie Pearce @thirdeyetraveller: 61; Alice Fekete @inhalice: 61; Sikta Anurakta @sikta_anurakta: 65 br; Victoria Brewood @pommietravels: 67 tl; Claire Wang @adventureatwork: 72 bl; Peter Parkorr @peterparkorr: 85 tl; Laia Lopez Barnadas @laialopez: 87; Andini Ria Djugo @andiniria: 96 bl; Peter Parkorr @peterparkorr: 101 bl; Lauren Kana Chan @laurkana: 103 tr; Zahirah Soo @zahirahzer: 103 bl; Alexis Enriquez Matthews @aleximaria: 109 tr; Jad Idriss @jad_idriss: 121 tl; Margarita Samsonova @s_marga: 122 bl; Anna Karsten @anna.everywhere: 125 tr; Vicki Summers @tonkstravelling: 131; Eriko Shiratori @eriko_shiratori: 144; Peter Parkorr @peterparkorr: 151 bl; Helene Sula @heleneinbetween: 174 bl; Anna Karsten @anna.everywhere: 183 bl, 205 br; Peter Parkorr @peterparkorr: 217 tr; Tom Walker @tomwalker33: 223; Vasylyna Golovachova @liftinstyle: 224 bl; Sophia Goh @sophigoh: 239 tr; Vasylyna Golovachova: 242; Elizabeth Mulder @ thelma.leez.travel: 244 bl; Dina Hjelset @dinahjelset: 251 tr; Peter Parkorr @peterparkorr: 257 tr; Rebecca Dixon @rebecca21dixon: 261 tr; Taylor Daoust @taylordaoust: 273 tl; Kaylee Rule @kayleerule14: 277 tl; Jaquelyn Marshall @thatgirl_jaq: 277 tr; Rebecca Ryan @beck8ryan: 285 tr; Thomas Chaffaut @thomas_chaffaut: 293 tl; Eileen Lahi @eslimah: 306; Helene Sula @heleneinbetween: 307 bl; Sophie Pearce @thirdeyetraveller: 310; Madhumitha Ramesh @mad_humitha: 311 tr.

Pixabay dpatdfci: 21 tr; Ivan Stangherlin: 32; Gerald Lobenwein: 33; Jeongmin Seo: 43 br; Hypatie: 169; Marc Benedetti: 253 tl; dfsym: 263; eyw2008: 273 br; skeeze: 280 tl; Michoff: 284 tl; StockSnap: 286 bl; Kanenori: 287; Kerry Barbour: 291 tl; David Mark: 303 tl; Mati Saloczee: 303 br.

Sabina Trojanova 3, 6, 21 bl, 62, 74 tr, 79, 80, 110, 113, 151 tl, 153, 172 tr, 222, 236, 237 tr, 241 tl, 274 tl, 283 br, 313.

Wiki Jan Reurink CC BY 2.0: 265 tr; Celestebombin CC BY-SA 4.0: 303 bl.

Other Petr Trojan: 94, 98, 313 br; Renata Trojanova: 126; Katerina Subrtova: 141; Rebecca Keely: 233 tl, 236; Mohammad Jabr: 247.

While every effort has been made to credit photographers, HarperCollins would like to apologize for any omissions or errors, and would be pleased to make the appropriate correction for future editions of the book.